Art *of the* Spirit

CONTEMPORARY CANADIAN FABRIC ART

Art of the Spirit

CONTEMPORARY CANADIAN FABRIC ART

Helen Bradfield, Joan Pringle, Judy Ridout

Brian J. Thompson, Photographer

DUNDURN PRESS

TORONTO & OXFORD

Editing: Nadine Stoikoff
Design: Andy Tong

The writing of this manuscript and the publication of this book were made possible by support from several sources. The authors wish to thank the **Ontario Heritage Foundation**, **Ministry of Culture and Communications,** for two research grants, and the **Anglican Foundation** for a grant towards publication.

Dundurn Press wishes to acknowledge the generous assistance and ongoing support of **The Canada Council**, **The Book Publishing Industry Development Programme** of the **Department of Communications, The Ontario Arts Council**, the **Ontario Publishing Centre** of the **Ministry of Culture and Communications** and **The Ontario Heritage Foundation.**

Care has been taken to trace the ownership of copyright material used in the text (including the illustrations). Credit for each quotation is given at the end of the selection. The authors and publisher welcome any information enabling them to rectify any reference or credit in subsequent editions.

J. Kirk Howard, Publisher

Canadian Cataloguing in Publication Data

Bradfield, Helen, 1938– .
 Art of the spirit: contemporary Canadian fabric art

Includes bibliographical references and index.
ISBN 1-55002-152-4

1. Textile crafts – Canada. 2. Fabric pictures – Canada.
3. Art, Canadian. 4. Art, Modern – 20th century – Canada.
5. Art and religion – Canada. I. Pringle, Joan, 1931–
II. Ridout, Judy, 1935– . III. Title.

NK8813.A1B73 1992 746.797 C92-094985–1

Dundurn Press Limited
2181 Queen Street East
Suite 301
Toronto, Canada
M4E 1E5

Dundurn Distribution Limited
73 Lime Walk
Headington, Oxford
England
OX3 7AD

Printed in Hong Kong

CONTENTS

PREAMBLE

L iturgical textile art enriches the life of the worshipping community and complements the liturgy. It conveys meaning and provides a source of inspiration; it nourishes the community spiritually and reflects the needs and aspirations of each congregation.

Prior to World War II much fine work was done by needlework guilds, but they often perpetuated styles of a bygone era. Traditional designs were repeated over and over again. There was little creative experimentation.

Following the war a cultural awakening in the entire religious world of the West resulted in changes in liturgy and traditional approaches to worship. The Second Vatican Council of 1962 was a landmark. It stimulated new architecture, new design, new music, new art and new forms of service. Celebration, joy and thanksgiving emerged as the new expression. Funerals went from having a theme of mourning to having one of celebrating a life well lived. Community became central to worship. This liturgical renewal has done much to create living worship.

The rich colours and designs of today's liturgical art are strong and arresting. The eyes of the congregation are drawn to the sanctuary, the focal point of the liturgy, just as the eyes of the audience are drawn to the stage, the focal point of the theatre. The symbolism may have been inherited, but today it is given new expression. This new expression must be understood, at least to some extent, by anyone who enters the church and sees it, awakening an emotional, intellectual and aesthetic response.

In textile art this response is achieved through the use of good design, an endless variety of colour and colour harmony, and new and exciting techniques.

For generations artists have created, with devotion and artistry, beautiful hangings and vestments for places of worship throughout Canada. The creative achievements of these artists should be documented as a significant part of our heritage. Many of the artists are women who have worked, without fanfare, either singly in their own homes, or in groups. Often their art is unsigned. For the most part this work has been unrecognized except by a few, and it is important that this artistic endeavour be recorded and celebrated before it is lost forever. In *Art of the Spirit* we have attempted to chronicle some of the finest examples of Canadian liturgical art created during the last twenty-five years.

INTRODUCTION

"A FAIR WHITE LINEN CLOTH"
CONTEMPORARY CANADIAN LITURGICAL
TEXTILES IN HISTORICAL CONTEXT

Nancy-Lou Patterson
Professor of Fine Arts, University of Waterloo
Waterloo, Ontario

Art is not a theory, but a way, a search, and the artist who is committed to it for the sake of the spirit will find in Church and Synagogue the natural allies who welcome his work.

Rabbi W. Gunther Plaut
Canadian Religious Art Today II
(1966)

Liturgical art is art used in the context of worship. Religious ritual must take place in a physical setting, and frequently makes use of implements and furnishings. These settings and artifacts often display symbolic motifs or representational images, making visible the meanings of the rituals. Among the material substances used to mark, enhance and enable religious rituals, textiles play a major role: mantles cover the scrolls of the Torah; cloths cover altars; sacred spaces are closed with curtains; ceremonial vessels are draped; funeral palls cover coffins; towels accompany ritual washings; rugs and hangings adorn floors and walls; wedding canopies and christening gowns are prepared; enclosures for the Feast of Tabernacles are decorated and set in place; benches, thrones, chairs and kneelers require cushions; and those who carry out the rituals wear appropriate vestments.

As might be expected, these textile uses derive from ordinary household life, both in Christianity, where they began in the classical era with house churches, and in Judaism, which still includes religious observances carried out at home. Indeed, the textile furnishings of the Tabernacle of Israel and the Islamic mosque sprang from the culture of ancient Near Eastern desert life. Textiles are widely used to signal value; births, weddings and funerals often require special items of textile. Formal meals call for table linens; gifts of cloth are common for births and weddings; bedding expresses more than a need to cover sleepers; household decorations are art forms in themselves. So it is with religious textiles. They are beautifully and decoratively made, to signal the value of the ritual events, to enhance religious occasions with visible beauty and to express through symbols the sacred significance of the ceremonial actions.

Textiles are mentioned throughout the Bible, both descriptively and metaphorically. Cloth is old or new, clean or unclean; the Lord is clothed with strength; his priests are clothed with righteousness; a prophet prays to be clothed with the garments of salvation; Jesus is mockingly clothed with royal purple; the woman of Revelation is clothed with the sun. Indeed, the life of Jesus begins with the swaddling clothes in which his mother wraps him, and ends with the linen shroud found left behind after his resurrection. The veil of the Temple is rent as he dies, and the author of Hebrews compares this veil to his flesh. We read of the fine stuffs used for the Tabernacle and Temple: white linen, purple, crimson and blue; and God is said to roll out the heavens like a curtain. Cloth in these ancient writings not only covers but identifies; it both honours and conceals; it protects and encloses, but it also reveals.

A distinctive textile object displayed on a pole, variously called an ensign, a standard and a banner, is used in the Bible as a signal of identity, a centre of attention and a symbol of presence. The tribes of Israel are gathered around such an object, and medieval Christians interpreted Old Testament references to these as symbols of Jesus. "Every man of the children of Israel shall pitch [his tent] by his own standard, with the ensign of their father's house" (Num. 2:2); "In the name of God we will set up our banners" (Psalms 20:5); "Thus saith the Lord God, Behold, I will ... set up my standard to the people" (Isa. 49:22); "When the enemy shall come in like a flood, the Spirit of the Lord shall lift up a standard against him" (Isa. 59:19). It is no wonder that banners have become textile objects of religious meaning.

The textile adornments of the Tabernacle of Israel – a tent made of cloth and animal hide – and the temples of Solomon and Herod are prefigurations of the textile uses of Judaism and Christianity. The synagogue continued this tradition of textile use; a mosaic in the Synagogue of Beth Alpha (circa fifth century CE) shows a pair of large curtains drawn apart to reveal the Torah Ark, a custom persisting to the present day. In the same manner, curtains and altar covers were used in the early Christian church, continuing the curtains of late classical art into the fifth century A.D. Actual Christian textiles from sixth-century Egypt have survived; one such curtain shows a pair of pillars supporting an arch, enclosing the Ankh or Egyptian cross, and the Chi-Rho (monogram of Christ), flanked by lions and peacocks. Such elaborate curtains for many years hid the ciborium, where the liturgy was celebrated, from the eyes of the people, a custom surviving in the Eastern Orthodox iconostasis (altar screen).

The New Testament tells us nothing about ecclesiastical vestments in the early church for the very good reason that such garments originated from ordinary Roman clothing, such as the tunic and pallium. The chasuble, now a much-adorned overgarment, began as a cloak like the one St. Paul wore in his travels. The alb now worn under the chasuble emerged in the fifth century; the stole in the sixth century; and the cope and mitre, a cloak and headcovering still worn by bishops today, in the eleventh and twelfth centuries. These various textile objects coalesced in the period of Opus Anglicanum (1250–1509), an era of superb English embroidery. The Reformation encouraged a renewed simplicity in vestments, but after the establishment of the Church of England was completed under Elizabeth I, the alb, chasuble and cope were permitted by the rubric of the Book of Common Prayer (1552). As for other textile forms in Anglican use, the Prayer Book still in force today speaks only of "The Table at the Communion time having a fair white linen cloth on it."

In Canada the most beautiful liturgical textiles before the modern era are those created by nuns at the Ursulines' convent in Quebec City; these include several superb altar frontals, a chalice cover, a chasuble and a cope, dated from the seventeenth and eighteenth centuries. Traditional Anglican vestments have been made well into the twentieth century by women of parish and diocesan altar guilds, reflecting what in their various periods were contemporary ideas of liturgical revival and arts and crafts values.

The second half of the twentieth century saw the modern style, already expressed in certain European churches, come to full flower in liturgical art. Grounded, perhaps, in the ideas of abstract artist Wassily Kandinsky's *The Spiritual in Art* (1912), but immediately inspired by the upsurge of interest in religion after World War II, artists of the stature of Matisse and Chagall were persuaded to create works of art for religious settings.

The influences of these events on the Continent had made themselves felt in Canada by the 1950s, and on 25 January 1953, an exhibition said to be the "First Exhibit of Liturgical Work under Secular Auspices" opened at Hart House in Toronto, Ontario. The Contemporary Liturgical Art Exhibition, arranged by David Gardner and the Art Committee of Hart House, with the aid of Assistant Curator E.A. Wilkinson, went on to tour Southern Ontario, visiting Oshawa, Windsor, Peterborough and London during the subsequent four months. The works, both historical and contemporary, representing Quebec and Ontario artists, included paintings, sculptures, stained glass, metal and wood. Pearl McCarthy commented in the *Globe and Mail* (24 January 1953) that "liturgical art is entirely serious" and "it is invigorating to look at art which springs from the urgency of feeling."

This exhibition was the precursor of a remarkable series of Canadian liturgical art exhibitions which culminated in 1989 with "the most comprehensive exhibition of liturgical textiles ever held in Canada," the Liturgical Arts Festival, shown from 14 September to 15 October at the Cathedral Church of St. James in Toronto. On display were "100 fabric works chosen for their contemporary (post-1970) expression of the liturgy," according to *Craft News* (October 1989). Comprising the work of seventy-nine Canadian artists, it was curated by Helen Bradfield, Joan Pringle and Judy Ridout. Anne McPherson wrote in the *Globe and Mail* (23 September 1989) that it concentrated "on the past 20 years, during which forms of worship and the design of churches have responded to new ... directions in theology." These new directions, an upsurge of long-developing ideas, sprang from a variety of sources, but certainly the spiritual renewal introduced by Pope John XXIII in 1958 and culminating in the Second Vatican Council (1962–65) formed a watershed in liturgical style in North America.

In 1963 nearly three decades of frequent religious art exhibitions were set in motion with two major shows in Ontario. The first was Canadian Religious Art Today, co-organized by Peter Larisey and Oscar Magnan at Regis College in Willowdale, Ontario, displaying the works of forty artists. Larisey commented in *Weekend Magazine* (no. 24, 1963) that "Good religious art has been practically non-existent in Canada. I hope this show will help its renaissance." In the same year, Religious Art exhibited the work of thirty artists at the Art Gallery of Toronto. The Anglican dean of Montreal, William Bothwell, wrote in the catalogue that "at Ronchamp and Coventry ... and in such exhibitions as the present one, the Christian world has begun to accord the artist his proper place." In a similar manner, the decade continued with Liturgical Artists of Ontario, curated by Nancy-Lou Patterson at the University of

Waterloo in 1964, Canadian Religious Art Today II, curated by Peter Larisey at Regis College in 1966, and exhibitions entitled The Jew and His World, displayed at Beth Tzedec Congregation in Toronto in 1966 and 1967.

The exhibitions of the 1960s concentrated upon the religious expressions of artists, predominantly painters and sculptors, along with some liturgical objects, a few in textile form. The specialized interest in liturgical works of textile artists in Canada came to public notice in 1970. There is probably a direct link between Vatican II and the vogue for liturgical banners in Canada; Norman Laliberté, a Canadian artist, was commissioned to create a series of banners for the Vatican Pavilion at the New York World's Fair (1964–65), but major liturgical textiles had already appeared in Europe in the 1940s and 1950s. Such a major textile work is the set of vestments designed by Matisse for the Chapel of the Dominican nuns at Vence in France in the late 1940s. The most significant textile was probably the tapestry for the new Coventry Cathedral (completed 1962), designed by Graham Sutherland.

In 1970 Marie Aiken, a well-known Ontario textile artist and teacher, opened a series of five annual exhibitions of liturgical textiles by Canadian artists with her Exhibition of Liturgical Stitchery and Weaving, prepared with the assistance of the Ontario Crafts Foundation, at Trinity United Church, Gravenhurst, Ontario, 1–31 August 1970, including the works of nine artists. Constance Mungall captioned her review in the Globe and Mail (2 September 1970) "Liturgical Art exhibition enhances beauty in Muskoka." Liturgical Stitchery followed in 1971, with works by twenty-four artists from 12 September to 4 October. Shows entitled Contemporary Church Stitchery and Banners appeared from 25 June to 6 September 1972, from 25 June to 4 September 1973 and from 1 July to 2 September 1974. These exhibitions created a significant venue for the display of liturgical textiles and greatly encouraged the productions of such works among the participating artists.

The interest generated by these shows established the reputation of Canadian liturgical textile artists, and this awareness resulted almost from the outset in other shows. Liturgical Stitchery appeared at St. James' Anglican Church, Dundas, Ontario, in 1971, showing the work of artists from across Canada. Worship 72 at St. Augustine's Seminary, Scarborough, Ontario, included textile artists, and Festival of Arts: Ecclesiastical Embroideries and Textiles from Canada showed works of artists from the Anglican and United churches of Ontario, Quebec, Nova Scotia and Alberta at First United Methodist Church at Western Springs, near Chicago, Illinois, in March 1972. The Presbyterian Church of Canada's Centennial Competition for Ecclesiastical Banners, Stitchery, and Hangings toured Canada from July 1974 to December 1975.

In 1974, coinciding with the fifth and last of the Gravenhurst liturgical textile shows, Helen Bradfield, Joan Pringle and Judy Ridout coordinated the first of their major sequence of exhibitions, beginning with their three Create & Celebrate shows, held at Grace Church on-the-Hill, Toronto, Ontario, in 1974, 1978 and 1983. A fourth exhibition, Faith and the Imagination, continued this sequence at Trinity College Chapel, Toronto, in 1987.

As with the shows coordinated by Marie Aiken, the Create & Celebrate series also inspired other exhibitions. Alleluia: Contemporary Religious Embroidery and Vestments appeared at Christ's Church Cathedral, Hamilton, Ontario, in 1983, and the Ontario Crafts Council opened 1988 with a significant show curated by Alison Parsons, Hallowed Objects: An Exhibition of Liturgical Works, which opened in Toronto at the Crafts Gallery and travelled to Sarnia, Cobourg, Cambridge, Hamilton, Kenora, Fort Frances, Stouffville and Belleville into 1989. Of the ten artists included, five showed textile works. The show was distinguished by the inclusion of Islamic as well as Jewish and Christian works. Liturgical Textiles was shown at Holy Trinity Anglican Church, St. George, Ontario (also in 1988), and Signs and Stories, created by Alison Parsons and sponsored by the Ontario Crafts Council, showed liturgical textiles at the John B. Aird Gallery, Toronto, in 1989.

The national exhibition, Liturgical Arts Festival: Contemporary Liturgical Art in Fabric, curated by Helen Bradfield, Joan Pringle and Judy Ridout in 1989, drew upon many decades of continually expanding development, both in the creation of significant works of liturgical art in textile media and in the public recognition and display of such works as a major form of Canadian art. In these works, the promise of a "renaissance" has been amply fulfilled.

FOREWORD

In the course of our research for this publication we have become increasingly aware of the diversity and extent of liturgical fabric art which has been created in our country during the past twenty-five years. No publication has dealt to any degree with liturgical textile art in Canada. The information we have presented here is important for future generations. Too many fine works of art are forgotten or lost in our rapidly changing society. We have attempted to document in this book the artists, their works and the places of worship in which their works are so effectively displayed.

We know that there are artists who will feel their work has been overlooked, and there are churches which possess beautiful vestments, paraments and hangings unknown to us. We only regret that we have been unable to be more comprehensive. It is our hope that this publication will lead to new discoveries, new knowledge and new understanding.

Our research was undertaken for the most part in Christian churches and Jewish synagogues. We pursued information about as many different denominations and places of worship as we were able. However, a sense of disappointment has haunted us throughout our investigation; we have not discovered vestments or hangings in a contemporary style in the sacred places of many other important faiths. Often in new Canadian churches, temples and mosques, traditional expressions are still adhered to, no doubt serving to remind people of their roots. Omissions are regrettable, and we genuinely wish for a future opportunity to rectify these oversights in our research.

The whole map of Canada became alive as we explored different communities of the First Nations. Patterns emerged which developed in us a curiosity and a desire to discover more. Opportunities to learn about Canada and its beginnings helped us to become aware of our common ground, and to respect different interpretations and reflections. We are excited to find similarities that complement each other. We, in turn, celebrate our different approaches.

Although some books on this art form have been produced – most notably in the United States and Britain – nothing to our knowledge has been published in Canada. It is our hope that this book will be a valuable source of reference to art historians and those interested in fabric art.

ACKNOWLEDGEMENTS

The production of *Art of the Spirit* has been our dream for the past number of years, and its publication, therefore, gives us great joy. We are keenly aware of the supporting role performed by a great many people on our behalf, and we hereby acknowledge their contribution and thank them most sincerely.

Our initial involvement originated with Create & Celebrate, a liturgical arts celebration at Grace Church on-the-Hill in 1974, the idea for which was initiated by the rector, Canon Malcolm C. Evans, to mark the hundredth anniversary of the parish. Among the artists participating in that exhibition were two women who were to add profoundly to the growth of fabric art in this country, and also to influence greatly the three of us. Helen Fitzgerald gave generously of her time and expertise. Her work is a constant source of inspiration and we thank her for her many helpful contributions. Our friendship with Doris McCarthy also dates from this period. Her wise advice and forceful interest have acted as a constant guide and respected example to us, and the warm companionship we have shared is indeed treasured.

Nancy-Lou Patterson delighted us with her spontaneous response to our invitation to have a part in this publication. No one could be better qualified to write the introduction to this book; her knowledge of this art form and her sensitivity to our vision have set *Art of the Spirit* in context and given it its rightful perspective.

One of the highlights of Faith and the Imagination, Trinity College, 1987, was the inclusion of the Holy Blossom wedding *chuppah*, designed by Temma Gentles. The help proffered by her at that time cemented our friendship. We are indebted to Temma for introducing us to the world of contemporary textile art created for synagogues, and also for connecting us to the Pomegranate Guild, with whom we have shared interesting times and ideas.

We were warmly welcomed to Wikwemikong on Manitoulin Island by members of the Liturgical Vestment Cooperative. Our knowledge and interest were kindled by their creativity, and mutual interests engendered an appreciation of our common ground. While a visit to the Arctic has not yet been realized, Peter Bishop, in the Diocese of the Arctic office in Toronto, provided photographs and recollections of his years spent there, and we are indebted to him for expanding our knowledge. Special mention should be made of Flo Dutka, who offered valuable assistance in the West, and of Lucy McNeill, Susan Judah and Carol Oliver who welcomed us in the East.

Our greatest debt of gratitude is undoubtedly reserved for the many artists with whom we have worked. Their dedication to this art form and their creativity have been our inspiration. Our one disappointment is that the constraints of space have forced us to limit the number of artists and works included in the publication.

As rector of St. James' Anglican Church, Dundas, Ontario, and later as dean of the Cathedral in Hamilton, Bishop Joachim Fricker was an active promoter of the use of contemporary art to enrich the liturgy. We drew on his time and his innovative thinking, and are extremely grateful for his encouragement.

For the past four years, Barbara LeSueur has reflected an artist's awareness of the need to pursue the dream. She has given advice based on her own experience, and has encouraged and promoted our work. We are

grateful to her for having created the work of art that graces the cover of *Art of the Spirit*.

Violet and Keith McKean have provided us throughout with opportunities to discuss our endeavours, and have listened with warmth and interest. Ann Wainwright too has offered assistance and understanding support.

A major portion of our expression of thanks is owed to that vast assembly of women and men, over four hundred volunteers, from the following Toronto churches: St. Simon's, Christ Church Deer Park, St. Thomas', St. George's on-the-Hill, St. James' Cathedral, Timothy Eaton Memorial, St. Clement's, St. Margaret's, St. Richard of Chichester, St. Michael and All Angels, St. Timothy's, and Grace Church on-the-Hill. Their participation was to a large extent reponsible for ensuring the success of the Liturgical Arts Festival, and we continue to benefit from their interest in our projects.

Crucial to our commitment to *Art of the Spirit* was the understanding and loyalty of friends, too numerous to identify. The Cariboo Group of Grace Church on-the-Hill, where we three have been members for many years, was always there and more than ready to assist in all ways possible. In September of 1991, they organized a theatre night as a fund raiser on our behalf; the theatre sold out, and the proceeds enabled us to complete the photography. A number of friends, unable to attend, made donations as a sign of their support.

Vital to any undertaking is the belief in its successful outcome. We are grateful to the following individuals who shared our faith in the worth of the publication and, in an unobtrusive gesture, gave tangible support to us in the early stages: Lee Booth, Annabelle Bradfield, Win Burry, Christ Church Deer Park Anglican Church Women (ACW), Janet Gouinlock, Judith James, Margaret Machell, Doris McCarthy, Hilary Nicholls, Pam Richardson, Joan Stevenson, Mary Lou Thompson, Isabel Wilks, Carol Wishart, Jane Wright and Leslie Pringle Wright.

Especially meaningful to us was the assistance provided by the Toronto Diocesan Anglican Church Women, not only in the form of a grant to this production, but in the close working association at the time of the Liturgical Arts Festival, 1989. Jean McCallum has been especially helpful and considerate.

Grateful acknowledgement is also expressed to the Anglican Foundation for a grant on our behalf, and for two research grants from the Ontario Heritage Foundation.

Alice Corbett was the first to read our manuscript; her advice was invaluable. The title, *Art of the Spirit*, was a direct result of conversation with Alice and her husband, Paul. We thank them both very much indeed.

All photographs, unless specifically credited, are the work of Brian Thompson. He spent many hours in many out-of-the-way locations working with us during the past three years. Brian was always cheerful and willing, and his work enhances this publication. We enjoyed working together, and we thank him.

To Kirk Howard, publisher, Dundurn Press, we express our warmest appreciation. To Nadine Stoikoff, the editor, who has a remarkable way with words, and to Andy Tong, the designer, whose creative touch with the computer made the vision a reality, we extend our many thanks. Authors who come in triplicate present unusual challenges!

Perhaps the greatest joy for us has been the countless associations made with people across this country, and we dedicate *Art of the Spirit* to all who have created art for places of worship.

MARIE AIKEN-BARNES Aurora, Ontario

This Is My Father's World (1968)
Multi fabric collage, appliqué,
with embroidery
1020 x 120 cm
Collection: Trinity United Church,
Gravenhurst, Ontario

Drawn from the images of the surrounding countryside, the vibrant tapestry *This Is My Father's World* stretches thirty-four feet across the balcony of Trinity United Church in Gravenhurst, Ontario. Pine trees, flowers, lichen, soil and water blend and flow with the motion of the wind. The design is an abstraction of plant forms and rocks – "some readily identified and some quite imaginary," says the artist. The whole panorama teems with the growth of nature, and the themes, taken from nature close at hand, are fresh, vivid and delightful.

The variety and texture of the fabrics contributed by members of the church present a depth of meaning. The very size of the work is awesome. Particularly arresting is the warmth of colour, which is intensified by virtue of the contrast with the simplicity of the church interior and its subdued stained glass. No white or grey, black or gold, yellow or orange are used in the tapestry.

This tapestry was designed and supervised by the internationally recognized craft teacher and artist Marie Aiken-Barnes. The whole undertaking of layout, stitching, appliquéing and embroidering was done by a group within the United Church community.

An enthusiastic promoter of contemporary art in textile, Marie Aiken-Barnes is especially interested in lichen dyes, a subject on which she has lectured widely throughout this country, including the Canadian Arctic and Australia, and which was the basis of her presentation to the World Craft Conference in Dublin, Ireland, in 1970.

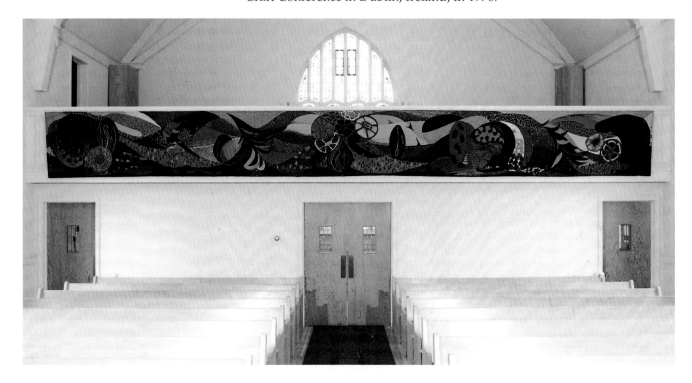

MARJORIE WATHEN AITKEN Fredericton, New Brunswick

The Mary Banner (1990)
Felt, on wool worsted
204 x 100 cm
On loan to
Saint Thomas University Chapel, Fredericton, New Brunswick
Photograph by the artist

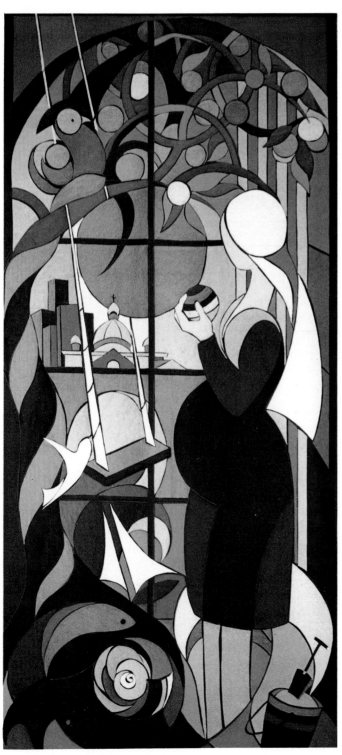

A meditative and reflective exploration of feminine characteristics, *The Mary Banner* combines the world of myth with a contemporary Christian contemplation of Mary. The interpretation that follows is taken from the artist's own description.

The Mary of this banner is a young pregnant woman. Waiting, expectant, she holds the ball of the world in her hand, a world of brown, black, yellow and white peoples. She is standing inside a room by the edge of the sea, where life began and from which emerged Aphrodite, the ancient goddess of love and beauty. Mary is looking out through a window upon the world, a world that is a garden, a city and a seaside playground.

In the playground stands a dual tree, the tree of knowledge, around which twists the serpent tempter and the serpent healer, and the tree of life whose fruit gives "everlasting life" and "whose leaves are for the healing of the nations." On its branch sits a cockerel, a reminder of Peter's denial and of our own.

Just as a child by the seashore picks up a shell and listens to the sound, so the shell at Mary's feet represents curiosity, inquiry and interior listening. In her humility Mary chose to listen to the word of God. A child's shovel and pail of sand suggest our playing with moments of time, while the frail boats indicate our sailing forth on a spiritual adventure.

The Christian fish circle the seas and the tree roots, and a crescent moon in the waves at Mary's feet represents tides, time and the reference in Revelation to "a woman clothed in the sun for her mantle, and the moon at her feet."

The distant city can be interpreted as the Rome of "non nobis sed urbi et orbi" (not for ourselves but for our city and the world), a place of political and social action.

The swing is an image of where we are, or where we hope to be. Coming from a world outside the definition of this banner, the swing is motionless until moved by the spirit of the child within, who will grasp and articulate a new vision. Then, growing creatively together, we can say with Mary, "My soul doth magnify the Lord and my spirit hath rejoiced in God my Saviour."

CAROLYN BEARD Wilberforce, Ontario

Lazarus (1982)
Fabric collage, machine stitchery
210 x 90 cm
Collection: St. James' Anglican Church,
Dundas, Ontario

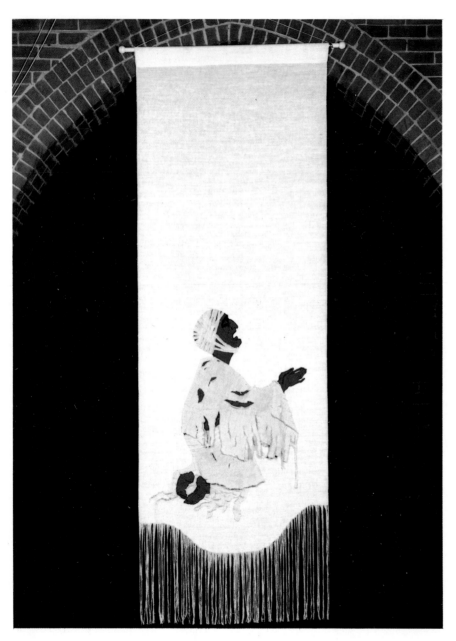

Carolyn Beard, self-taught in the art of needlework, has produced a modest body of work but one that reflects a remarkable and varied style and always a powerful emotional content.

Lazarus, a fabric collage, brings into focus the church in the inner city. Simple, stark and powerful, it bespeaks today's world within the context of the Bible. The tattered and torn clothing of the resurrected Lazarus becomes the piteous cry of the disadvantaged, homeless and isolated in a world teeming with riches. While emitting a piercing cry, the collage nonetheless reflects an attitude of faith and gratitude. The limited colour range, the sensitivity of the embroidery, and the placement of the figure in the lower section of the hanging all combine to make a simple, strong and highly dramatic statement. It is hard to imagine this banner hanging in a church even fifty short years ago.

JANE DAMS Georgetown, Ontario

Cloak for a Recording Angel (1984)

Silk dupioni ground, sponged with dye
and metallic powders, screenprinted
with sublimation dyes, and
embellished with hand and machine
embroidery, appliquéd fabrics and gold
leathers, gold couching
and beadwork
Semicircular cloak, 316.8 cm from neck
to end of train
Collection: The artist
Photograph by P. Dams,
Georgetown, Ontario

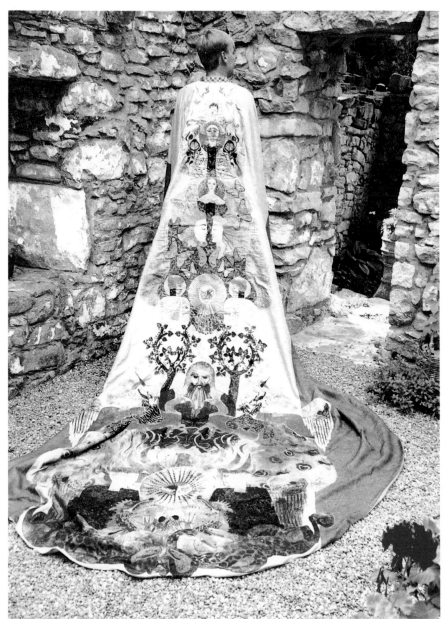

The original concept for this magnificent work was to design a vestment that could be worn to celebrate all of the important occasions in a person's life. From top to bottom, the embroidery depicts, symbolically and pictorially, the stages of birth, marriage, death and the resurrection of the soul.

Sky, water and the earth are suggested by the colours that pour down over the cloak. Water is symbolized by mermaids and fertility by pomegranates, while angels represent divine activity in the world of men and women. The phoenix and butterfly stand for resurrection, while peacocks suggest immortality, all built around the tree of life. One can spend hours looking for the endless array of images that fill this glorious composition in a variety of matchless artistic skills.

The artist states:

I like to paint using fabric and thread and find the very nature of the materials stimulating. Designing and drawing are perhaps the most exciting stage for me, especially in the use of colour, form, and texture. Most of the themes chosen are based on figures, natural forms, and subjects derived from literature. The use of a sewing machine, when used as a drawing tool, and various dyeing techniques in conjunction with hand stitching plays a prominent part in my work, allowing me to create my own fabrics. There are no set boundaries in embroidery, the possibilities extend even into the third dimension.

JOY BELL Burlington, Ontario

Parable of the Sower (1978)
Fabric with appliqué and
hand stitchery
Set of 6 banners,
each 355 x 120 cm
Collection: The Baptist Convention of
Ontario and Quebec,
Toronto, Ontario

The six panels which comprise the *Parable of the Sower* graphically portray the vast landscape of that biblical land, while at the same time visually enacting the familiar verses:

> *A sower went out to sow; And as he sowed, some seeds fell along the path, and the birds came and devoured them. Other seeds fell on rocky ground where they had not much soil, and immediately they sprang up, since they had no depth of soil, but when the sun rose they were scorched; and since they had no root they withered away. Other seeds fell upon thorns and the thorns grew up and choked them. Other seeds fell on good soil and brought forth grain, some a hundredfold, some sixty, some thirty.*
> (Matt. 13:3–8)

A powerful stage is created beneath an omnipresent sky that changes dramatically. The story unfolds in simple pictures set against a backdrop of extraordinary reality captured with amazing dexterity in the medium of fabric. The rocks and the thorns and the grain, and even the circling birds, have a tactile quality that almost invites the viewer to enter the scene.

For the past fifteen years, Joy Bell has played an active role in the field of liturgical fabric art and has made a significant contribution to it, especially in the creation of pictorial banners.

Another set of six banners (not illustrated) is based on the theme of caring:

> *I was hungry and you gave me food,*
> *I was thirsty and you gave me drink,*
> *I was a stranger and you welcomed me,*
> *I was naked and you clothed me,*
> *I was ill and you visited me,*
> *I was in prison and you came to me.*
> (Matt. 25:35–36)

This set (like the former one) was commissioned for the Baptist Convention held in Montreal in 1979. Rendered in batik, it conveys the feeling of compassion and mutual responsibility.

Seasonal pulpit hangings and Bible markers for MacNeill Baptist Church in Hamilton display Joy Bell's ability to create on a small scale. Delicately embroidered with pearls and beads, these hangings crafted in wool with silk and satin appliqué display the artist's extraordinary range of expression and skill.

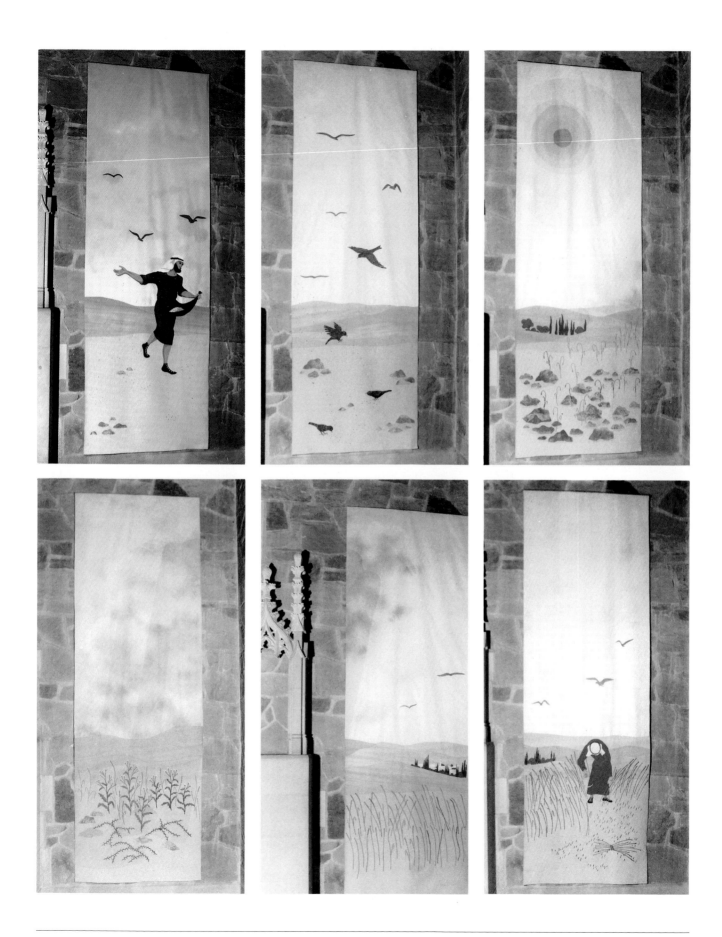

ANNE BOYLE Belleville, Ontario

Last Supper (1987)
Fabric collage, finished with painted
wooden hearts
60 x 40 cm
Collection: The artist
Photograph by Harold Duke, Toronto, Ontario

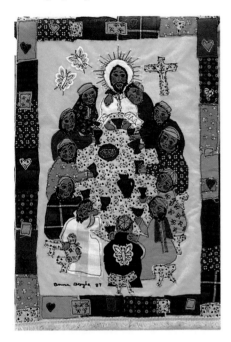

Bold and simplified forms created from odds and ends of fabric characterize the work of Anne Boyle. Her banners and wall hangings are usually appliquéd, with hand embroidery, or machine stitchery, and frequently they are embellished with touches of folk art – carved and painted wooden adornments or brass bells, buttons or braid, and sometimes hand-painted facial features. Always colourful, they display an extraordinary vitality and liveliness; charming and animated works of art, they never fail to illustrate clearly the scripture on which they are based.

The *Last Supper*, a banner not much larger than a place-mat, conveys the warmth and intimacy of mealtime by the closeness of the figures around the table, and by the use of warm colours in simple calicos. John, cast typically in an attitude of repose, lays his head on Christ's shoulder; Judas, in the lower left, with a coin bulging from his pocket, is portrayed with guilt and great sadness; the cross and butterflies anticipate the death and resurrection of Christ. The painted and embroidered faces and the characteristic headgear of the disciples evoke a regional distinctiveness. Patches of fabric with appliquéd hearts, as well as carved and painted wooden hearts suspended from the sides of the banner, complete this simple and unusual treatment of the *Last Supper*.

Madonna of the Lilies is the single bright and colourful accent in an otherwise subdued architectural setting. In a richly panelled chapel with carved wooden figures that relate the early history of the Dominicans in French Canada, this image of the Virgin Mary plays an important role. Legend has it that the Virgin appeared to St. Dominic (the founder of the Dominican order) and gave him a rosary.

Jesus Calms the Sea is crafted of simple, decorative shapes that form fresh and unmistakable images. A sense of faith and trust illuminate the wide-eyed innocent figures, while playful fish toss about the swirling waters, totally unaware of the miracle about to be performed. Hand-carved wooden fish carry the theme beyond as they swing freely from the bottom of the banner.

Madonna of the Lilies (1975)
Velvet, printed cotton appliqué,
eyelet, braid, ribbon, brass bells
177.5 x 107.7 cm
Collection: Paroisse Saint-Jean Baptiste,
Ottawa, Ontario
Photograph by Harold Duke, Toronto

Jesus Calms the Sea (1979)
Mixed fabric, appliqué, finished with wooden fish
125 x 85 cm
Collection: St. Andrew's Presbyterian Church,
Belleville, Ontario

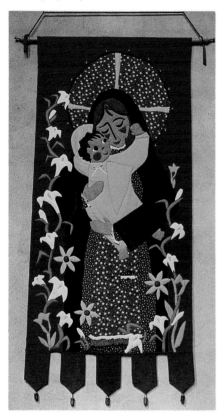

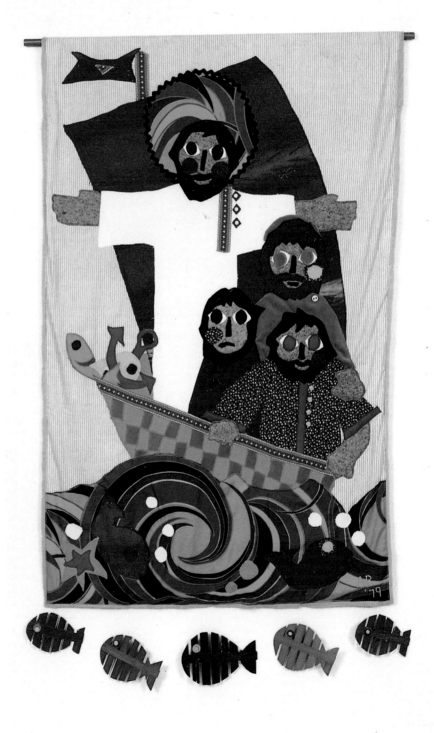

WINIFREDE W.R. BURRY Toronto, Ontario

Whither Thou Goest (1990)
100% Cotton, hand appliqué,
hand quilting
126.9 x 101.2 cm
Collection: C. James Burry,
Toronto, Ontario

And Ruth said [to Naomi, her mother-in-law], Entreat me not to leave thee, or to return from following after thee; for whither thou goest, I will go; and where thou lodgest, I will lodge; thy people shall be my people, and thy God my God. (Ruth 1:16)

While the text for this quilt is taken from the Old Testament Book of Ruth, the artist also incorporates the concept of the shaman of the Woodland native people. The artist has aptly chosen Canada geese to depict the symbol of consummate friendship: they mate for life. Within the moon's sphere is seen the eye of the shaman, the powerful intermediary between the natural and supernatural worlds believed to exercise powers of magic.

The central circle suggests the "Light of Christ," and quilted rays illuminate the universe. Light is everywhere. Note how the pine branch encircles the whole to suggest the interdependence and continuity of all things.

*The midnight moon's soft rays caress
Our Mother Earth, and Father Sky,
And to the cadence of their pines
Wings softly beat their lullaby.*

(W.W.R. Burry, 1990)

IVY DRAPER Town of Mount Royal, Quebec

The Nativity (1987)

Various fabrics, wool, acrylic paint,
with appliqué, embroidery,
rug hooking, and dyeing
390 x 135 cm
Collection: Town of Mount Royal United Church,
Town of Mount Royal, Quebec

W hen she was ten years of age Ivy Draper's artistic skills were recognized and admired. One of her early paintings was submitted by a schoolteacher to the Canadian National Exhibition, where it won first prize in her age category.

Since that time Ivy Draper has continued to paint and to create a large number of banners for Mount Royal United Church. She was a major contributor to a large Thanksgiving Banner (not illustrated) sewn by fifty-two people. It portrays a cornucopia of life-size fruits and vegetables in an extraordinary variety of fabric and technique.

The Nativity is hand sewn with appliqué and stitchery. The fabric background features a variety of materials which have been collected together to form the three-dimensionsal, two-thirds–life-size figures. Acrylic paint, straw, wool and beads all converge to display a strong, tactile and dramatic presentation of the birth of the Christ Child, in a stable surrounded by his family, the barnyard creatures and small children. The artist writes:

I wanted to get across the Love in this scene. The love of family and the love for each other. Joseph's arm is lovingly around Mary as she cradles their new baby, our Lord. There is a lot of touching in this scene and a young child offers the baby her only toy. I have the children in the Nativity scene because the children viewing this banner can relate to it and feel part of it.

Ivy Draper considers *The Last Supper* (not illustrated) her greatest achievement. It took two years to complete. The figures are life-size. This large construction is accompanied by twelve banners of the individual disciples. The collective work is a unique didactic statement.

CHRIST CHURCH DEER PARK STITCHERY GROUP Toronto

The Benedicite Kneelers (dedicated, 1988)
Needlepoint
2430 x 45 cm
Collection: Christ Church Deer Park,
Toronto, Ontario

The thirteen kneelers at Christ Church Deer Park, in midtown Toronto, were designed in 1982 by Joyce Hamilton. There was general agreement that the remodelled sanctuary of the church would be enhanced by a new set of kneelers, in needlepoint. A contemporary rendering of "Benedicite" was completed by eleven stitchers, members of the parish, whose work was coordinated by Mary Lou Thompson.

"Benedicite, Omnia Opera" is a canticle taken from "The Song of the Three Children" in the Apocrypha. It is sung by the three Jewish youths Ananias, Azarias and Misael in the fiery furnace, and it is a paraphrase of the 148th Psalm. This paeon of praise to the Lord refers to the heavens; the angels rejoice; fire and hail, snow and vapours and stormy wind fulfil His work; mountains and all hills, fruitful trees and all cedars, beasts and all cattle, creeping things and flying fowl, kings of the earth and all people, princes and judges of the earth, both young men and maidens and old men and children – let them praise the name of the Lord.

The total length of the kneelers is eighty-one feet. The design is continuous, radiating from the central cushion that proclaims the main theme, "All ye works of the Lord, praise Him and magnify Him forever."

The Benedicite Kneelers received an award for their excellence in design and the quality of the stitchery at the sesquicentennial Liturgical Arts Festival at St. James' Cathedral in Toronto during the fall of 1989. They are a superb example of the fine workmanship that can be achieved by a group of talented, dedicated stitchers.

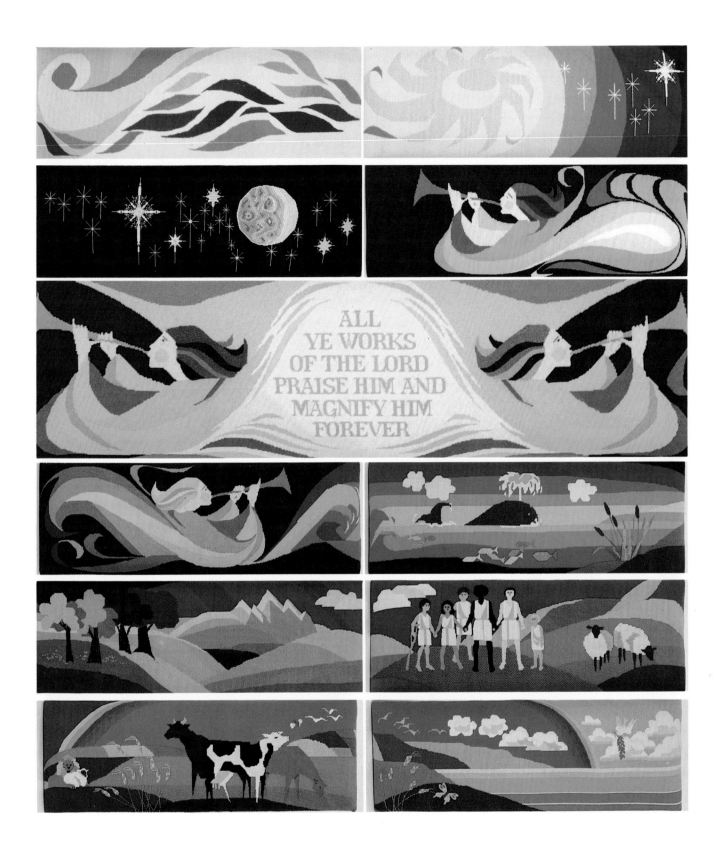

MARTHA COLE Disley, Saskatchewan

Cope: Flames of the Spirit (1990)
100% silk with silk satin band
and gold synthetic thread, quilted
Collection: Holy Trinity Church, Regina, Saskatchewan
Photograph by Gary Robins, Available Light, Regina, Saskatchewan

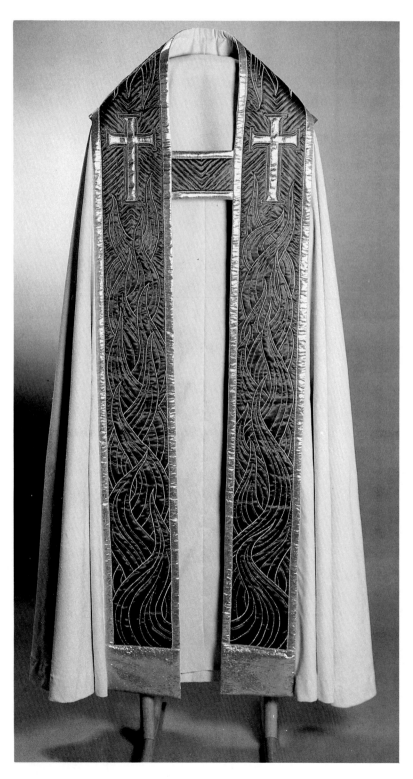

The magnificent cope, *I Am the Resurrection and the Life* (facing page), is part of a complete set of twelve items that comprises dalmatics, a chasuble, stoles, an altar frontal, pulpit fall, and prayer desk covers. The motif of flowing water is used on all the vestments and on the altar frontal; the remaining pieces are done in solid colours with silver.

When entered in the juried competition at the 1989 Liturgical Arts Festival, St. James' Cathedral, Toronto, this award-winning cope was cited by the jury for its masterly design and remarkable economy of colour, resulting in heightened solemnity and grandeur. The flowing water described in curves on a flat surface symbolizes baptism and resurrection.

A second bishop's cope (on left) entitled *Flames of the Spirit* is made of ecru silk with bands of red flames that sweep upwards to the crosses on both front panels emulating the spirit of Christ. The orphreys are made of red satin with quilted flames sewn in gold metallic thread and bound in gold fabric.

Cope: I Am the Resurrection and the Life (1986–87)
Blue satin and silver lamé on white antique satin ground,
appliquéd by machine in silver satin stitch
Collection: St. Paul's Cathedral,
Regina, Saskatchewan
Photograph by Gary Robins, Available Light, Regina, Saskatchewan

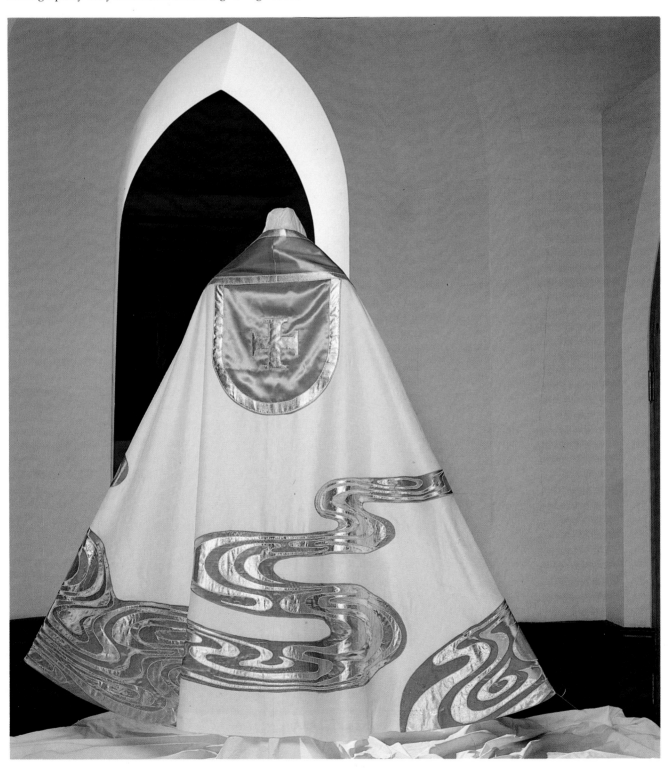

LEE CLIFTON Oakville, Ontario

The Psalm of David (1986–88)
Fabric with appliqué and embroidery
In four panels, each 240 x 120 cm
Collection: Chartwell Baptist Church,
Oakville, Ontario

In 1986, Lee Clifton designed this set for Chartwell Baptist Church in Oakville. The familiar words of the 23rd Psalm are translated faithfully and with great clarity.

The first two panels on the left are designed in soft shades of mauve, green and blue to suggest the comforting words of the first verses of the psalm:

The Lord is my shepherd, I shall not want;
He maketh me to lie down in green pastures;
he leadeth me beside the still waters. He
restoreth my soul; he leadeth me in the paths
of righteousness for his name's sake. (Ps. 23:1–3)

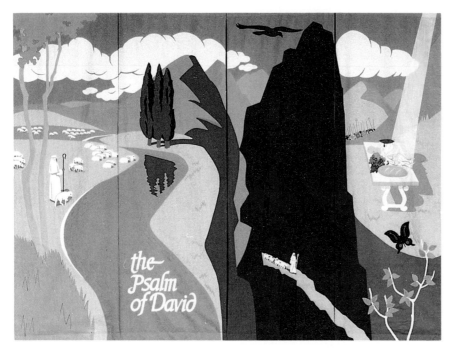

The third panel is in deeper and more dramatic shades of blue: "the shadow of death," symbolized by the black bird hovering with outstretched wings, looms darkly above the shepherd who "fear[s] no evil ... thy rod and thy staff, they comfort me." The last panel on the right completes the psalm: "a table before me" is depicted "in the presence of my enemies," who appear ominously with spears and shields on the distant horizon.

This mammoth project evokes a strong emotional appeal. It was worked on over a period of two years by the women in the congregation under the direction of Joy Bell (see page 18).

KAREN COLENBRANDER Mississauga, Ontario

Cope (1985)
Silks, on linen ground, appliqué, padded kid,
gold laidwork, beading and stitchery
Collection: St. Paul's Anglican Church,
Mississauga, Ontario

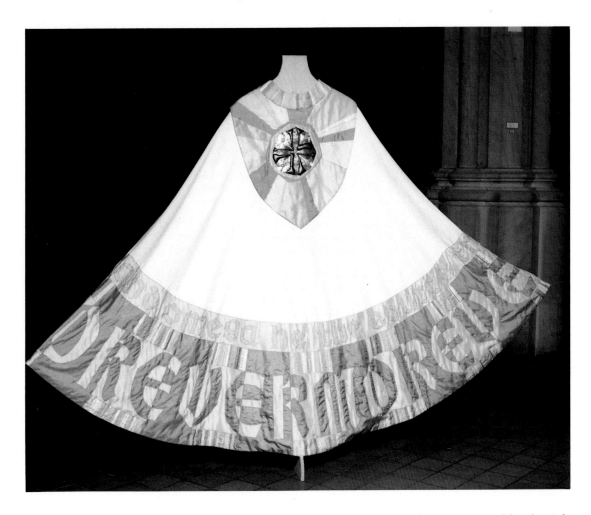

This cope, worn for festive occasions, has an elegance created by the rich colouring of many varied shades of gold silk, and by the unusual design, the inspiration for which was drawn from the hymn "Of the Father's love begotten ... /He is Alpha and Omega/He the Source the Ending He." The refrain "Evermore and Evermore" is spelled out in continuous ten-inch-high lettering appliquéd on the lower edge.

The medallion on the hood and also the morse are padded bronze leather, gold kid and wire, beads and gold laidwork forming an irregular cross. The medallion is set in a sunburst of gold silks. The uneven strips of yellow-gold and wheat- and cream-coloured silks form the orphreys and are interspersed along the lower band.

Having never before attempted a project of this magnitude, Karen Colenbrander relied greatly on the encouragement of the rector and the parish. She regarded the project as a time of learning and growth both in technique and in faith.

COPPERMINE (Kugluktuk), N.W.T.

Triptych (c. 1965)
Felt, white polyester, caribou hide, wolf and
wolverine fur, plywood, pearls and beads, appliqué
Three panels: 210 x 90 cm, 210 x 210 cm, 210 x 90 cm
Collection: St. Andrew's Anglican Church,
Coppermine, N.W.T.
Photograph by Peter Bishop,
Diocese of the Arctic,
Toronto, Ontario

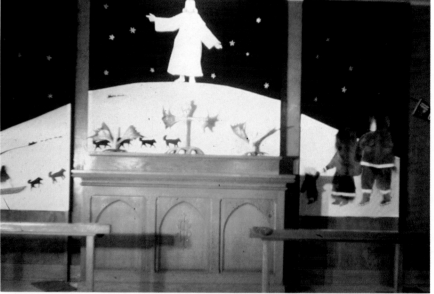

The Christ figure, silhouetted against a starry sky, stands atop the world. The figure is on a felt background and robed in white. His face and hands are painted by John Allukpik, a local artist. The stars, formed from pearls and beads and sewn in place by individual women of the congregation, are a constant reminder for today's generation of the handiwork of their grandmothers. Attired in summer caribou skins and trimmed with wolf and wolverine fur and with white, caribou belly, the onlooking figures and travellers all look towards Christ.

The figure of Christ is seen both as Christ of the Ascension and as Christ coming again. The Inuit make no distinction between the two visions of Christ; they like to see the figure in the dual role.

The women of A.E., or the Angnait Ekayuktiukatauyun (literally meaning "women who help together"), crafted this large three-part wall hanging under the leadership of the then priest-in-charge, the Rev. J.R. Sperry, later Bishop of the Arctic, and his wife, Elizabeth, after consultation with a visiting artist.

A cross and candlesticks, made from caribou antlers, may be seen on the altar. Scenes depicting Jesus walking on the water and the feeding of the five thousand, engraved and highlighted with blacking on the candlesticks, are the work of Charlie Avakana.

SYLVIA DENNY Eskasoni, Cape Breton Island, Nova Scotia

Frontal (1987)
Deerskin, poplar, beads
Collection: Holy Family Parish Church,
Eskasoni, Nova Scotia
Photographs by Stephen Oliver,
Antoinette Ridout, Toronto, Ontario

This altar frontal was the first artistic achievement of Sylvia Denny. Surviving a near-fatal fall and a crushed hand, she discovered a gift of which she had been unaware. Since that time Denny, a Micmac, has continued to create banners and frontals for her church. They are all adorned with symbols of the Micmac culture.

Set on this frontal is a wigwam-shaped tabernacle of cowhide, decorated with painted motifs, pine trees, stars and the hieroglyphics for "Holy Eucharist." The characters are repeated on the deerskin frontal, painted in red by Denny's husband, the respected artist Eugene Denny. The fringe is adorned with three rows of beads which repeat the zigzag border of the frontal. Seven red flowers carved from poplar by the artist's neighbours and friends are attached decoratively, as well as a pair of rabbit's feet on each side.

The introduction of the native culture into the Roman Catholic liturgy is deeply significant to the members of the congregation. Their traditional beliefs have historically been so close to their present faith that it has not been difficult for them to integrate their culture with their religion.

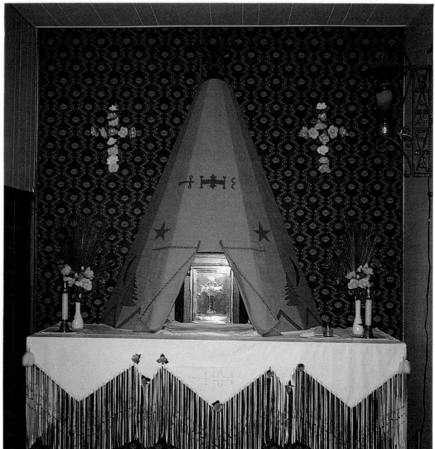

DOGRIB Rae, N.W.T.

Chasuble (1986)
Caribou hide, with embroidery
Collection: Denis Croteau, OMI
Bishop of Mackenzie-Ft. Smith,
Yellowknife, N.W.T.
Photograph courtesy of Reuters/Bettman, New York, N.Y.

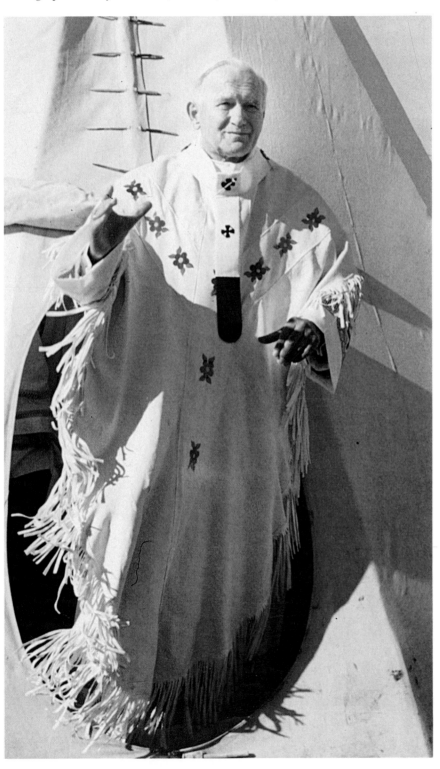

When poor weather prevented Pope John Paul II from reaching Fort Simpson on his cross-Canada tour in 1984, the native people, who had travelled great distances and waited for days in anticipation, were terribly disappointed. His promise to return, however, was made good on 20 September 1987. His Holiness was offered for the occasion a chasuble made of caribou hide.

Embroidered in sections by the Dogrib women of three communities, Rae-Edzo, Rae Lakes and Lac La Marte, the chasuble (and mitre) had been made and presented to Denis Croteau at the time of his consecration to the episcopate of Mackenzie-Ft. Smith, which took place at Croteau's request not in Yellowknife, but at Rae, the location of his first assignment as a priest with the Dogrib.

FLO DUTKA Ardrossan, Alberta

Frontal: I Am the Light of the World (1988)
Hand-dyed fabric, fabric collage, hand and machine stitching
80 x 183 cm
Collection: Ottewell United Church,
Edmonton, Alberta
Photograph by Joe Bally, Edmonton, Alberta

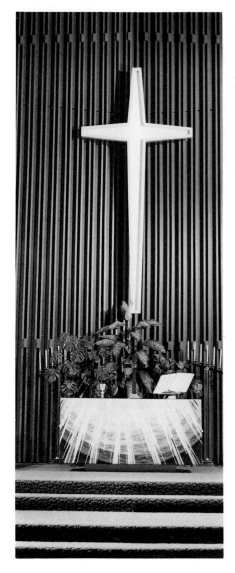

"My favourite source of design is nature," says the designer and creator of this magnificent altar frontal. A broad expanse of landscape reaching to infinity is laid before the viewer in a soft but rich palette of colours and textures that evokes scenery unique to the mountainous west. Dazzling rays of light, captured in a combination of coloured fabric and stitchery, remind one of the aurora borealis, that phenomenon that lights the sky particularly in northern regions. It is, however, the light of Christ that shines down as if from the cross, while at the same time the eye and spirit are swept upwards.

This is just one of several equally successful liturgical pieces by this gifted artist. In *The Four Seasons* (not illustrated), a circular hanging in the sanctuary of the same United Church in Edmonton, Dutka has created seven fabric collage panels of gently rolling landscape in which the changing seasons are depicted in subtly changing colours and textures. *The Four Seasons*, completed in 1982, is motorized, causing it to revolve very slowly; the sequence of the seasons unfolds as the panels move, taking about an hour to complete the circuit.

In a remarkable cluster of lavish embroidery highlighted with glittering beads, the essence of Easter, the light of the risen Christ, is captured in *Easter Sunrise* (not illustrated), a multi-layered hanging. The artist states:

> *The tactile and textural qualities of fibre can be greatly enhanced with stitching and provide dimensions to artistic expression which line and colour alone cannot achieve. In creating a work, one chooses from this infinite variety of interpretations which is a constant challenge so that the inspirations from Nature can be shared and enjoyed with others.*

HELEN FITZGERALD King, Ontario

Advent Frontal (Laudian) (1988)
Handworked silk appliqué,
stitchery, beading
224 x 413 cm
Collection: Grace Church on-the-Hill,
Toronto, Ontario

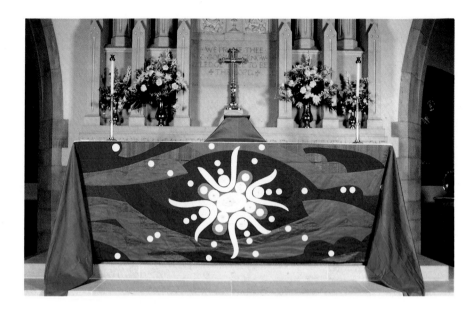

The star, lighting the darkness of the heavens at night, is a symbol of divine guidance or favor. [*]

The *Advent Frontal*, part of a seven-piece altar set, was dedicated on Advent Sunday, 1988. It presents a bold design in white on a predominantly blue background, suggestive of a direction arising out of infinity. In the artist's words:

> *The star-like forms represent the drawing near of light through the dark firmament, the forerunner of wondrous happenings. It announces that the time for preparation and new beginnings has arrived. It is meant to suggest great hope, a fanfare for the time of joyous celebration. It is a visual token of the coming of Him "That was the true Light, which lighteth every one that cometh into the world"* (John 1:9).

The *Festal Frontal* (facing page) for the Church of St. Philip the Apostle was commissioned in 1972. The carved wood screen by Sylvia Hahn that is set behind the altar is painted vermilion and decorated with Canadian emblems of gold pine cones and red maple leaves. Strong colours and strong shapes constitute a forceful background for this Laudian-style frontal. Bold in design, theme, texture and colour, it shows the sun as representing Christ, twelve stars as the apostles, and four larger stars as the evangelists. The slubbed off-white cotton background, vermilion-red ribbed cotton, and various commercial braids, cords, yarns and gold kid are machine stitched and hand appliquéd. The materials are used in such a way as to give a visual sense of richness which complements the existing

[*]George Ferguson, *Signs & Symbols in Christian Art* (New York: Oxford University Press, 1961), 44.

Festal Frontal (Laudian) (1972)

Cotton, machine quilted, with braids,
cords, and yarns machine applied;
padded gold kid, embroidered and
appliquéd; cotton braid fringe
Collection: The Church of
St. Philip the Apostle,
Toronto, Ontario

church furnishings. The white, gold, red, yellow and orange come together
to make the altar covering a cohesive part of the church interior.

This frontal was commissioned to replace one that had been lost in a
fire. Since only a very limited amount of the insurance money was avail-
able, the new frontal represents, says the artist, "a most satisfactory solu-
tion to all aspects of a commissioned work ... design, materials, symbolism,
setting, cost and time factors."

A full set of altar vestments for Pentecost, with matching cope, was
commissioned by Grace Church on-the-Hill in 1977. It illustrates the com-
ing of the Holy Spirit, fulfilling Christ's promise to his disciples that he
would send the Holy Spirit to dwell in his church.

This *Pentecostal Frontal* makes a bold statement of symbols whose
interplay is expressed in contrasting colours and thrusting forms. The
crimson background frames a vision of cloven flames in orange and yellow

Pentecostal Frontal (1977–78)

Wool, machine quilted, with appliqué
and embroidery in silk and wool, with
pearls and red "jewels"; stretched on
wooden frame
38 x 108 cm.
Collection: Grace Church on-the-Hill,
Toronto, Ontario

Lenten Frontal (Laudian) (1984)
Polyester gabardine, pieced
Collection: Grace Church on-the-Hill,
Toronto, Ontario

and white, while the swirling ball of fire bursts with energy and contrasting shades and colours.

> *And suddenly a sound came from heaven like the rush of a mighty wind ... and there appeared to them tongues of fire ... and they were all filled with the Holy Spirit and began to speak in other tongues.* (Acts 2:2–3)

Technical difficulties encountered in the preparation of the work resulted in a very great amount of actual stitchery. Literally, miles of silken thread were used to couch down the tapestry wool yarn used in the flames.

This design is set off-centre, conveying a great sense of motion and drama. Many different threads are interwoven and a wide variety of stitches are employed. Altar cloths of the past were balanced and restrained, rigid in symmetry and static in design. By contrast the impact of this frontal is theatrical. Close at hand the decorative skills of the artist, especially in the intricate stitchery and the use of seed pearls and red "jewels," arrest the eye.

The altar pall is an ancient method of dressing the free-standing altar, which is seen on all sides (Laudian). This *Lenten Frontal* based entirely on colour and patchwork, not embroidery or texture, represents a whole new dimension in Fitzgerald's career. The material used is polyester gabardine; it will not crease when folded in a drawer for storage. This pieced frontal is executed in stark simplicity. Blacks, browns, moss greens, and airforce blue form a background for vibrating waves of white and blue/grey. A slender white cross on bold shades of red is the central focus. For an artist who began her career in the black and white medium of advertising layout, lettering and calligraphy, "it is a personal satisfaction that such strength and richness as it possesses were achieved through colour alone ... for me the colour *sings*."

OTTILIE FODOR Montreal, Quebec

Tapestry (1984)
Handwoven in wool
175 x 125 cm
Collection: Christ Church Cathedral,
Montreal, Quebec
Photograph by John Geeza, Montreal, Quebec

This charming pastoral scene is framed by the wooden arch that occupies one wall of the diminutive Children's Chapel located toward the rear of Christ Church Cathedral in Montreal. Commissioned as a memorial, it hangs behind a simple wooden altar which divides the scene into upper and lower halves.

Executed with great skill, the work includes a variety of textures that capture the country setting where the artist used to live. In the foreground we see God's creatures in the form of woolly lambs, grazing peacefully amidst a landscape described in the well-loved hymn "All Things Bright and Beautiful," on which the tapestry is based:

The purple-headed mountain,
the river running by,
the sunset, and the morning
that brightens up the sky.

FRIEDEL Peterborough, Ontario

Blessing of the Spirit (1979)
Handwoven tapestry
600 x 360 cm
Collection: Immaculate Conception Church,
Peterborough, Ontario
Photograph by Ron Eakins, Peterborough, Ontario

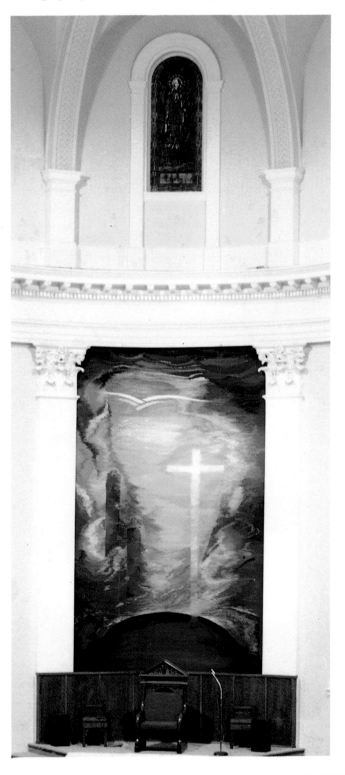

Blessing of the Spirit is a tapestry that stretches twenty feet in height and dominates the stark white walls of the semi-circular sanctuary beneath a pale-blue vaulted ceiling. It portrays in magnificent colour the four stages of Christ's life: blue is the earth; red, pink and burgundy represent the emotions of human existence; the light of gold leads beyond the earth to the dove of the Holy Spirit through which comes all creation; the white cross of the resurrection radiates with the promise of life eternal. In this work as in a similar composition, *Resurrection*, hanging in Donwood United Church, near Peterborough, light emanating from Friedel's tapestries creates a mystic space.

Blessing of the Spirit, an enormous undertaking, was made possible by the volunteer assistance of more than 100 students, teachers and friends who were involved in dyeing, in spinning wool, in building the large loom that the size demanded, and in mounting the tapestry. This communal effort grew out of Friedel's experience and contacts while artist-in-residence at Peterborough's Trent University.

PAM GODDERIS Calgary, Alberta

Banner (1990)
Strip piecing, and machine appliqué
240 x 180 cm
Collection: Red Deer Lake United Church,
Calgary, Alberta
Photograph by the artist

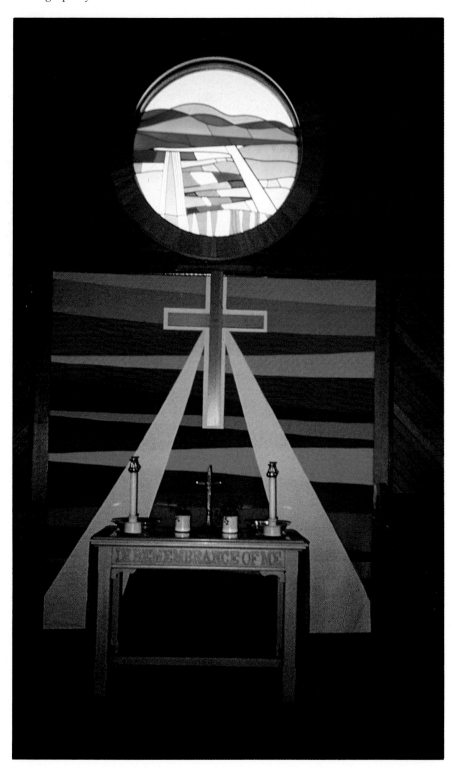

This banner was commissioned to reflect the design and colour of the circular stained-glass window (designed by Ottawa architect William B. Gregg, in memory of his father) immediately above, while the wooden cross is incorporated into the overall image. The artist's inspiration is drawn from nature, as evident in the strong suggestion of an open western landscape, reaching to the mountains and beyond.

This particular work is a bold contemporary statement that fills the sanctuary with light and colour in this, the oldest United Church still in use in Alberta. It was built in 1905.

Godderis is a leading fibre artist and lecturer whose work is much in demand in western Canada. Over the past three years she has completed ten liturgical commissions.

TEMMA GENTLES Toronto, Ontario

Torah Mantles (1988)
Various fabrics, machine appliqué
Collection: Congregation Beth Israel,
Northfield, New Jersey
Photographs by Harold Duke, Toronto

The two Torah mantles pictured here represent a set of five commissioned in 1990 for the Congregation Beth Israel, Northfield, New Jersey. The three red covers are used daily; the outer two are white and used on Holy Days. The Hebrew text for the daily mantles is an abbreviated version of a proclamation by a rabbinic scholar: "The world is sustained by three things: by Torah, by worship, by deeds of loving kindness." These spiritual elements appear amidst stylized symbols (inspired by Kandinsky) of civilization's physical support system, such as the wheel, windpower (kite) and columns. The text of the two Holy Day mantles also suggests both physical and spiritual integration and balance.

The *Chuppah* (facing page) represents the home to which the bridegroom welcomes his bride. Some couples also cover themselves during the wedding with a *tallit* (prayer shawl), signifying protection and the presence of God's spirit. Historically, Jewish weddings took place in front of witnesses under the open sky or in the market square.

The image on this *chuppah* represents a successful marriage. Diverse colourful elements start out as interlaced threads which, through the passage of time, shift and form themselves into a harmonious rainbow of hope and promise for the future of the couple and of the Jewish people. The silk rainbow cascades towards the ground. On the streamers is painted the last of the seven *b'rachot* (wedding benedictions) and the dedication. On the upper level of the pale blue cloth are appliquéd seven glistening stars, an acknowledgement of the felicitation in the marriage ceremony regarding children – may the young couple have as many children as there are "stars in the heavens."

Chuppah (Wedding Canopy) (1984)
Polyester drapery sheers, silk pongee, metallic fabrics, aniline dyes,
ribbon, aluminum tubing, marine cord and fittings
540 x 300 cm
Collection: Holy Blossom Temple,
Toronto, Ontario

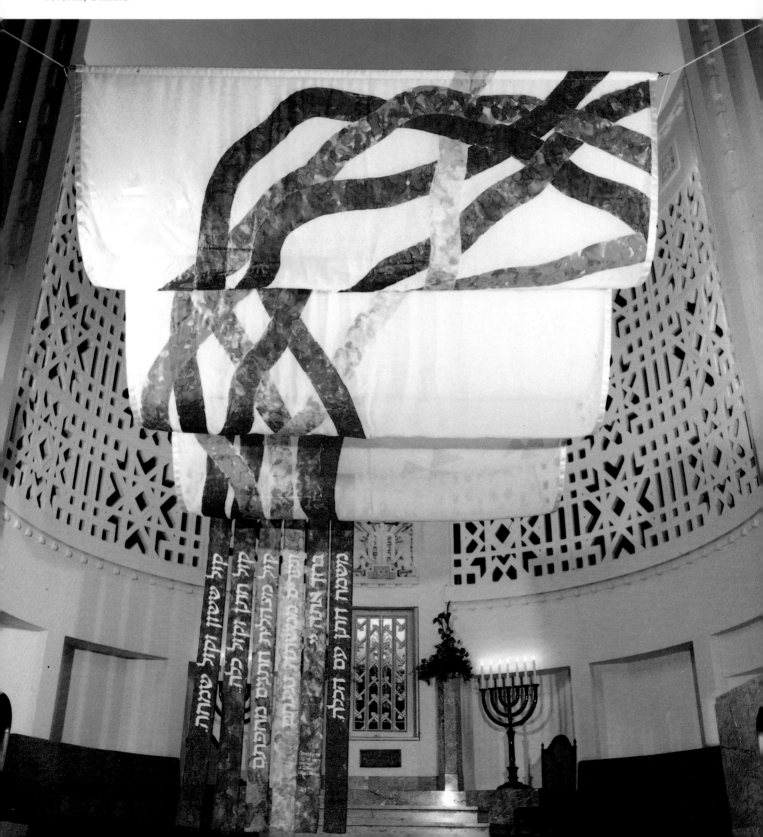

AUDREY GILL GRANTHAM Waterdown, Ontario

The Prisoner (1986)
Cotton, appliqué, with embroidery
and quilting
180 x 100 cm
Collection: Emmanuel College,
Toronto, Ontario

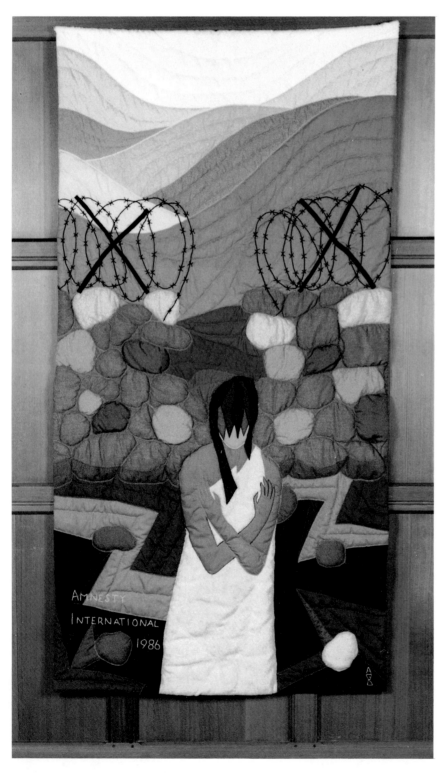

The Prisoner articulates vividly the message of Amnesty International: to defend human rights; to defend freedom of speech, opinion and religion; and to work for the release of "prisoners of conscience" throughout the world.

The female figure in the foreground, depicted in an attitude of supplication, suggests isolation and oppression, while the stone wall topped with black-coiled barbed wire presents an image of war, confinement and torture. A break in the stone wall appears, and with this opening, leading to a peaceful beyond, the promise of hope is suggested in the outline of a cross. The artist has taken the biblical text of Ephesians, chapter 2, verse 14, as the underlying theme: "For he is our peace, who has made us both one and has broken down the dividing wall of hostility."

Disturbing and powerful, the message is effectively conveyed.

CATHERINE HALE Fredericton, New Brunswick

Chapel Hangings (1981)
Collage of antique lace, crochet
225 x 60 cm
Collection: Christ Church Cathedral, Fredericton, New Brunswick
Photograph by Geoffrey Gammon, Fredericton, New Brunswick

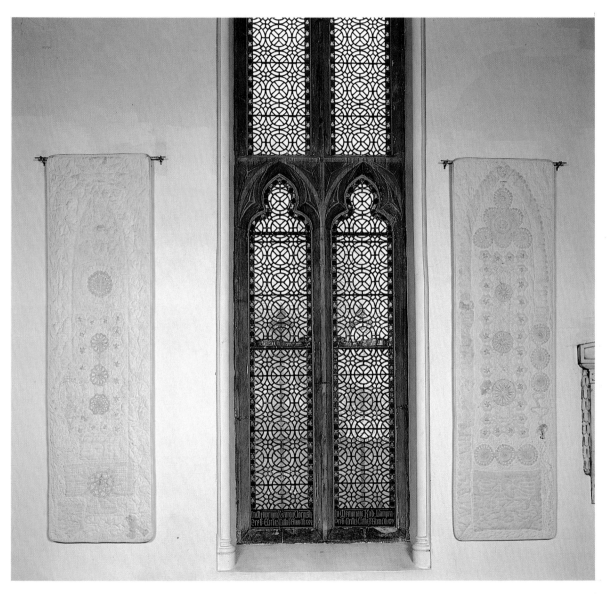

"Catherine Hale seeks out fabrics and lace made lovingly and patiently by women from another time. She places them in a new context restoring life and meaning to them."* This New Brunswick artist creates cloth artworks from antique lace, crochet, beadwork and fragments of exquisite lace, collected over the years. She achieves a spiritual statement in these hangings, which can be seen in the chapel of Christ Church Cathedral. Tom Smart, curator of the Beaverbrook Art Gallery, describing her work in *Catherine Hale: An Affinity with Time*, a 1990 solo exhibition, writes, "her pieces are elegies. Her work alludes to the notion of time as an eternal present." Delicate historic fabrics are restored and given new meaning.

*Sylvain Filion, "Catherine Hale, the Fabric of an Artist," *New Brunswick*, 9, 1 (1984).

DOROTHY GREGSON Dundas, Ontario

Festal Frontal: Dogwood (1980)
Fabric, appliqué with machine
and hand embroidery
Central panel, approx. 44 x 66 cm
Collection: Trinity Anglican Church,
Simcoe, Ontario

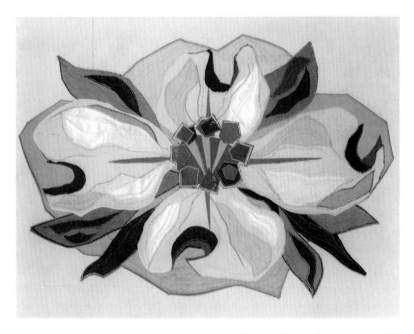

The Anglican community at St. James' in Dundas has an extensive history of involvement with the arts. One of the stalwarts of this creative activity has been fibre artist Dorothy Gregson. Trained originally in Great Britain, she currently teaches and leads workshops in embroidery design and related textile arts. Her commissions for frontals, vestments and banners are found all across the Niagara area and beyond.

Her designs are initially inspired by the actual church setting. Then, as she says, "I cut shapes and colours from fabric and manipulate them into the form or idea I have in mind."

Her *Festal Frontal* in an historic church in rural Ontario has a particularly interesting design. Trinity Anglican Church in Simcoe is situated in part of the Carolinian forest where the dogwood flower blooms in spring. Legend has it that the dogwood was the wood of the Cross. The artist has skilfully designed the four flower petals of the dogwood in the form of the cross, and the stamens form a crown of thorns, a remarkable blend of symbolism and nature to enrich the worship of this congregation.

The Anglican Church Women in the Diocese of Toronto commissioned a cope and mitre to celebrate the role of women in the church during the past 150 years and in the ongoing message and ministry of the church today. The off-white cope depicts on the back panel the Cathedral Church of St. James surrounded by recognizable features of the Toronto skyline, most obviously the CN Tower, houses and factories, hills and fields, and small outlying communities. The orphreys blaze with numerous small churches, machine appliquéd in jewel-like colours of stained glass, and with the rich texture of raw silk and details of hand embroidery. The design of the churches is drawn from actual architectural styles found in the diocese. The cope symbolizes the strength, community, communion and geography of the Diocese of Toronto. Strikingly elegant, the cope makes a statement. At the same time it is a vitally practical garment, made of fine-quality polyester, wrinkle-free and lightweight, which travels well in a small folded package!

Cope and Mitre (1990)
Fabric appliqué with machine
embroidery
Collection: The Rt. Rev. Terence Finlay
Bishop of Toronto

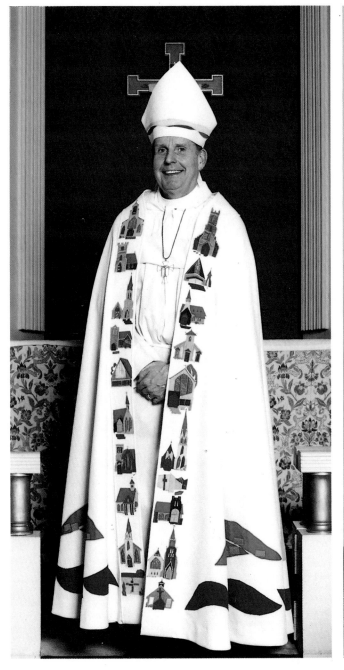
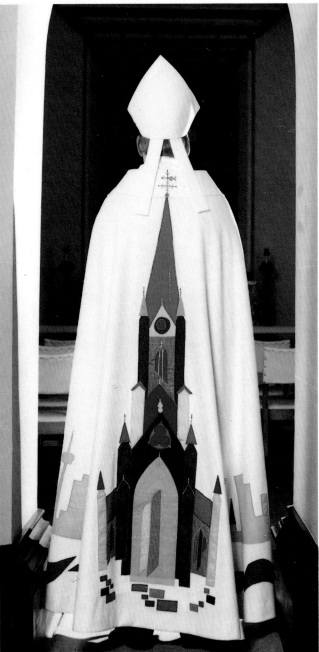

WILLEM HART Toronto, Ontario

The Flying Angels Banner (1990–91)
Cotton appliqué, gold lamé, hand embroidery, machine stitchery,
buttons and some padding
300 x 97.5 cm
Collection: The Missions to Seamen,
Toronto, Ontario

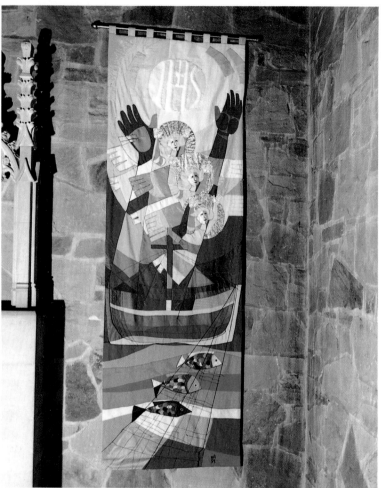

The Flying Angel Mission, situated at Pier 51 in the Toronto harbour, is the Toronto home of the Missions to Seamen. Its purpose is to provide hospitality to the thousands of seamen who sail into the Port of Toronto. These seafarers are often far away from home and from those they love. Frequently, they know little English and feel lonely in a strange land. For a few hours, for a few days, the Missions to Seamen is home to these men and women of the sea.

The Toronto club is housed in a cosy wooden chalet by the lake, where seafarers can relax, read, watch television, write or telephone home, or enjoy a game of pool. This banner is the latest addition to the clubhouse and hangs in the stairwell.

Inspiration for the theme of the banner came from Fr. David Mulholland, the energetic Anglican chaplain of the Flying Angel Mission, who suggested a combination of the name of the Mission and the three griffins on the British naval ensign. Further inspiration was provided by the designer's memory of a Dutch children's song, "Little Ship in the Care of Jesus." Other iconic references are the Trinity; the monogram for Jesus in the IHS; the ship, an emblem of the early Church; and the fish, a secret symbol during the days of the Roman persecution of the Christians. The hands are raised both in supplication and in celebration, elevating the host.

The creation of the banner is the result of the combined efforts of the Cariboo Group at Grace Church on-the-Hill, who spent over a year crafting it; the designer, Willem Hart, who was inspired by the work of the Missions to Seamen and dreamed of contributing a distinctive work of art to their clubhouse; and the chaplain, who welcomed the participation and contribution of all parties in this outreach venture.

The artist and the Cariboo Group at
work on *The Flying Angels Banner*,
summer, 1991.

LEWIS HINDLE Toronto, Ontario

Phoenix Rising from the Ashes (1976)
Appliqué in cottons
330 x 112.5 cm
Collection: Parkdale United Church,
Toronto, Ontario

The banner *Phoenix Rising from the Ashes* acts as a backdrop behind the altar in a small rebuilt United Church in downtown Toronto. The original red brick building was destroyed by fire in the 1960s. The new one, constructed on the same site, and using windows, bricks and pieces salvaged from the flames, forms a corner of a modern residential apartment complex. The phoenix, a bird of pieced white cotton shapes, lifts the eye up from the orange, bronze, yellow and burgundy tones of the rectangles and triangles designed to represent the neighbourhood. As the phoenix rises triumphant above the rooftops of surrounding buildings, the whole is striking in its statement.

LIZ HODGKINSON Westbank, British Columbia

Madonna (1979)
Gobelin tapestry, wool,
hand-dyed fibres
151.8 x 171.6 cm
Collection: The Church of St. Philip the Apostle,
Toronto (commissioned by Tom and
Irma Gerry in memory of Tom's mother)

In her book *Textile Art in the Church*, Marion Ireland describes tapestry as "a technique in weaving wherein design and background are woven together on a loom. Tapestries woven with the Gobelin technique are worked from the back ... A full-sized cartoon is fastened to the wall behind the weaver, and mirrors are placed beyond the warp threads so that the weaver can separate the warp and see the right side of the work as well as the cartoon behind her. Outlines are traced on the warp to show where the design is to be."*

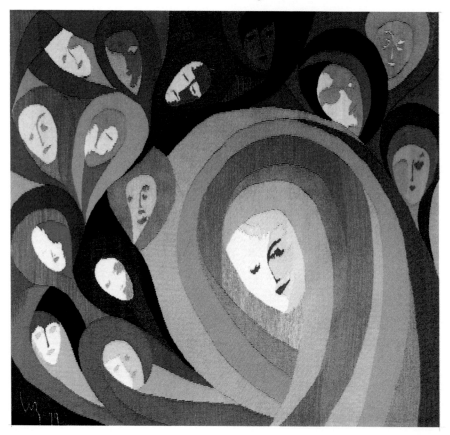

Madonna was conceived and designed by Hodgkinson for the Lady Chapel, and the delicate shades and hues of blue were chosen to complement the surroundings. Also, handweaving lends itself to "particular textures and blends of thread, colours and tones." The central madonna figure is surrounded by many smaller faces. The multitude of women is suggestive of women of all races and ages, with various needs and wants, of every social stratum – "all women," reflects the artist, "who have followed Her in faith and obedience to our Lord." The circular flow of design and the delicacy of shading create a lyrical unity in the tapestry.

* Marion P. Ireland, *Textile Art in the Church* (Nashville and New York: Abingdon Press, 1966), 253.

HOLMAN (Uluqsaqtuuq), N.W.T.

The Last Supper (1960s)
Sealskin, boot polish
Collection: Church of the Resurrection,
Holman, N.W.T.
Photograph by Rae Barrass,
Denman Island, British Columbia

*T*he Last Supper is made entirely of sealskin. The variations in colour tones are derived from the different areas of the seal's body from which the skin is taken. After the skin is scraped with an *ulu* (a woman's knife) and washed, it remains shiny, oily and stiff. The skin is then cut into shapes and inlaid to form the design. The brown hair is achieved by staining the sealskin with boot polish. It is the natural grain of the sealskin that gives the illusion of marble.

The banners hanging on the wall on either side of the altar were made by the women's organization, the A.E., or Angnait Ekayuktiukatauyun. They proclaim in Kitingmiut dialect, "Let us praise the Lord," and in English, "Worship the Lord."

IQALUIT (Frobisher Bay), N.W.T.

The Tapestries of St. Jude's Cathedral (1972)
Wool, with felt appliqué
Collection: St. Jude's Cathedral,
Iqaluit, N.W.T.
Photographs by Ronald S. Fellows, Peter Bishop,
Toronto, Ontario

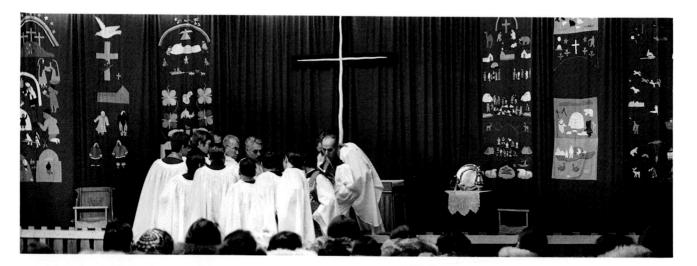

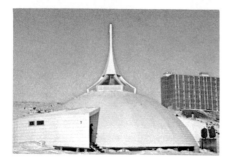

*From time immemorial when women first pushed needles of bone into the skins of animals, Eskimo women justify a position in the world as needlewomen of experience and originality.**

The Anglican cathedral in Iqaluit, consecrated on 9 April 1972, resembles an igloo in design. It was built entirely by the Inuit people. The tapestries which hang in the sanctuary are like stained-glass windows, illustrating stories from the Bible and the early days of the Arctic church and giving colour and warmth to the interior of this eloquent "snow house."

The panels, each of which tells its own story, were created by women from the six areas of this northern diocese: Igloolik, Kugluktuk (Coppermine), Povungnituk, Inukjuak (Port Harrison), Arviat (Eskimo Point) and Qamanittuaq (Baker Lake). These women were members of the Angnait Ekayuktiukatauyun, the Inuit equivalent of the Anglican Church Women in each community.

Each tapestry is crafted of colourful wool fabric on a background of rich purple. The designs on each panel depict many symbols, all of which relate to well-loved stories and the life of the Inuit people. We see the rainbow which signifies God's covenant to Noah and the love and hope it implies. There are also many different animals found in the Arctic and in the Bible, as well as flowers and churches, dogteams and sleds, tents and many people. In the centre of the six panels hangs the narwhal tusk ivory cross.

This "snow-house" cathedral was constructed as a continuing reminder to the people of the Arctic that it is uniquely their Cathedral, reflecting their Arctic way of life. Snowshovel-shaped hymn boards, communion rails and a pulpit constructed from dog sleds, and collection plates woven of indigenous grasses are among the special treasures found at St. Jude's. The font, made of soapstone from Povungnituk, is in the shape of an Eskimo blubber lamp; the top is a replica of a cooking pot of soapstone from Inukjuak. The silver bowl inside is a gift from Her Majesty Queen Elizabeth II. This truly is a community church, a reminder to all who worship here of the ancestry, skill and faith of the Inuit people.

*Winifred Marsh (wife of Donald B. Marsh, former Bishop of the Arctic), "The Tapestries of St. Jude's Cathedral," in *Embroidery Canada* 10, no. 2 (February 1983): 10.

DIANE JAMES Edmonton, Alberta

Visitation Chasuble (1984)
Blue and white silk appliqué on white
wool, with embroidery in white and
gold metallic thread, quilting
Collection: The Rev. Kathleen Schmitt,
North Vancouver, British Columbia

The theme of the chasuble is the Visitation, when the mother of Jesus visits her elderly cousin, Elizabeth, who is pregnant with John the Baptist. On a background of white wool two appliquéd figures of blue silk join hands, thus expressing love and support. A halo of gold metallic couched threads signifies the figure of Mary. Separating the two robes is an exquisite column of seminole patchwork in dark blues and purples, a reminder of native culture as a part of Canadian expression. The border is white satin appliquéd on the wool with couching, red on the right side to symbolize the blood of Christ, and blue on the left to symbolize the waters of baptism for John the Baptist.

On the back of the chasuble are appliquéd two large satin lilies whose stalks are intertwined, yet separate, and enhanced with yellow French knots and green-stem leaf embroidery. The lily is commonly associated with Mary, and the curved stalk suggests the staff of John the Baptist. The design itself is cruciform; the symbols refer to feminine imagery in the Christian faith.

The matching stole (not shown) has a medallion cross stitched at the base of each panel that represents a lily resting in a crescent moon. White, yellow and green threads are colour blended on a dark blue field. The effect of the whole set is serene, fluid and harmonious.

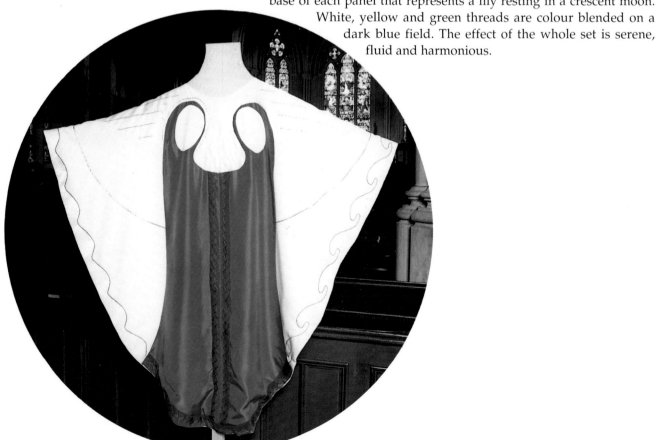

CONNIE JEFFERESS & DIANE ROBINSON London, Ontario

Altar Set and Chasuble (1986–88)
Dupioni silks, with embroidery,
appliqué and quilting
Collection: St. James Westminster Anglican Church,
London, Ontario

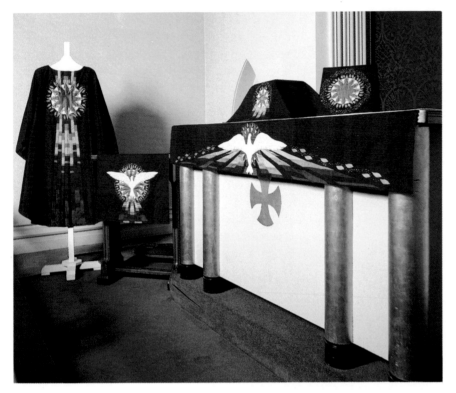

The mood of anticipation and excitement of Pentecost, the coming of the Holy Spirit with tongues of fire, is communicated in the intensity of the red dupioni silk, chosen for the background fabric in this complete set of paraments.

An ascending dove with wide-spread feathering wings surmounts a fiery sun encircled with tongues of fire. On close inspection, these tongues can be seen to be embellished with fine stitchery and detail. Leading up and into this central design is a pathway of colour, moving from deep blue, through burgundy, violet and pink, and pieced to give depth and distance.

The profusion of colour, climaxing in a pure white dove silhouetted against the gold and red, suggests the Light of the World and the divinity of Christ.

When on exhibition at the Liturgical Arts Festival, St. James' Cathedral, in 1989, this set was greatly admired. Designed by Jefferess, it was executed by her and her sister, Diane Robinson.

SUSAN JUDAH Fredericton, New Brunswick

Hostia (1987)
Wool, silk, linen, cotton, metallic thread
300 x 155 cm
Collection: Sts. John and Paul Church,
New Maryland, New Brunswick
Photograph by Geoffrey Gammon, Fredericton, New Brunswick

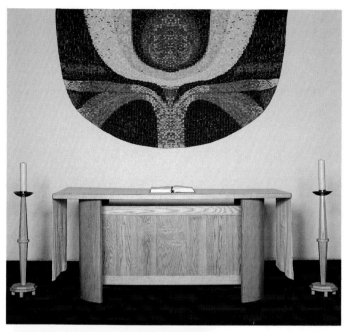

Susan Judah is influenced strongly by her surroundings. She believes that the essential relevance of a work is directly related to its environment. Her tapestries do not dominate their space but become integrated with it.

An excellent example of this is the reredos in the sanctuary of Sts. John and Paul Roman Catholic Church. *Hostia* celebrates the culmination of the eucharistic rite. The warm colours of purple, pink, white and cream create a mosaic, while the natural fibres are strip-woven into patterns that are illuminated by diffused light. The simple angular shapes of this handsome modern church are softened by the gentle curves in the large semi-circular tapestry. The uplifted hands receive the host, and the spirit is nurtured in the tranquillity of meditation.

Another work by Susan Judah hangs high in the foyer of Marysville Place. Located in a small community across the Saint John River from the city of Fredericton, this nineteenth century milltown was incorporated into Fredericton in 1973. Woven entirely by hand this uniquely historic tapestry consists of five panels, which together, tell the story of Marysville, each panel depicting a different event or theme.

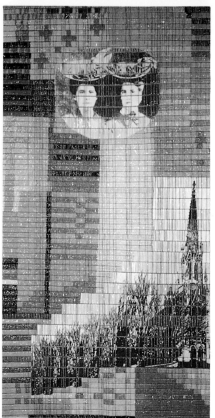

"Church and People," the first panel, includes a photographic reproduction of a United Church built in 1873 and destroyed by fire in 1911. There is also a portrait of two women, Mrs. Maggie Robinson and Mrs. Alice Watts, who were active members of the church at the turn of the century.

Other panels capture the spirit of the people, highlighting: "Industry and Sports"; "Alexander `Boss' Gibson," a figure of authority and a benefactor of the town; "The Cotton Mill"; and "Mayors and Brass Band," a tribute to two former mayors and to the civic spirit enjoyed by this historic village.

The use of transparent mylar and of original photographic negatives (enlarged and printed onto cotton twill tapes which are then integrated into strip-woven patterns) reinforces the sense of timelessness. The play of light on varied surfaces and the effect of multicoloured threads enhance the beauty of this striking tapestry. The whole work shimmers and reflects images as well as suggesting ghost-like images from the past.

Church and People (1987)
Mylar cotton, tapes
One of five panels, each 152 x 91 cm
Collection: New Brunswick Provincial Government, Marysville Mill, New Brunswick
Photograph by Geoffrey Gammon

SUE KRIVEL Downsview, Ontario

Scroll Covers (1990)
Silk, machine appliqué, metallic
thread, beads
64 x 24 x 14 cm
Collection: Holy Blossom Temple,
Toronto, Ontario

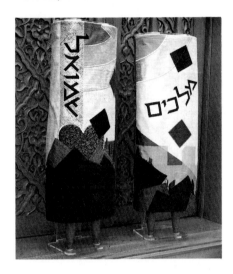

Samuel and Kings are two in a series of nine scroll covers commissioned by Holy Blossom Temple in Toronto. Eight of the covers are for scrolls containing individual Books of the Prophets; one is for a scroll containing the Book of Ruth, Ecclesiastes and The Song of Songs. (These are not Torah scrolls)

The text "Behold I have laid a foundation in Zion ... an indestructible foundation" (Isa. 28:16) is the inspiration for the series.

The monochromatic palette, a wide range of silks in black and grey in various weaves and textures, reflects the sombre message of the Prophets: the dire consequences if men and women fail to live by justice and morality. However, since the Prophets also speak of hope and redemption, each cover has one element of colour on the outside and is lined in that colour.

Samuel, the scroll cover on the left, is inscribed with the words "Here I am" (Sam. 3:5). The imagery tells of the consolidation of ongoing faith and of Israel's move to unity and nationhood. On the right, the Kings scroll cover bears the words, "I have built for You a stately House" (Kings 8:13). Shown here is the continuation of the development of individual faith, as well as the historical account of the building of the first temple, which was ultimately destroyed.

Chuppah (facing page) reflects the message found in the Talmud where it is written that during the spring festival of *Tu B'Shvat* it is customary to plant a cedar for every boy and a cypress for every girl born the previous year. For their wedding the boughs of the couple's trees are harvested and used to form their *chuppah* (facing page). The four-strand intertwined ring that circles the canopy represents branches growing from the *chuppah's* four wooden poles which in turn represent the corners of a *tallit* (prayer shawl). In the centre of the ring the fingers of the hands are held in the form of a priestly blessing. The seven chain links in the central circle refer to the seven blessings given during the marriage ceremony.

The Hebrew text within the circle of branches was added to the marriage ceremony in medieval times: "May He who is strong, blessed, and great above all else, bless the bridegroom and the bride." The words from The Song of Songs on the valance mean, "I am my Beloved's, and my Beloved is mine." Further references to that biblical poem of romantic love are the species in each corner: grapes, lilies, rose of sharon and apple blossom.

Almost every illustrated depiction of a Jewish wedding since the seventeenth century features the *chuppah* under open skies. The sheer central circle in this wedding canopy admits light and is a reminder of a Divine Presence. Because the artist created this *chuppah* expressly for use by generations of her family and friends, many motifs from Israel, the Torah and Talmud acknowledge and create a link with the historical and spiritual continuum that marriage represents.

Chuppah (Marriage Canopy) (1988)
Canopy: silk, machine appliqué, stencilling, couching, beading,
acrylic paint, gold thread, synthetic pearls, velcro
180 x 180 x 30 cm
Framework: oak, stain, natural wax, steel base-plates, velcro
180 x 180 x 225 cm
Collection: The artist

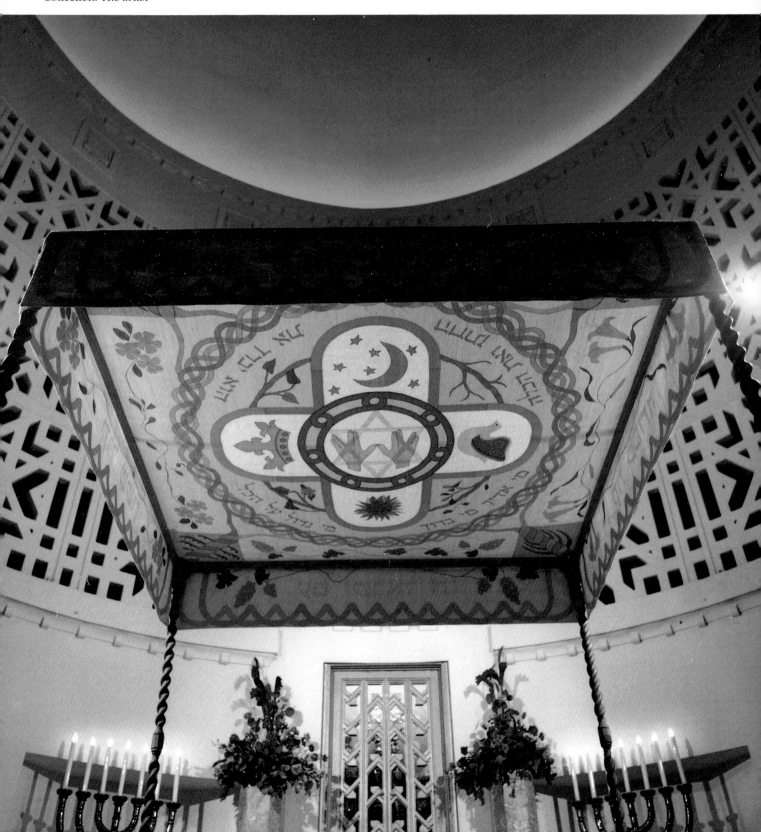

KWAGIULTH Cape Mudge, Quadra Island, British Columbia

Kwagiulth Altar Cloth (1980)

Wool, mother-of-pearl buttons, abalone shells
Designed by Dora Cook; sewn by Louisa Assu and
women of Cape Mudge Village
Collection: Quadra Island United Church,
Cape Mudge Village, British Columbia
Photographs by Hilary Stewart,
Quadra Island, British Columbia

The restoration of a half-century-old church, whose congregation dates back 103 years, is an attempt "to honour the Kwagiulth culture as well as the Christian heritage." Originally a Methodist mission church and later an Indian congregation, the Quadra Island United Church in 1978 invited all inhabitants of the island to share in worship, and today this congregation is fully integrated.

Liturgical art in the building draws upon the spirituality of both cultural heritages. As Harry Assu, chief of the Lekwiltok tribe of the Kwagiulth Nation, recalls, "Fish was the food of our people. Cedar was also important. Almost everything we had was made from cedar."* Haida artist Bill Reid drew two large salmon leaping and diving in a circle, and Jim Hart carved the magnificent bas relief from cedar boards to form the reredos for the altar in this restored church. The flowers on the altar are contained within an old native Indian basket, made from cedar root. There

*Harry Assu with Joy Inglis, *Assu of Cape Mudge*
(Vancouver: University of British Columbia Press, 1989), 93.

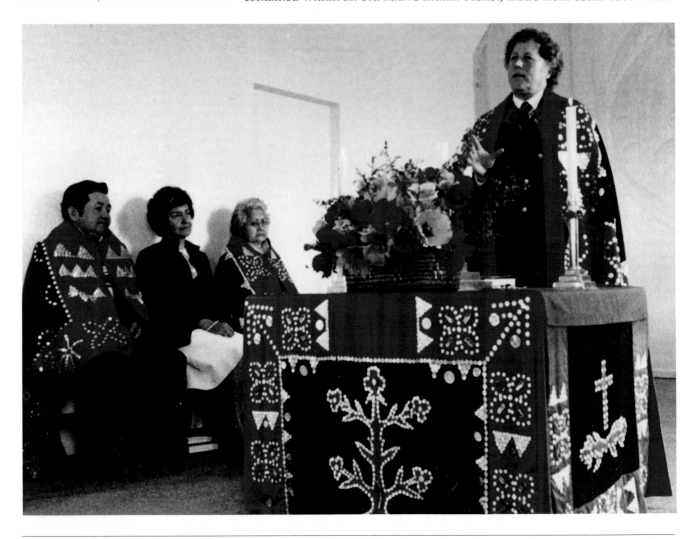

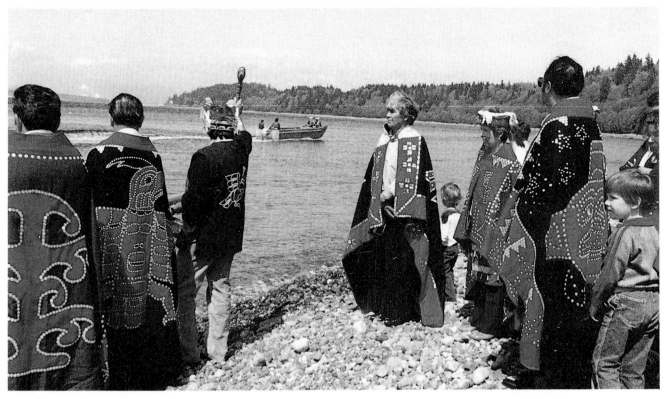

First Salmon Ceremony

is a design imbricated on it with cherry bark, both natural and dyed black, and the stalks are of reed canary grass.

The ancestral heraldry of the congregation is the central design on the altar cloth. The ancient symbol of the Tree of Life is shared by many cultures and adapted by the church in the cruciform. Permission for the image of the Tree of Life on this frontal for the communion table was ceremonially given for liturgical use by its inheritors, the Sewid family. It includes the four-leaf icon which is sacred to the Kwagiulth. The mother-of-pearl buttons (gathered from United Churches across Canada) and abalone shells effectively create a lovely tree root. There is a suggestion of divine energy emerging from the tree in the form of arrows projecting from each corner. The red border on the Kwagiulth blankets represents their sacred cedar bark.

Bread, fish and wine are all important elements in the communion service. Fish have great significance for the Kwagiulth Nation. Harry Assu describes the day in April 1984 when the bas relief was installed, following which the congregation walked in procession to the beach where

> we put on the First Salmon Ceremony. I hadn't seen that done in our village for seventy years. Everyone tasted the first four salmon of the season, and then the Sewid twins carried the bones back into the sea. Our people think of twins as Salmon people. This ceremony shows repect for Salmon.[*]

Hirano, a Simon Fraser University graduate in geography and head of band operations on Quadra Island, hopes

> the renovation and preservation of the church and display of liturgical art will fuse common bonds of spirituality within the congregation and symbolize the successful integration of divergent cultures.

[*]Ibid, p. 94.

NORMAN LALIBERTÉ Nahant, Massachusetts

Nativity (1977)
Hand-dyed cloth, appliquéd,
with ribbons and bells
240 x 75 cm
Collection: Amoco Corporation,
Chicago, Illinois
Photograph courtesy of Amoco,
Chicago, Illinois

Gloria (1977)
240 x 75 cm
Hand-dyed cloth, appliquéd,
with ribbons and bells
Collection: Amoco Corporation,
Chicago, Illinois
Photograph courtesy of Amoco,
Chicago, Illinois

Crusader (1965)
Appliqué
140 x 106 cm
Collection: G. Hamilton Southam O.C.,
Ottawa, Ontario
Photograph by Pierre Zabbal,
Montreal, Quebec

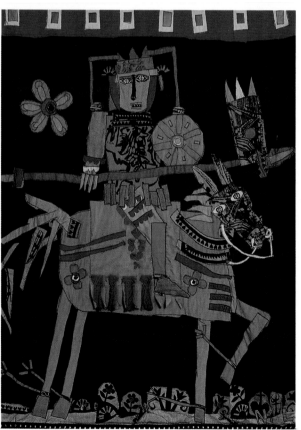

In 1963, Norman Laliberté was asked to be the design consultant for the Vatican Pavilion at the New York World's Fair. The structure was a stadium-sized glass building with virtually no wall space, a circumstance that inevitably posed problems for the display of art. The solution came in the form of resurrecting the concept of the medieval banner. Hundreds floated in mid-air. People were not using banners in those days, and the impact the display had on the millions of visitors to the fair in 1964–65 has often been credited with the sudden and continuing interest in this very rich art form. There is no question that Norman Laliberté has been the leader of this revived expression.

The eighty-eight banners (depicting the seasons and festivals of the church calendar, parables from the New Testament, and the central figures of the gospels) that Laliberté designed for the Vatican Pavilion were acquired in 1966 for the Rockefeller Memorial Chapel of the University of Chicago as a memorial to Mary MacDonald Ludgin. Other collections of his work hang prominently in buildings all over the North American continent: National Arts Centre, Ottawa; Canadian Jewish Congress, Montreal; New York State Bar Association, Albany; Ashland Oil Company in Kentucky and Ohio; and Chicago Lyric Opera, to mention just a few.

Laliberté's images and symbols are drawn from history, religion, mythology and folklore, and assembled with a spontaneity that captures the very essence of the subject with inventiveness, humour, sympathy and a profusion of vibrant colour. *Crusader* is just such a banner; simple and effective, originally designed as a magazine cover for *Canadian Art* and reproduced there in the November/December 1965 issue.

Nativity and *Gloria*, the two Christmas season banners (facing page) are part of Amoco Corporation's *Celebration of the Seasons*, a series of fifty-six banners created by Laliberté to soften and enhance the white stone walls of the upper lobbies of the company's Chicago headquarters. The changing seasons are portrayed on double-sided banners hung fourteen at a time, each set reflecting the symbols of that season in an appropriate palette of coloured cloth. Spring, with birds in flight, is cast in blues and greens; summer features the sun and conveys light and heat in warm colours of red, orange and yellow; autumn has organic symbols in earthy tones; and winter, the season of feasts and festivals, is cast in whites, greys and silver with bright coloured accents. At Amoco, not only do the banners change in anticipation of the seasons but they are never arranged the same way twice, thus creating an ever-changing scene, as in life and the seasons. As their brochure states: "Characterized by timeless, symbolic expressions of joy and fantasy, Laliberté's banners are a reflection of his vital, creative personality and his understanding of and love for life."

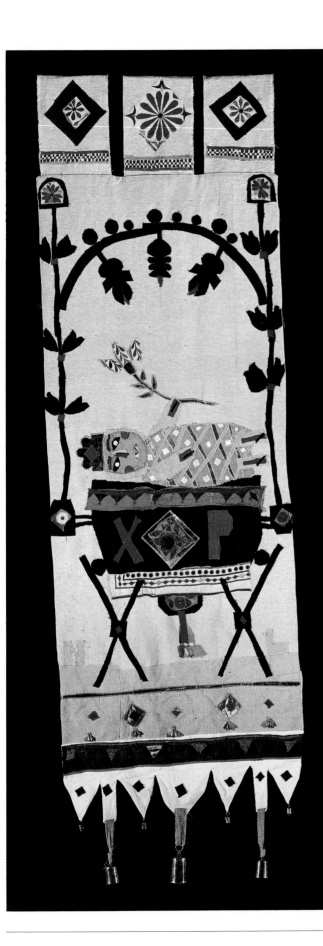
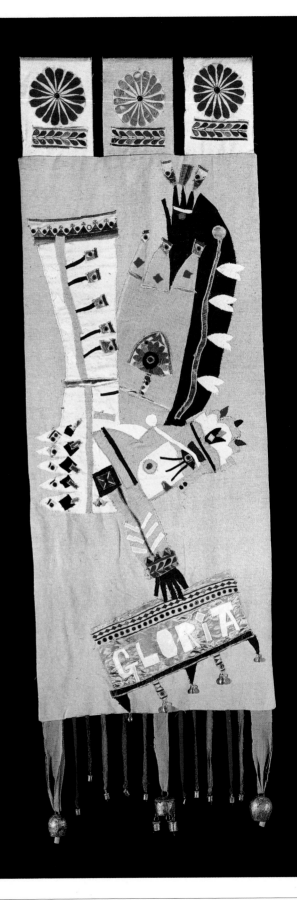

BARBARA LESUEUR Port Hope, Ontario

The Giving of the Gifts (1989)
Red cotton twill, coloured silks,
white polyester, appliqué with hand
embroidery
211 x 88 cm
Collection: The artist

Age-old symbols created anew in contemporary form have a profound and moving effect on the viewer. Universal signs act as the language of the soul and need no words; indeed, frequently there are no words for the expression of these inner realities.

The artist has translated the verses from I Corinthians, chapter 12, verses 4–11, into a simple, beautiful, outward and visible image:

> *Now there are varieties of gifts but the same spirit; and there are varieties of service, but the same Lord; and there are varieties of working, but it is the same God who inspires them all in every one. To each is given the manifestation of the Spirit for the common good ... All these are inspired by one and the same Spirit who apportions to each individually as he wills.*

The eight gifts of the Holy Spirit – wisdom, knowledge, faith, healing, the working of miracles, prophecy, the discernment of spirits, and the interpretation of tongues – are represented by the graceful coloured flames emanating from the tail of the dove, while the same colours suffuse the wings and body. On contact with the receiver-bird, the gifts are transmitted through the golden wafer. The hummingbird hovers in the mid-air feeding position to convey the feeling of hesitant expectation and awe in receiving the gifts of the Holy Spirit. The aim of the artist was to depict the ancient symbol of the dove in a more active, available and powerful role. The piece is marked by striking colour contrasts from afar and, on closer inspection, the addition of exquisite embroidery.

ELIZABETH DUGGAN LITCH Elora, Ontario

Harvest Cope (1987)
Cotton velvet with satin trim and hand embroidery
Collection: St. James the Apostle Anglican Church,
Guelph, Ontario

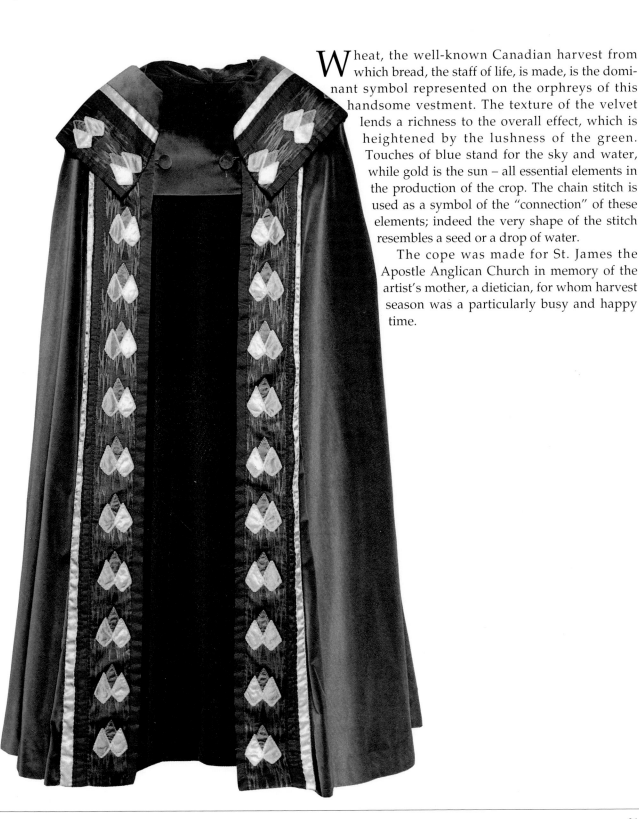

Wheat, the well-known Canadian harvest from which bread, the staff of life, is made, is the dominant symbol represented on the orphreys of this handsome vestment. The texture of the velvet lends a richness to the overall effect, which is heightened by the lushness of the green. Touches of blue stand for the sky and water, while gold is the sun – all essential elements in the production of the crop. The chain stitch is used as a symbol of the "connection" of these elements; indeed the very shape of the stitch resembles a seed or a drop of water.

The cope was made for St. James the Apostle Anglican Church in memory of the artist's mother, a dietician, for whom harvest season was a particularly busy and happy time.

EVELYN LONGARD Halifax, & CLAIRE BIRD Liverpool, Nova Scotia

Creation (1987)
Handwoven, appliqué and embroidery
180 x 270 cm
Collection: Bridgewater United Church, Bridgewater, Nova Scotia
Photograph by Brian Segal, Redgull Images,
Antigonish, Nova Scotia

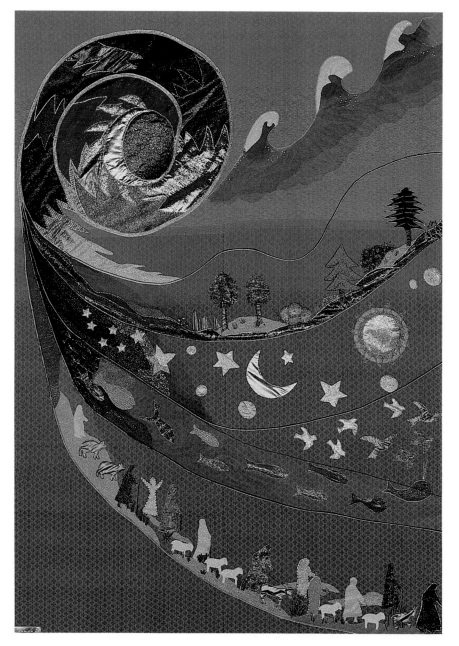

Evelyn Longard and Claire Bird are sisters, both graduates of the Nova Scotia College of Art. Longard specializes in multi-harness weaving, while Bird has a particular interest in embroidery. They have worked together since 1982. Prior to that time Longard was associated with Bessie Murray, and together they completed many commissions throughout Canada from St. John's, Newfoundland, to Victoria, British Columbia. They were nominated for the Saidye Bronfman Award in 1962.

Creation is one of a set of three hangings designed for Bridgewater United Church. It is a representation of the six days of creation as related in the first chapter of Genesis. We see light emerging from darkness, the division of the firmament from the waters, and the first signs of vegetation. The sun, the moon and the stars appear, as does life, first in the waters and then on the land. Living creatures come forth, "everything that creepeth," and finally humans, male and female. Order has emerged from chaos. "And God saw everything that he had made and behold it was very good."

The background was handwoven specifically for this hanging, depicting the change of light. Imagery is shown through the artists' use of a variety of appliquéd and embroidered textures.

BETTY MacGREGOR Mississauga, Ontario

Cope: Victory is Complete (1988–89)
Hand-painted, hand-quilted silk,
with soft sculpture closure and hood; reversible
Collection: The artist

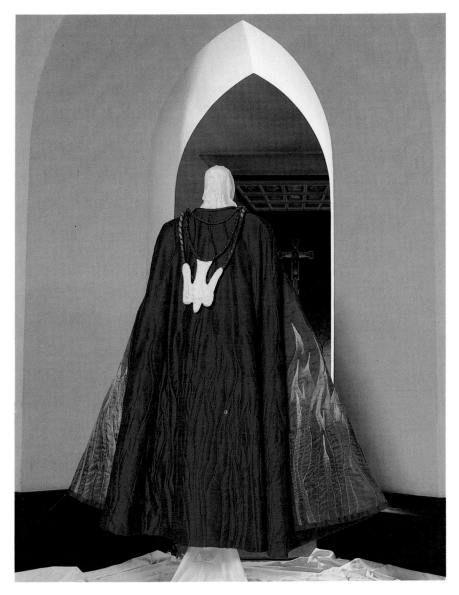

"According to a Greek historian, the phoenix was a bird like an eagle, with red and gold plummage, which was burned at the altar and rose again. It was therefore a symbol of the resurrection, and an emblem of immortality." These are the artist's words to describe her inspiration for this rich and outstanding cope.

Hand-painted tongues of fire dance over the smooth silk on one side and are echoed on the reverse with subtly etched quilting lines. The soft sculpture white dove, suspended on rich burgundy cord, is readily removed to complement this uniquely reversible vestment.

For her own parish church, Erindale United, Mississauga, the artist has designed and made full sets of paraments for every season of the church year. The variety of materials and techniques, and the richness of colour, reflecting the elements of each season, make these a remarkable collection.

DORIS McCARTHY Scarborough, Ontario

Funeral Pall (1985)
Red wool, with appliqué of silks, braid
300 x 210 cm
Collection: Grace Church on-the-Hill,
Toronto, Ontario

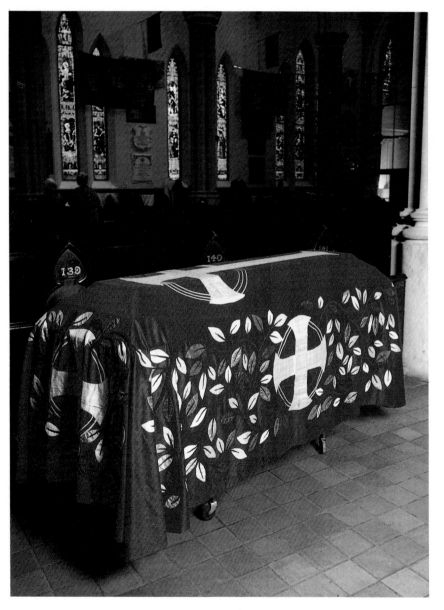

Doris McCarthy's liturgical art is less well known than her renowned Canadian landscapes. However, the same reverence for nature and the same sure sense of design which characterize her oils and watercolours govern her work in fabric.

The funeral pall, stitched by the Cariboo Group of Grace Church on-the-Hill, Toronto, is made of fine scarlet wool, vibrant with a message of joy and hope. The vine motif on the sides symbolizes new life in Christ the vine, growing from the triumphant gold cross of the resurrection. Crosses and leaves are of silk shantung with silk braid for the vine and stems. In colour and imagery the pall speaks of celebration of the life ended on earth and of hope for the new life entered.

The artist's hand-carved and painted-wood Nativity figures, which are twenty-four inches high (not illustrated), are a focus every Christmas at St. Aidan's Anglican Church in the Beach area of Toronto. In a side chapel of the same church, her fabric hanging (not illustrated) covers one whole wall with the history of St. Aidan and the parish named for him.

At Cana Place, a residence for the elderly which is run by the Sisters of St. John the Divine, in Scarborough, the artist covered the chapel wall behind the altar with a colourful and whimsical depiction of Jesus' first miracle, the water into wine at the wedding at Cana in Galilee (not illustrated).

Benedicite, Omnia Opera places "O All Ye Works of the Lord, Sun and Moon, Fire and Heat, Whales, and all that moves in the Waters" around a central sunburst cross. By imaginative stylization and skilful arrangement of the figures – all of the orders of creation – Doris McCarthy achieves a sense of joy which seems very appropriate for the chapel of a girls' school.

Benedicite, Omnia Opera (1980–81)
Various fabrics appliquéd on cotton
600 x 535 cm
Collection: St. Mildred's-Lightbourn School,
Oakville, Ontario

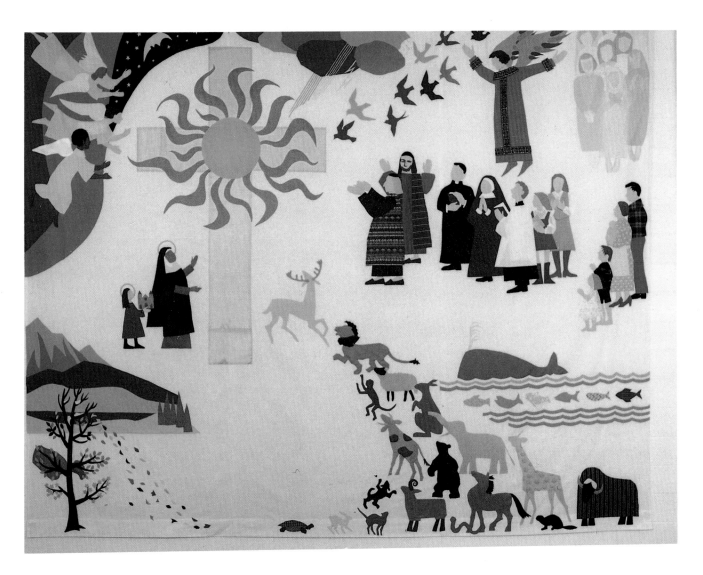

BETTY McLEOD London, Ontario

The Life and Times of St. Aidan (1987–1992)
Canvas embroidery, needle weaving, appliqué
Ten panels, each 75 x 85 cm
Collection: St. Paul's Cathedral,
London, Ontario

Betty McLeod, an artist of impressive achievement, has created many vestments and hangings over the past twenty years. One of her most accomplished pieces is *The Travels of St. Paul Cope* (1987) (not illustrated) which is a record, in beautiful stitchery on the orphreys, of the many journeys St. Paul had taken on foot and by water.

McLeod has also completed a set of six unique canvas embroideries (not illustrated) for the sanctuary and chancel of St. Paul's Cathedral, London, which depict the history of the city of London and of the cathedral from the time of the early pioneers. These tapestries are colourful works of meticulous detail, representing years of dedicated research and superb stitchery.

The five panels seen here are part of a set of ten designed for the St. Aidan's chapel in the cathedral. Entitled *The Life and Times of St. Aidan,* they describe the barbaric violence of life in seventh-century Iona, where this monk lived, taught and preached. He became the Bishop of Lindisfarne and introduced Christianity to England.

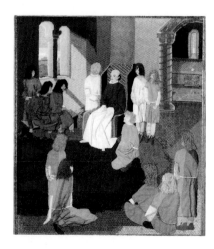

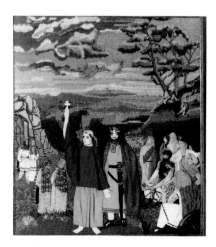

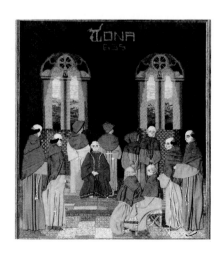

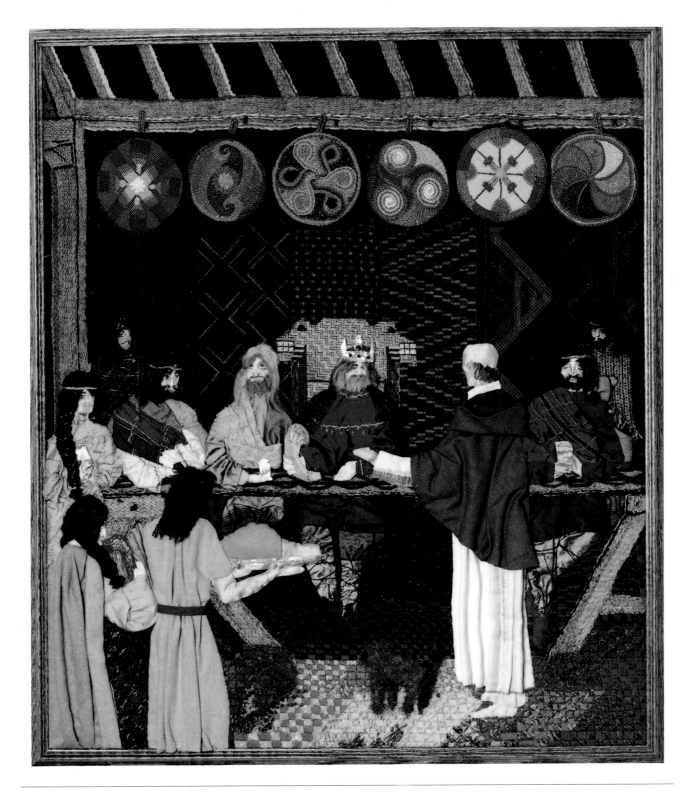

LUCY McNEILL Fredericton, New Brunswick

Festal Stole (1982)
Pure silk damask, embroidered,
Jap gold
Collection: The artist
Photograph by Roger J. Smith,
Fredericton, New Brunswick

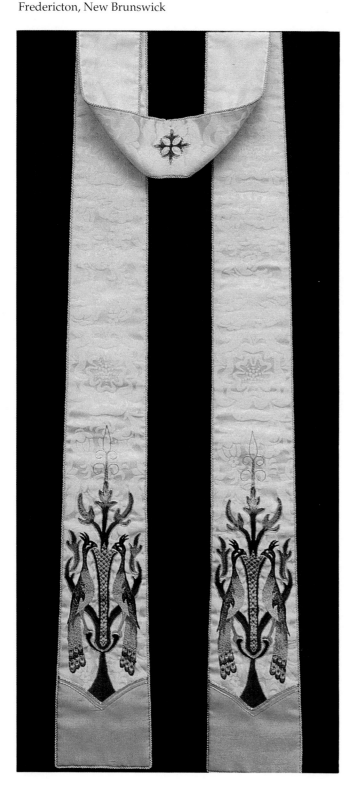

Here, in this elaborately embroidered *Festal Stole*, the peacock confronts the Tree of Life. In Byzantine art the peacock symbolizes resurrection and the immortality of the soul. It is a symbol derived from the analogy that when it sheds its splendid tail this plummage is brilliantly renewed. The elaborate stitchery of the peacocks' tails includes French knots, while the heart of the tree shows laidwork overlaid with diaper, a rich silk fabric. The tree is outlined in two strands of Jap gold.

Another work of special significance by this artist is the festal set (not illustrated) made for Christ Church Cathedral, Fredericton. The first known Christian worship on the Saint John River was conducted in 1611 by a French missionary who said Mass for French fishermen from St. Malo; this is commemorated by the fleur-de-lis. The Tudor rose signifies the coming of the Loyalists, who, for king and country, chose to leave their lands and most of their worldly goods for a new beginning. Insufficient rations arrived late. The settlers were saved from starvation by the Indians who showed them large patches of beans growing wild. Marked with a black cross, these white beans were called "The Provincial Loyalist Bread, the staff of life and hope of the starving." This richly embroidered frontal highlights elements of the early settlement which brought together Indians, Acadians and the British.

DINI MOES Peterborough, Ontario

Christening Robe,
Matching Capelet (1985)
Handwoven, wool and silk
92 cm in length
Collection: The artist

This charming christening ensemble consisting of a gown with matching capelet is woven in cream wool and silk. The lace areas were produced by the finger-manipulation weaving technique, and the other embellishments were woven in. The ensemble was fashioned after a christening garment worn in earlier times.

In Memory of Sonja, a *tallit* with matching bag, "was woven," says the artist, "in memory of my young Jewish school friend who did not return from imprisonment after the Second World War."

The design, with seven stripes in seven shades of blue for the seven times a day "do I praise thee," is based on the prayer "May the tallit spread its wings over them and save them."

The *atarah* (collar), meaning "crown" is a woven inlay with silver thread stating the prayer "May God spread his protecting tent of peace over us," while the design of the *tzitzit* (knotted corner) comes from the prayer "How precious is your kindness." The design on the bag is taken from the text that requires a *tallit* to be worn: "See it and Remember."

The two pieces are exquisite in every detail. It is no surprise that Moes, an internationally recognized weaver, was nominated in 1981 for the Saidye Bronfman award for excellence in crafts.

In Memory of Sonja (1980)
Handwoven, overshot pattern with
inlay, wool, silk, metallic fibre
Tallit 200 x 70 cm
Bag 39 x 30 cm
Collection: The artist

NISHGA New Aiyansh, British Columbia

Pair of Ceremonial Blankets and Mitre (1975)
Melton cloth with mother-of-pearl
buttons and white beads
Collection: The Most Rev. Douglas Hambidge,
Archbishop of New Westminster,
Vancouver, British Columbia

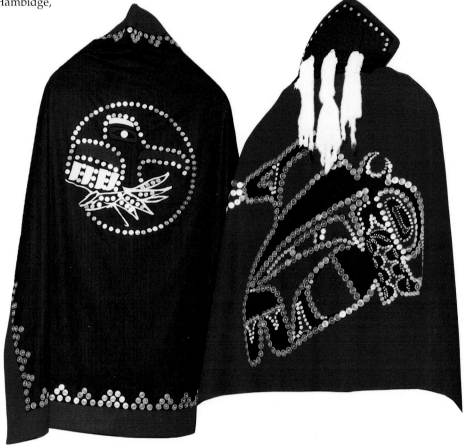

The traditional ceremonial button robe is an eye-catching, prestigious and costly coded legal document decipherable by those who understand the art and traditions of the Indians of the Northwest Coast. Like the totem pole, it proclaims hereditary rights, obligations and powers. During the nineteenth century the art of the button blanket developed, achieving its classic form by 1850. These robes were increasingly used among the coastal Indian nations from Vancouver Island to the Alaska Panhandle. Only the Salish-speaking peoples did not accept the button blanket.

Traditionally the blankets were dark blue wool with red flannel borders and appliquéd figures. The red borders represent life, new life; the black or dark blue represents death. Mother-of-pearl buttons and abalone shells are stitched on in heraldic patterns which serve as a living record of the wearer's cycle of life.

Illustrated here are two Nishga blankets of black and red wool. On the left-hand robe is depicted an eagle, a symbol of power and wisdom; on the red blanket cope is displayed a whale, a symbol of strength and endurance. The bishop's mitre is ornamented with an embroidered hummingbird on the front and three ermine tails on the back.

JESSIE OONARK Baker Lake (Qamanittuaq), N.W.T.

Untitled (c. 1972)
Stroud, felt, embroidery floss, thread
212 x144 cm
Collection: Art Gallery of Ontario,
Toronto, Ontario
Photograph courtesy of Art Gallery of Ontario, Toronto

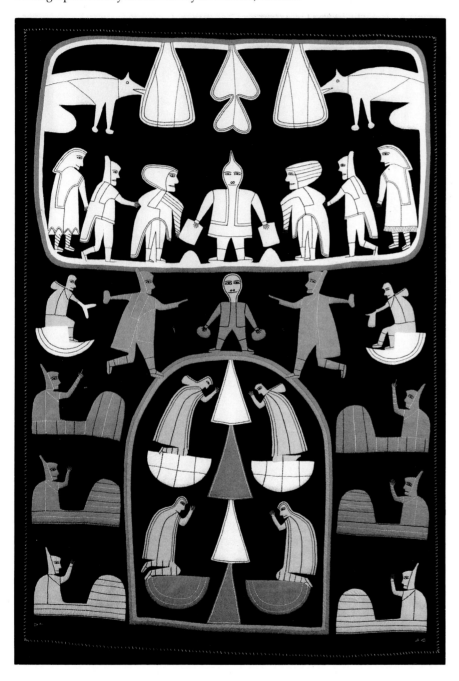

From a very early age Jessie Oonark's drawing ability was apparent. The first of her prints released in the 1960s in the Cape Dorset collection. Her subject matter encompasses hunting, fishing, kayak and drum-dance scenes, animals, shaman with helping spirits and various supernatural beings, and Christian subjects. Her work is informative of specific traditional practices and beliefs. Wall hangings had a special appeal for her; she was a tireless seamstress. Her strong interest in parka design led her to use interlocking panels, trim and fringe for her stylized two-dimensional images.

This 1972 wall hanging is considered to be one of Oonark's best and reveals

*her work to be a complex synthesis of observation and experience. Although untitled this particular work undoubtedly reflects Christian beliefs. The upper rectangle containing white figures harkens back to the Old Testament, when the word of God was delivered to mankind by Moses. Directly beneath could be the figure of Jesus holding loaves of bread, which are eagerly awaited by the surrounding people. Starvation was once a harsh reality for Oonark, and Jesus as the giver of bread was also the giver of life — an attractive proposition to the new converts.**

*Norman Zepp, "Inuit Art," in *Art Gallery of Ontario: Selected Works* (1990), 435.

PANGNIRTUNG N.W.T.

Wallhanging (1960s)
Handwoven wool, with felt appliqué
Collection: St. Luke's Anglican Church,
Pangnirtung, N.W.T.
Photograph by Peter Bishop,
Diocese of the Arctic, Toronto

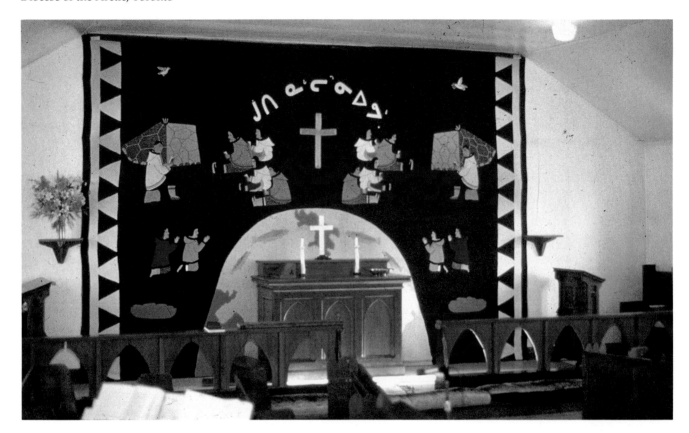

The background of this large hanging is wool with a coarse ribbed texture, handwoven in the Pangnirtung Weave Shop. A map of the world, on which Baffin Island is central, is shaped like an igloo and speaks of the world-wide message of the church. In the past, religion was based on fear; supernatural spirits did what they liked. Christianity brought with it the message of love as spelled out in the syllabics "God Is Love." On either side of the cross, groups gather to learn from lay readers seated outside skin tents.

The A.E., or Angnait Ekayuktiukatauyun in Pangnirtung, an active group of about twenty women, made the hanging under the guidance of the then priest-in-charge, Michael Gardener (now Dean of St. Jude's Cathedral, Iqaluit; see page 50), and his wife, Margaret.

An ivory cross and narwhal tusk candlesticks are placed on the altar. The kneelers are made of sealskin.

PAYNE BAY (Kangirsuq), Embroiderers of Holy Trinity, Payne Bay, Quebec

God Is Love
Felt, with appliqué and hand embroidery
270 x 180 cm
Collection: St. Margaret's Church,
Toronto, Ontario

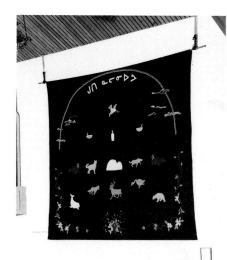

The subjects chosen for this dossal curtain reflect local interests and mirror the environment of this remote northern community. The embroiderers made no attempt to use purely traditional Christian symbols; every figure depicted has relevance for the Inuit people and their way of life.

"God Is Love," expressed in Inuktitut characters at the top of the dossal, is framed by a rainbow which, shaped in an arch, denotes the church. The igloo, the central focus, is surrounded by familiar animals of the North, while above are whale-oil floating candles. The dove, a symbol of life, returns with a leaf, a remarkable sight in a land without trees.

The artistry of this dossal is simple and strong. The figures, cut from felt, are appliquéd. The rainbow and the clouds, as well as the colourful flowers of the tundra, are embroidered in a style characteristic of the North. The same stitchery is used in the decoration of parkas.

This work was created in Payne Bay, Quebec, and presented to the Bishop of the Arctic, the Right Reverend Donald Marsh, who in turn presented it to St. Margaret's Church.

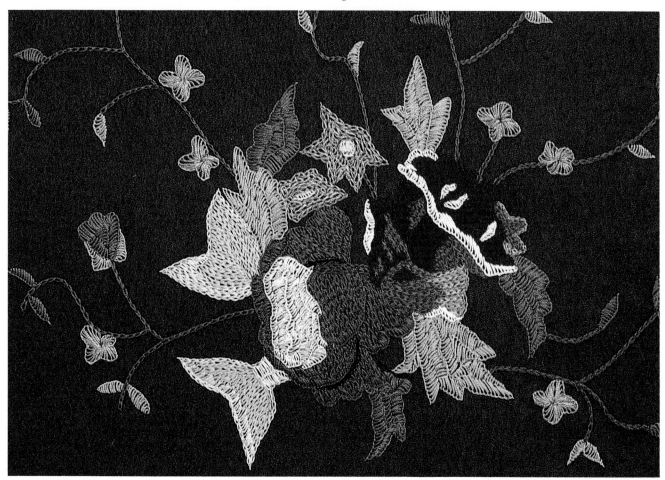

KAREN MADSEN PASCAL Markham, Ontario

Praise the Lord!
Velvet, satin, machine appliqué
330 x 130 cm
Collection: Mr. and Mrs. Elson Miles,
Unionville, Ontario
Photograph by Harold Duke, Toronto

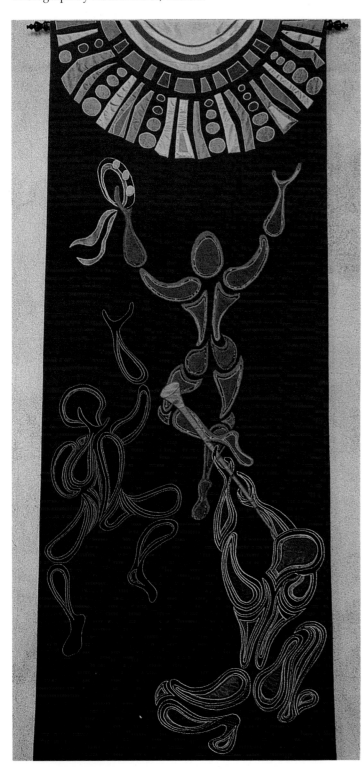

Throughout the 1970s and early 1980s Pascal produced a great number of works of art in fabric, many of which are held in private collections. Displayed in Faith and the Imagination, at Trinity College, 1987, and here reproduced in black and white, *Praise the Lord!* celebrates the 150th Psalm. It shows some of the kinds of figures that inhabit Pascal's banners, and fairly resounds with the sounds of music and the joy of dance, the praises of God.

The Emmanuel Church Tapestry (facing page) is "a visual expression of `Our Life in Christ.' It incorporates the elements that are central to Emmanuel Anglican Church, the altar and the cross, and repeats the arch shape found in the windows and the front of the church." So begins the description of this installation in a brochure prepared by the church at the time of dedication, 10 June 1984.

Many Christian elements are combined to form this unusual reredos. A rainbow which appeared after the flood, a symbol of pardon and of reconciliation, frames the work. The hands of God extend down to the silver cross that adorns the altar, at the same time forming a dove. A radiant sunrise suggests the eternal light of God, while human figures – their hands raised in worship – flank either side of the central motif.

Other splendid works may be seen in churches and institutions in and around Toronto. At St. John's York Mills, a very large work entitled *The Word Became Flesh* is based upon the many scriptural references which surround the Baptism of Jesus; in the chapel of St. Andrew's College, Aurora, a powerful, uplifting banner forms the reredos; Riverdale Hospital Chapel has *The Phoenix Rises;* and *That Which Has Broken You Has Broken Me* is a graceful and touching banner in the Wexford Senior Citizens Residence. One of Pascal's proudest achievements is the three-dimensional *Resurrection Banner.* Constructed from velvets and ribbons which move gently, it hangs in St. Martin's Episcopal Church in Detroit, Michigan.

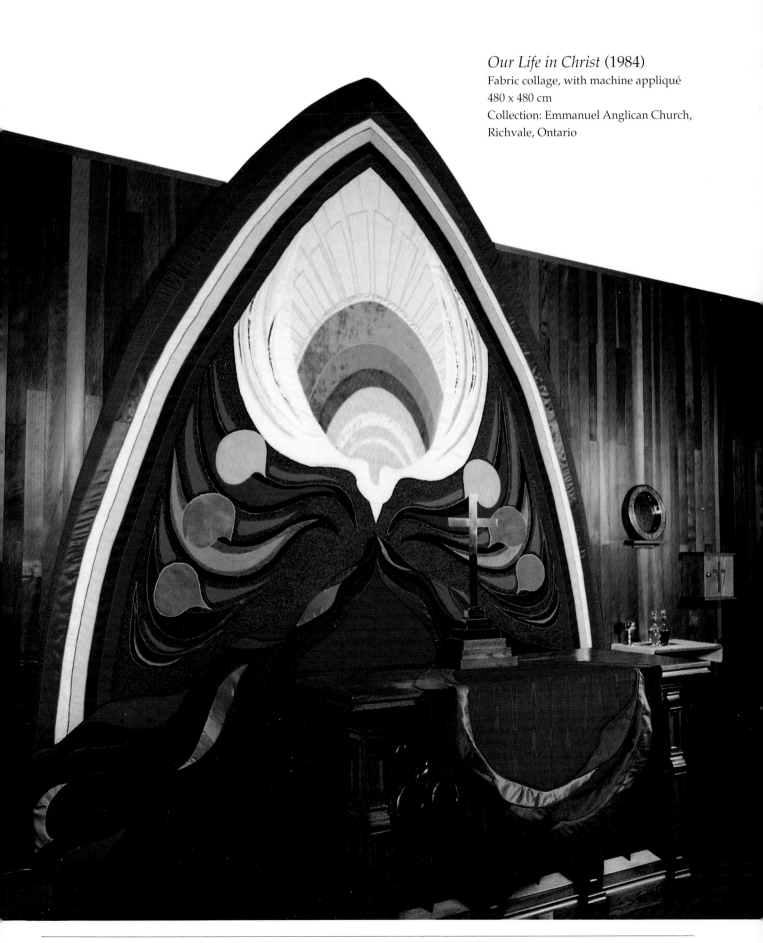

Our Life in Christ (1984)
Fabric collage, with machine appliqué
480 x 480 cm
Collection: Emmanuel Anglican Church,
Richvale, Ontario

NANCY-LOU PATTERSON Waterloo, Ontario

Our Lady of New Life (1981)
Appliqué in cottons,
with hand embroidery
180 x 120 cm
Collection: St. George of Forest Hill Anglican Church,
Kitchener, Ontario

Feed My Sheep (1979)
Pieced cottons
810 x 270 cm
Collection: St. Peter's Lutheran Church,
Kitchener, Ontario

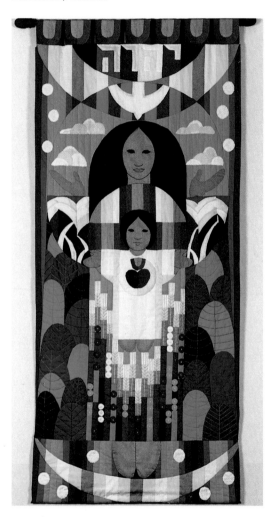

Scholar and teacher, illustrator and stained-glass designer, poet and author, and undisputed authority on both Mennonite folk art and Canadian native art, Nancy-Lou Patterson is one of Canada's leading textile artists. A recognized liturgical artist in Seattle, Washington, where she was known for her illuminations and sculptures, Patterson received her first Canadian commission soon after her arrival in Waterloo in 1962. The magnificent stained-glass windows in the Conrad Grebel Chapel at the University of Waterloo are testimony to her excellence of design and use of colour.

Commissions to create liturgical banners followed soon after. Her early renderings in cut and glued felt were filled with bold imagery. From her teenage years when she designed and made sets for theatrical productions at school, the artist says she "understood how to work at a very large scale with cloth, to create a sense of drama by the distribution of big masses of intense colour ... and to handle this scale with forms that would be intelligible at a distance." Her finest and most successful piece from that era, *Our Lady of Israel* (not illustrated), was exhibited in the 1970s at Seattle's exhibition of Flags and Kites and was used to illustrate the catalogue.

Patterson's inspiration comes "completely from within," supported by the reading of passages from the Bible to find appropriate images, by consulting books on symbols and by looking at other people's work. In the artist's own words, "once the conception occurs, I turn the image over in my mind, in the visual part of my imagination, for maybe several weeks, and every time I think of it again, I find that it has refined itself." It is then externalized in the form of a drawing or sketch, reworked, and finally laid down on graph paper according to the exact measurements, allowing for aesthetic and spatial judgements. First she divides the background into basic areas of colour, then she adds images here and there, and finally she provides some texture to give it "a little action."

One of Patterson's biggest and most exciting challenges came when she was invited by St. Peter's Lutheran Church in Kitchener to create a banner to fill the awesome expanse of a forty-foot-high wall and yet not compete with the stained-glass windows of the church. *Feed My Sheep* (facing page), measuring twenty-seven-feet high and nine-feet wide, is executed in brilliant cottons, pieced and quilted by devoted members of the Mennonite community, and hung finally with an elaborate suspension system designed to control the tension. A panoply of images drawn from both the Old and the New Testaments portrays the burning bush. The inverted cross, in red, symbolizes the martyred St. Peter who was crucified upside down. As well, there is a living cross depicted as a tree of life, the dove of the Holy Spirit, and the words spoken to Peter by Christ, "Feed My Sheep." Also, there are images of the sun, the moon and many stars.

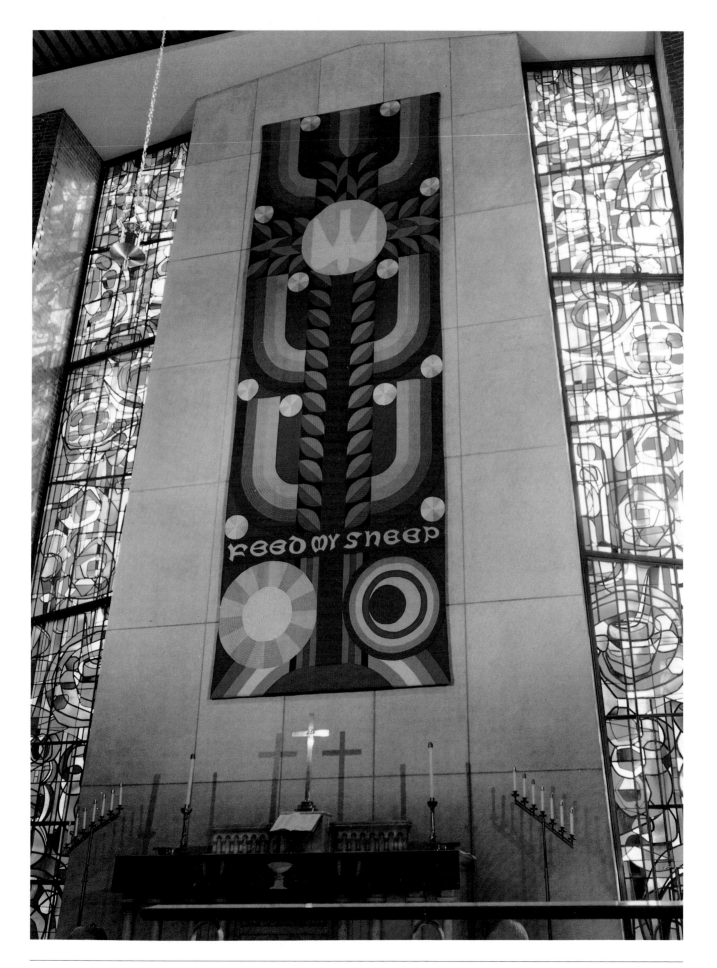

The Tree of Jesse (1982)
Needlepoint
90 x 207 cm
Collection: St. John's Lutheran Church,
Waterloo, Ontario

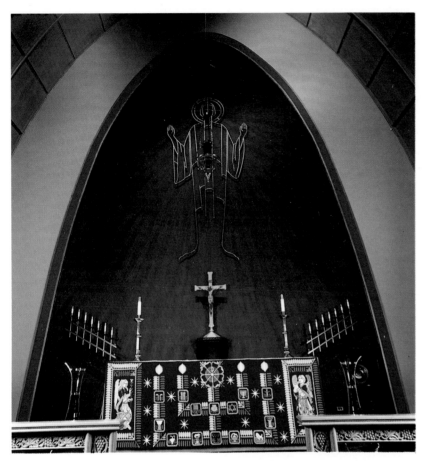

The artist also does a great deal of designing for liturgical needlepoint, which allows for more intricate work. An example of this is the Advent frontal, *The Tree of Jesse*, designed for St. John's Lutheran Church in Waterloo. The symbols and images used here to trace Christ's lineage in the Jesse Tree are elaborate in their detail. Done in sections by women of the parish, it was then pieced together to make a rich and glorious whole that is formal, elegant, and most striking from a distance.

It was the commissioning of a memorial work for a church in Seattle, received while she was living in Waterloo, that taught Patterson how a congregation or parish could carry out her design and complete a work in her absence. From full-scale drawings and coloured maquettes, an accomplished leader (in this case, her sister Margaret) was able to oversee the job to perfection. This experience has led Patterson to design many works for others to craft and complete, when time would not permit her to undertake such demanding and time-consuming jobs. Both *Feed My Sheep* and the *The Tree of Jesse* are examples of this community-wide creative experience.

One of the last banners to be hand-crafted entirely by Patterson herself was *Our Lady of New Life* (see page 76), a work commissioned by a family who had adopted two boat people. Worked in appliqué, this colourful banner depicts, in the words of the artist:

> the Blessed Virgin Mary presenting her divine son, Jesus, to the rejoicing Universe. Symbolizing the Holy Trinity are the Hebrew name of God the Father ... the dove of the Holy Spirit, and God the Son incarnate as the child Christ ... Mary ... the physical source of His human life ... is depicted wearing a gown of wheat ornamented with the "lilies of the field" (poppies, daisies and cornflowers), the sleeves of which display mountains and waterfalls, and covered with a mantle reaching from the sky with its clouds down to the trees of the forest. Beneath her feet is the moon, symbol of her virginity. The love-filled heart of the Christ child is displayed upon His breast and He holds out his arms to the entire Creation.

GWENDOLEN PERKINS Waterloo, Ontario

Cope of Freedom (c.1980)
Silk, appliquéd, with hand embroidery
Collection: The Rev. Dr. J. D. Leighton,
London, Ontario

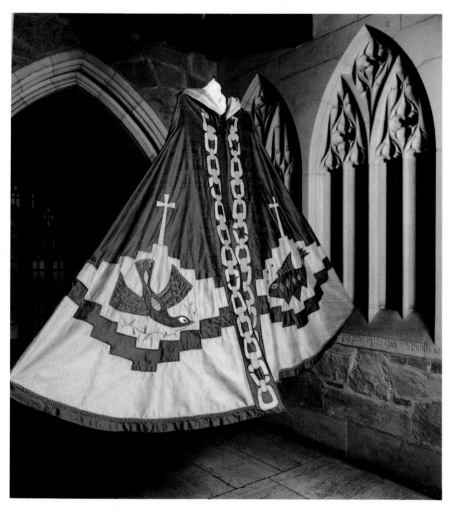

The *Cope of Freedom* was commissioned by Dr. Leighton in 1980. Large links of broken gold chain, symbolizing a release from bondage to freedom, highlight the orphreys on this rich blue silk cope. Five additional symbols, starting at the right front of the cope, are the dove of peace, with an olive branch in its beak; a ship to symbolize the Church of Christ; an open book with the Alpha and Omega to symbolize God the Son; the butterfly, a symbol of the Resurrection; and the fish, the early Christian symbol of Christ. Each of these symbols is surmounted by a gold cross.

Complementary colours and the richness of the silk increase the visual impact. The design is big and bold and rhythmic, creating a magnificent work of art that makes a powerful Christian statement.

The artist was responsible for the founding of the Canadian Embroiderers' Guild in London, Ontario, in 1971. It continues to flourish today. Classes are held in St. Paul's Cathedral on a regular basis, and the guild organizes an annual workshop at Brescia College, conducted by recognized experts in the fields of stitchery and embroidery from Great Britain, the United States and Canada.

SYBIL RAMPEN Oakville, Ontario

Angel Triptych (detail) (1991)
Filigree machine embroidery and
natural materials,
milk weed, wild cucumber and
Chinese lantern on silk
105.6 x 57.2 cm
Collection: The artist

O n this unique cope (facing page) is portrayed, in the colours of the four seasons, a celebration of the history of Canada. The glacier age is depicted at the top with Arctic forms of winter white and grey. Spring comes with Matisse-like shapes and leaves, suggesting forests and the tree line; summer produces the flowers of the provinces represented from east to west; and fall reveals the settlements that grew up in the wake of the railway. The railway ties the country together from coast to coast, and villages sprout up, each one focused on its church. Finally at the bottom we return to winter, the present, a high-rise age of technology and communication. The sun and moon are depicted on the morse, and when the cope is worn, it takes us from day to night, East meets West, and Canada is one. In this poem the artist writes:

Seasons of Canada

In the beginning
This was a Land
Of ice and snow

Spring came
And spread her gentle Mantle
For Indian and Eskimo

Summer brought
Man across the sea
To pick provincial flowers;
To tie East to West
With a single track

Autumn is a harvest
Of growing Families
Clustered around
These tiny spires

Now ...
In our winter of Technology
Put on this robe of Canada
East greets the west
Moon sees the sun
Time and space
Are one!

This magnificent cope, a wearable history of our country, was honoured in 1984 with an Ontario Crafts Council Design Award.

Moving from fact to fantasy, from history to make-believe, we are confronted by an ethereal rendering of angels, inspired by the artist's visit to Burgundy. On the left panel of the *Angel Triptych* float two medieval angels, suspended in lacy filigree; in the centre panel the Queen of Heaven with children and three archangels look out from filigree nets; on the right panel an up-to-date punk

Canada Cope (1984)
Appliqué and machine embroidery
Semicircular, 250.8 x 132 cm
Collection: The artist

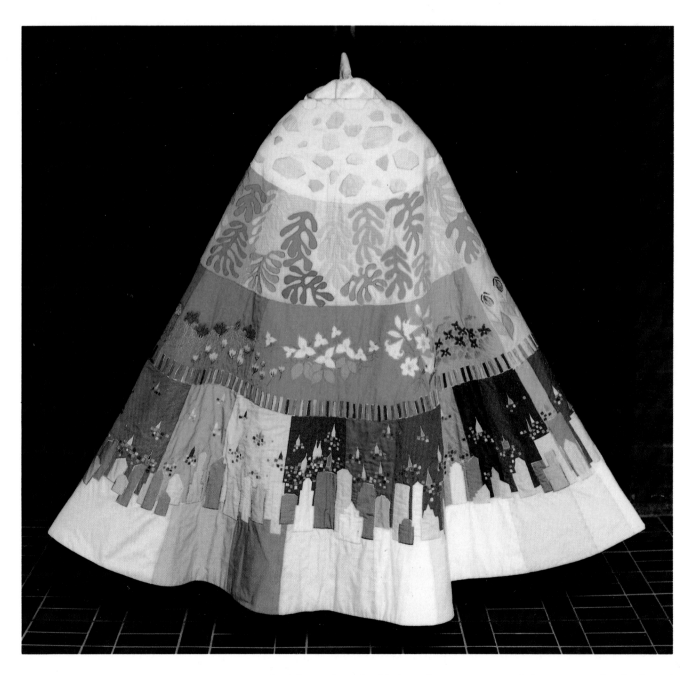

angel with purple spiked hair and strange green wings moves to the rhythm of the rock beat, a witness to the artist's ever-present and refreshing sense of humour. The angels formed by an innovative use of milkweed drift in a filigree cloud created by the artist's original treatment of dried and pressed wild cucumber, picked from the edge of the stream that flows outside her beautiful country studio.

THE POMEGRANATE GUILD OF
JUDAIC NEEDLEWORK Toronto, Ontario

Sukkah Installation:
How Beautiful Our Heritage
(1988)

Banners – cotton/polyester, polyester batting, beading, acrylic paint, various embellishments; hand appliqué, reverse appliqué, stencilling, embroidery, hand quilting
6 banners, each 120 x 90 cm

Baskets – natural and dyed reeds, mixed fibre, sea grass, beads, various materials; twining, weaving, various techniques
7.5 – 45 cm diameter

Festival Table
Etrog Container – silk, glass beads, beading, gold thread; soft sculpture, machine embroidery
18.75 x 12.5 x 7.5 cm

Centre Cloth - linen, cotton embroidery floss; hand embroidery
78.75 x 78.75 cm

Table Cloth – crochet linen, cotton/polyester, cotton embroidery floss, crochet cotton; hand appliqué, embroidery
130 x 130 cm

Underskirt - cotton/polyester; constructed
220 x 220 cm

Walls – vinyl-coated polyester thermal veil, velcro; hand sewn 3 walls, each 222.5 cm wide

Frieze – cotton embroidery floss on thermal veil; needlepoint
6 sections, each 17.5 x 222.5 cm

Structure Framework - pine, alkyd enamel, galvanized fittings
240 x 240 x 275 cm

Collection: The Pomegranate Guild of Judaic Needlework, Toronto
Photograph by Stephen Epstein
Toronto, Ontario

In the words of Rabbi W. Gunther Plaut, Senior Scholar, Holy Blossom Temple, Toronto:

According to the Torah, Sukkot [Tabernacles] is a seven-day festival which commemorates the trek of the Israelites through the desert. Therefore, we are bidden to build sukkot for ourselves and dwell in them, thereby to reenact the insecurities of our wanderings and to emphasize our reliance on God ... that only the mercy of the Almighty is our permanent shield ...

Decorating the sukkah is an old and honoured custom, for we are commanded to make our festivals beautiful in every way. There is a special dimension to these decorations, for they underline the spiritual aspect of the festival ...

Since Sukkot is an autumn harvest festival we traditionally gather the Four Species: the etrog (citron), and a lulav constructed from palm, myrtle and willow branches. While holding the etrog in the left and the lulav in the right, the rabbi says special blessings and the lulav is waved in all directions, a ceremony expressing our gratitude for the bounty God bestows on us.

The magnificent *sukkah* installation is the result of four years of intensive "planning, research, designing, sampling, fundraising," and loving work undertaken by forty-six Pomegranate Guild members and numerous helpers and advisors. The materials were chosen because they were readily available and could be used outdoors, in the hope that visitors would see the potential for their own *Sukkot*.

The three banners on the outside and two on the inside walls contain images from Israeli postage stamps and biblical texts pertaining to *Sukkot*. The sixth banner, an original design, extends hospitality to a guest each day of the festival in the ritual process called *ushpizin*. The Guild broke with tradition in involving the matriarchs as well as male biblical guests. Each frieze section is a translation of the Hebrew in the banner below it. The text over the *ushpizin* reads, "Let us invite the guests and prepare a table" (Zohar, Emor 103a). The frieze is needlepointed, using the thermal veil as "canvas."

The baskets are both independent sculptural forms as well as containers for natural ornaments, soft sculpture and harvest produce. The sides of the centre cloth of the festival table are embroidered with blessings said in the *sukkah*. The table cloth has a border of crocheted pomegranates which frames corners appliquéd with birds and plants.

This splendid work of art reflects the pride and sincerity of those who undertook to create it:

We are ... gratified that we have been able to take a tradition from our past, give it contemporary expression, and create a continuing legacy. Since it is a portable booth, we plan, wherever funds are available, to send it to other communities. Just as our ancestors made Sukkot while travelling from place to place, we hope that the work of our hands will reach others and inspire them with new awareness of our heritage.

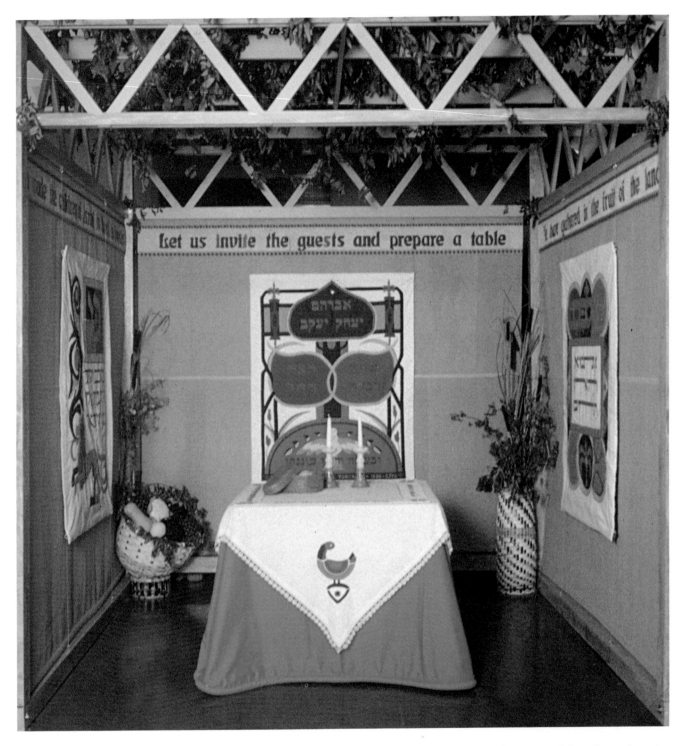

The *sukkah* installation has been exhibited in several locations since its inaugural display at the Koffler Gallery, Jewish Community Centre, North York, Ontario, in 1988. In February 1989, it was part of Signs and Stories: Liturgical Textiles, sponsored by the Ontario Crafts Council and displayed at the John B. Aird Gallery, Toronto; and at the Jewish Festival of the Arts Society, held in Temple Sholom, Vancouver, in September 1989. Part of the *sukkah* installation was entered in the juried competition, Liturgical Arts Festival, St. James' Cathedral, Toronto, 1989, where it was awarded a prize and commended for its sense of balance, colour and design, for its excellent execution, and for its element of achieving a sense of celebration. Parts of it were on display in November 1991 at the Beth Tzedec Museum, Toronto.

HEATHER REEVES St. John's, Newfoundland

Reconciliation Banner/Altar Cloth (1985)
Cotton velvet, cotton embroidery thread; tritik discharge
with stitching and lacemaking
232 x 135 cm
Collection: St. Teresa's Parish, St. John's, Newfoundland
Photographs by the artist

This set was designed for use during Lent and Advent and at all Reconciliation Services. The angular shapes cast in the darker colours of purple and red represent the sinfulness of men and women, while the graceful curve in gold and peach tones suggests God's redemptive power. Jagged shapes evolve into circles; one is transformed in reconciliation.

The stole derives its shapes and colours from the altar cloth, and incorporates triangular metal inserts to repeat the motif of the need for reconciliation.

Reconciliation Stole (1985)
Cotton velvet, cotton embroidery thread, artificial gold-covered thread,
copper and nugold metal; tritik discharge, stitching and lacemaking
Collection: St. Teresa's Parish, St. John's, Newfoundland

MAE RUNIONS Vancouver, British Columbia

Lenten Triptych (1987)
Left to right: *The Grieving Angels,* 132 x 66 cm
The Christ, 132 x 92 cm, *The Mother,* 119 x 66 cm
Fabric, appliqué
Collection: The artist

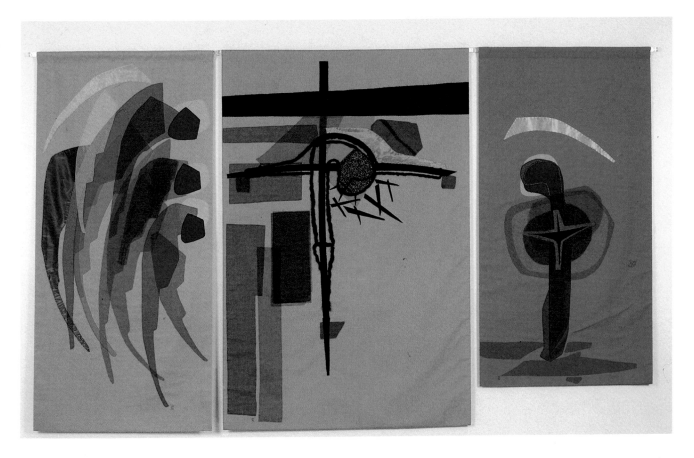

The visual impact of this *Lenten Triptych* is immediate and dramatic. The source of the impact is threefold: the colours; the design, shapes and rhythmic lines; and the familiar images that are given new form here.

The three panels, *The Grieving Angels, The Christ* and *The Mother,* placed side by side, intensify the poignancy which the artist has sought to create, the poignancy of grief in heaven and on earth. The bent Christ figure in sparse, black line drawing is silhouetted against a pale aqua background. The colours are sombre, yet vital, signifying that Lent contains the seed of Easter. The three parts of the triptych are drawn together by the placement of the cross, with the heavy horizontal arms of the cross reaching out to either side – to the hovering angels, and to the stark desolate figure of Mary. The events of Good Friday are here given fresh treatment in textile.

These works were originally created to be hung at a performance of *Messiah* at St. John's (Shaughnessy) Anglican Church, Vancouver.

ERICA LAURIE RICHARDSON Stratford, Ontario

Altar Set and Vestments (1988)
Painted dupioni silk, batik, appliqué,
embroidery
Collection: St. James Anglican Church,
Stratford, Ontario

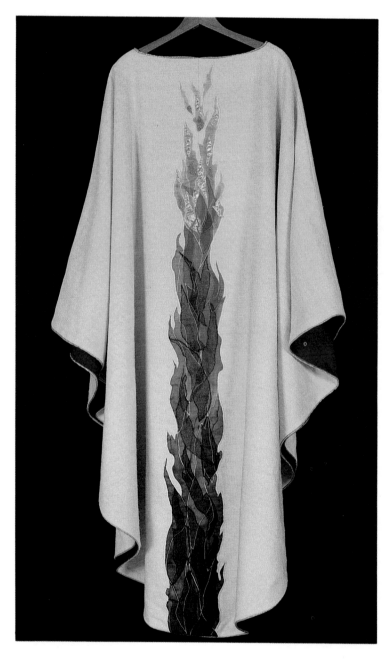

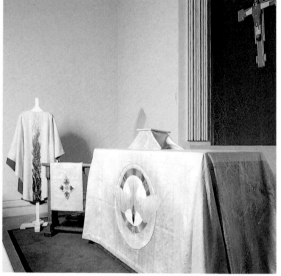

The inspiration for this set was drawn from the Victorian Gothic windows of St. James Church and the frescoes of Fra Angelico. As the artist says, "I wanted to get something of the feel of the fresco surface in the frontal fabric and to keep the purity of colour and design found in Fra Angelico."

The dove is the Holy Spirit as fire and light. Combining Old and New Testament passages, the inscription reads, "I Am" as God spoke to Moses in Exodus, chapter 3, verse 14, and the Greek letters for "Alpha" and "Omega" (Rev. 22:13). It complements the inscription in gold above the sanctuary in St. James Anglican Church: "I have come that they may have life, and have it abundantly."

On the cope (not illustrated) and on the chasuble (to the left) the theme of fire and light is repeated, with a suggestion of upward and outward motion. A scallop shell, the symbol of St. James (patron saint of pilgrims), crafted in glass by Connie Eaton, adorns the morse on the cope.

The artist's experience in the theatre as a designer, scenic artist, costume decorator and painter is clearly evident in this dramatic set, a rendering of quiet but effective tones that lift the spirit and complement the setting to perfection.

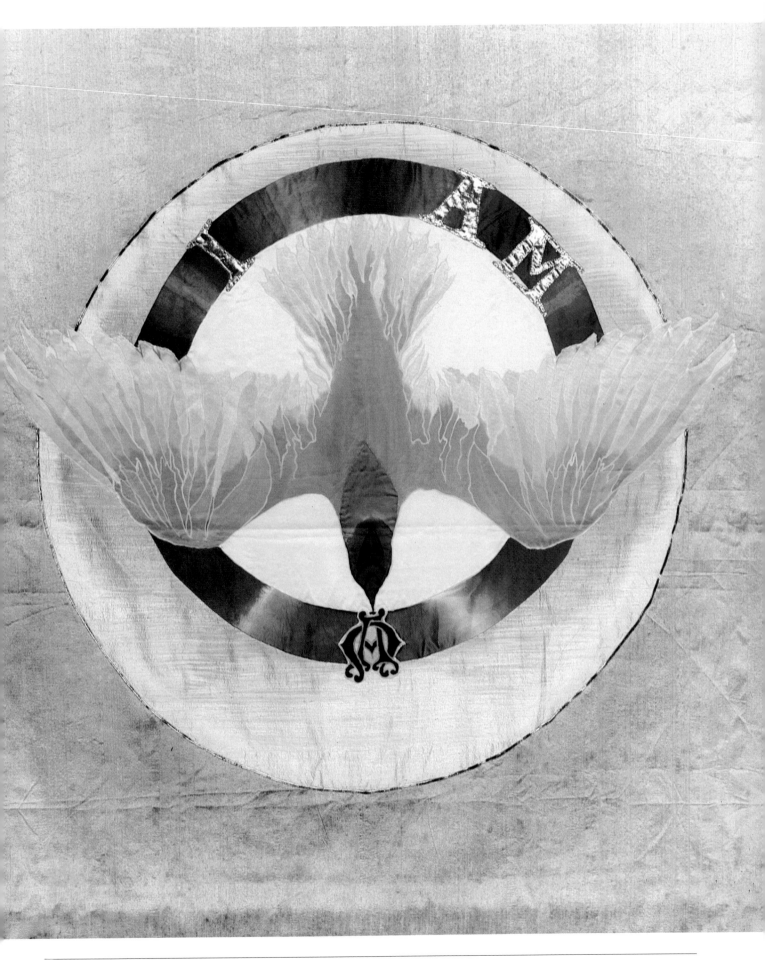

CAROLE SABISTON Victoria, British Columbia

Advent Altar Frontal (1974)
Thai silk, satin, gold kid; hand-stitched fabric assemblage
300 x 510 cm
Collection: Christ Church Cathedral,
Victoria, British Columbia
Photograph by Jeff Baker, In Focus, Victoria, British Columbia

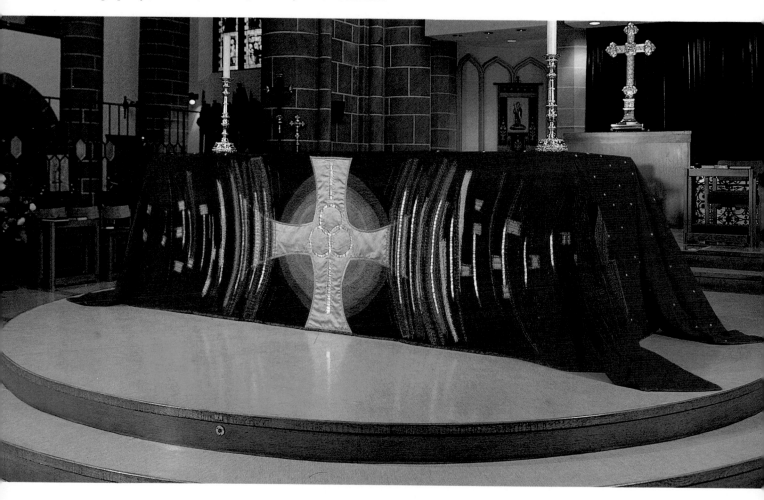

Carole Sabiston is keenly aware of the forces of nature. She thinks in cosmic terms. Her images reflect the universe and the world of ideas; her techniques are simple, employed as a means to execute an idea. She builds her compositions by layering and overlapping and by the use of net. Circles or spirals are used to describe all creation; vertical and horizontal directions and diagonal strips suggest the human intellect. The combinations and juxtapositions result in energy, light, movement and a sense of underlying space.

The vibrant *Advent Altar Frontal* for Christ Church Cathedral, Victoria, represents the Trinity, with the cross in the centre and radiating movements outward. The shimmering colours – thai (shot) silk cerise, purple and emerald – change with the viewing point. The smaller jewel colours echo early stained glass, representing the intense colours of medieval times.

The Earth Is the Lord's and Its Fullness Thereof is a memorial banner commissioned to honour a past headmaster of St. Michael's University School.

The Earth Is the Lord's and Its Fullness Thereof (1975)

Hand stitched, appliquéd, fabric assemblage

420 x 330 cm

Collection: St. Michael's University School,

Victoria, British Columbia

Photograph by Jeff Baker, In Focus, Victoria, British Columbia

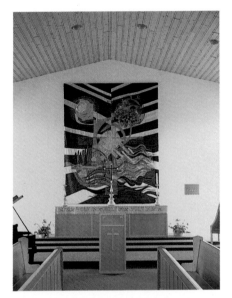

The students attending the school come from the four corners of the earth which are depicted by the four visible sections of the banner. The blue and white bands (the school's colours) represent the radiating life energies from the sun, which is in the centre. The circles depict the moon (or universe), the oceans and the land (forests and fields). The top right circle contains many tiny human faces, biblical animals and a few Canadian creatures, such as moose, bear and goose.

In 1984 the *Celebration Cape of Many Coloured Hands* was created for an exhibition at Harbourfront to commemorate Toronto's 150th anniversary and Ontario's 200th anniversary. The artist's concept was to celebrate by wearing one's own parade. Its shape resembles a cope, one of the earliest and simplest forms of ceremonial robe. The circle is symbolic of the earth and its cycles. The many-coloured hands represent the international and interracial component of Toronto's population – all celebrating the hope of a better life. A few years later a banner with a similar theme of many hands was created by a group of sewers to celebrate the service honouring Bishop Tutu of South Africa at St. Paul's Church on Bloor Street in Toronto.

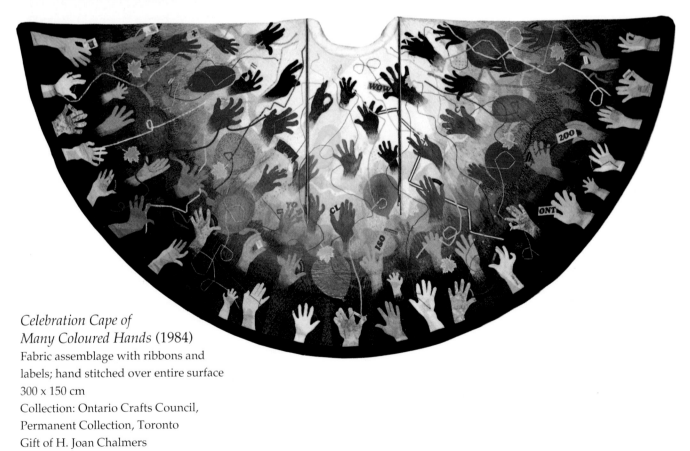

Celebration Cape of Many Coloured Hands (1984)

Fabric assemblage with ribbons and labels; hand stitched over entire surface

300 x 150 cm

Collection: Ontario Crafts Council,

Permanent Collection, Toronto

Gift of H. Joan Chalmers

SUSAN D. SHANTZ Saskatoon, Saskatchewan

Cathedral II (1983)

Wood, clay, cement, paint, fabric, lace, metal

66 x 66 x 237 cm

Collection: Wilfrid Laurier University

Permanent Art Collection

Waterloo, Ontario

Photograph by the artist

Raised a Waterloo County Mennonite, Shantz grew up in the shadow of that particular iconoclastic religious heritage. But as her own personal interests developed and she discovered her abilities in art, she looked to religious traditions and times (such as Catholicism, Eastern Orthodoxy and medieval culture), times when art was valued as an expression of spirituality.

Out of this experience grew her inspiration for this person-sized "Cathedral." Precast ceramic Mennonite figures form the spires; a bird bath becomes a baptismal font/foot-washing basin; and acrobatic Mennonite angel couples decorate the four columns. This construction became for the artist a playful bridge of the tension felt between her image-less heritage and her own need for a more visual and sensual religious expression.

The textile components of the work consist of a base/altar cloth on the floor, made from damask tablecloth fabric with the letters "C A T H E D R A L" reverse-appliquéd on each of the four sides. The letters stretch to fill and define a roughly circular inside space; their shapes are derived from the Fraktur lettering-style traditional to Pennsylvania-German Mennonites in Waterloo County. Each letter is outlined with black embroidery and the edge of the cloth is bordered with lace and beads. The "ceiling" of the cathedral is also textile. Four crocheted triangular pieces fit into the spaces between the "spires," imitating the lace-like stonework of many European cathedrals.

"In this piece," the artist writes, "I use textiles to replace mediums traditionally associated with cathedrals/altarpieces and male artisans (such as stonework, oil paint). Women's traditional labour in textiles is thus playfully elevated to become equal with them."

While Shantz sought her own expression in a mixture of derivations, she willingly cooperated in a project that has provided an extraordinary departure for the members of Erb Street Mennonite Church in Waterloo. A series of banners illustrating the Beatitudes (not illustrated) are hung along the side walls and over the centre front of the church. Approached originally to lead a banner workshop, the artist provided the general format of the banners, the lettering style, ground colours and a suggestion of Fraktur motifs. Men and women, adults and children participated in the workshop, planning and designing decorative motifs for each banner. The felt pieces were to have been glued to the ground fabric, but it was decided they deserved something better, so several women spent many hours machine-stitching the banners. Of any biblical texts, the Beatitudes are (unofficially) central to Mennonite beliefs, as are communal work projects (quilting bees, barn raisings, mutual aid), which is exactly what this project became. Shantz elicited as much participation as possible from the congregation while providing some input into the aesthetics and design. Done chiefly in rich shades of blue and red, with fresh colourful touches in the decorative motifs, the banners are a delightful addition to the church's interior.

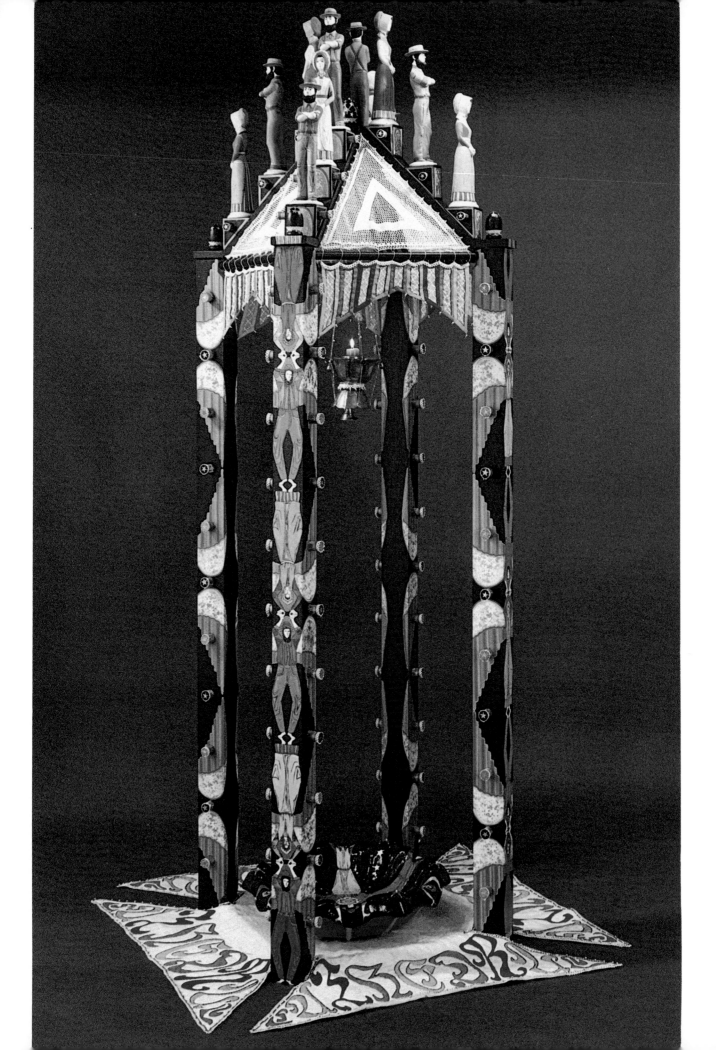

JOE SOMFAY Fergus, Ontario

The Yearning Cope (1973)
White linen lined with blue peau de soie, silk and velvet appliqué; heirloom silver bracelet used for clasp
Collection: The Rev. Canon D.W. Luxton, Etobicoke, Ontario

The decorative motif that rises up the back of this handsome cope speaks of "creation," of God's creation of the seas and the dry land called earth. At the bottom we see the waters of the seas that God assigned as boundaries at the edge of the earth. Beside these, vegetation emerges, which God commanded the earth to put forth. As the plants struggle to survive, they reach up to the light, the light of God and of creation.

By virtue of the design, the eye is drawn from the swirling waters up the tall green plants towards the light that shines from the sun, moon and stars. There is a message of hope as we witness creation's constant yearning after God.

The cope, designed by Joe Somfay and Sephora Inc. of Elora, was worked by Barbro Thompson, "Bleak House," Elora, and Sharon Somfay.

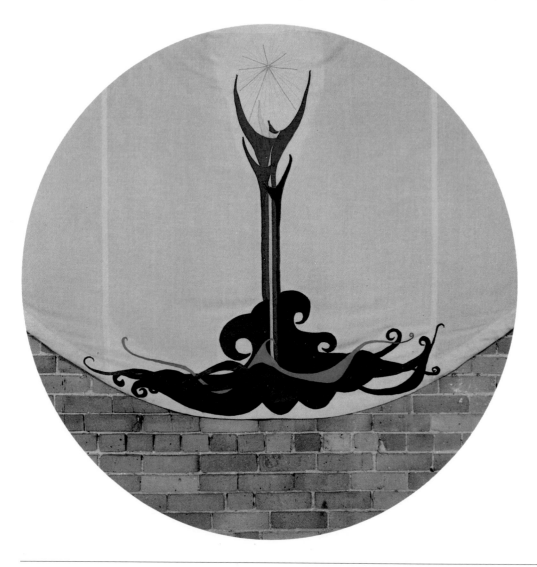

GOLDIE SPIELER St. Thomas, Barbados, West Indies

Tribes of Israel Tapestry (1975)
Needlepoint
Collection: Agudath Israel Congregation,
Ottawa, Ontario

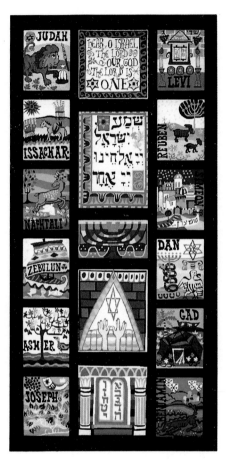

Members of the Sisterhood of Agudath Israel in Ottawa combined their efforts to execute two (of which this is one) contemporary needlepoint designs by Goldie Spieler. *Tribes of Israel Tapestry* consists of seventeen canvases. Six tribes are depicted on each side, as well as five symbols and ideas of Judaism in the centre.

The twelve tribes are depicted with symbolic images as follows:

Judah the traditional lion is represented with its kingly accoutrements

Issachar a strong ass crouching down between two burdens, the sheaves of wheat show abundance with the sun shining down on fertile lands

Naphtal the hind as the symbol of agility, grace and tenderness; the deer leaping over the bird has a menorah hidden in its spots

Zebulun the sailing vessel stands for the tribe's occupation in fishing and trading

Asher happiness and prosperity are signified by the fruitful pomegranate tree under which rests a colourful dove of peace

Joseph the flying bird with a crown commemorates Joseph as Viceroy in Egypt

Levi the Torah is in the travelling ark; bunches of grapes stand for blessed fruit, the candles for the Sabbath and the brick background for the Wailing Wall

Reuben the sheep for the nomadic tribe; orange tree in the shape of a menorah; green slopes and yellow mandrake flowers

Simeon the curved sword represents Simeon's warlike character; the walled city represents Jerusalem

Dan the menorah represents both the Tree of Life and justice; the scales of justice over the eagle's head are for fearless and just decisions; the horned viper, dangerous serpent of the desert, twines around the base of the menorah

Gad the tent is the warriors' home with spears in the doorway; the date palm and fields represent the fertile land

Benjamin shown as a ravening wolf before the Jordan River ensuring safety to the City of Jerusalem

Since man was created in the image of God (Exod. 20:4), Mosaic tradition opposes representation of the human figure. For this reason Spieler depicted each tribe by representing animals, flowers, fruits and symbolic elements from the Book of Genesis.

The top two centre panels display the most significant words in the Torah, in English and in Hebrew, "Hear O Israel the Lord our God. The Lord is One." The middle panel, an honoured position, is reserved for the menorah, the basic symbol of perpetual faith. The two lower panels together represent the First Temple. The upper canvas shows the hand symbols of the priestly blessing, the Star of David at the peak and the Wailing Wall in the background; the lower panel shows the two tablets containing the Ten Commandments.

This tapestry was completed in two years and was dedicated by the congregation as "a labour of love" and "the work of our hands." The second tapestry, dedicated in 1978, is entitled *The Holidays and Festivals Tapestry*. These two hangings are spectacular works of authentic Judaic symbolism.

FRAN SOWTON Toronto, Ontario

Lo the Green Blade Rises (Easter, 1987)
Silks, organza, net, threads, machine embroidery, hand-embroidered figure
90 x 202.5 cm
Collection: Church of the Holy Trinity,
Toronto, Ontario

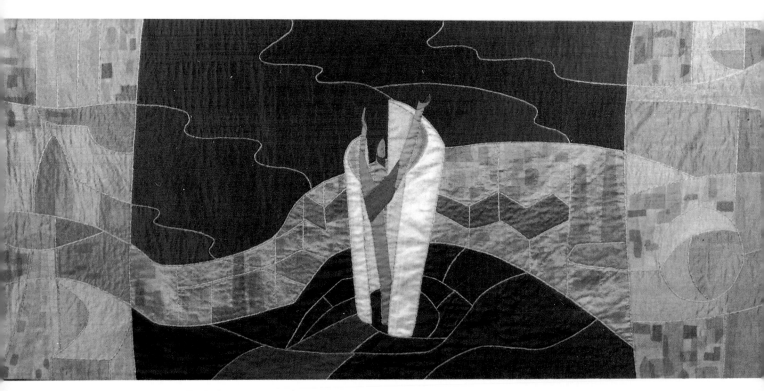

The Church of the Holy Trinity in Toronto is truly a downtown church, surrounded by the teeming city. This Gothic edifice nestles with dignity against the powerful urban structure of the Eaton Centre. It suggests the "still" point surrounded by whirling humanity. The altar frontal, *Lo the Green Blade Rises,* designed and stitched by Fran Sowton, addresses the irony of this juxtaposition. The theme of this work speaks of "Then and Now; There and Here," the artist explains. It refers to the green hill outside Jerusalem nearly 2,000 years ago, but it is set in Toronto today. Christ is the green man (a nature figure) bursting like a sprout from a seed casing in the City Hall. The Easter theme of resurrection is suggested by the green blade sprouting in the spring from the cold and barren ground. Landmarks of the city such as the CN Tower and the Gardiner Expressway are easily recognized.

Nativity Frontal (1986)
Dupioni silk, hand piecing, appliqué, quilting, hand embroidery
90 x 202.5 cm
Collection: Church of the Holy Trinity,
Toronto, Ontario

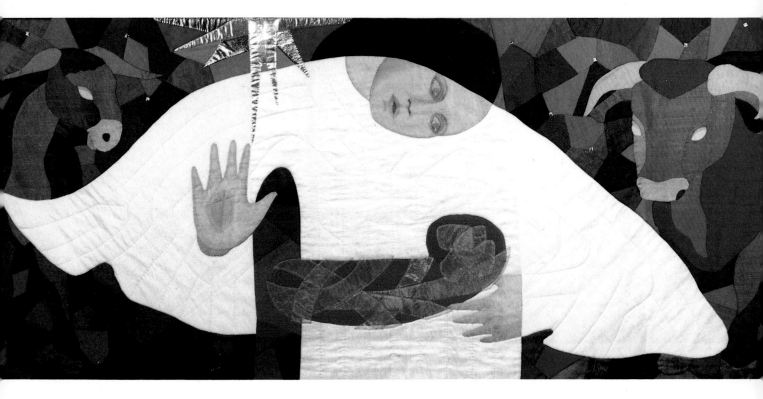

Nativity Frontal was also designed for the Church of the Holy Trinity. The artist writes about this work:

> *The Mary shape is that of a great white bird, the sleeves of her robe are like wings. The bird is a symbol of the soul and also of the Goddess. This is the meeting of the male and female principles so the male shape is phallic. But since he's just a baby the shape is overlaid with a rose. Mary's gesture is one of blessing, but also one of awe, her hands don't quite hold the child. Man and woman are together but also separate. The space under her arm stands for her womb and is "hot" at the moment of birth.*

Vibrant orange and pink are used effectively to portray this miraculous moment. Because Mary's skin is made of a sheer fabric of blue and orange threads, when seen from the side her skin darkens to suggest a black Madonna. The animals loom out of a dark-sky background of strongly saturated colours. A silver star illuminates the scene.

MARION SPANJERDT Toronto, Ontario

Apocalyptic Banner IV: Death and Hell (1978)
Various fabrics, appliquéd by hand and machine
600 x 180 cm
Collection: All Saints' Cathedral,
Edmonton, Alberta
Photographs by Joe Bally, Edmonton, Alberta

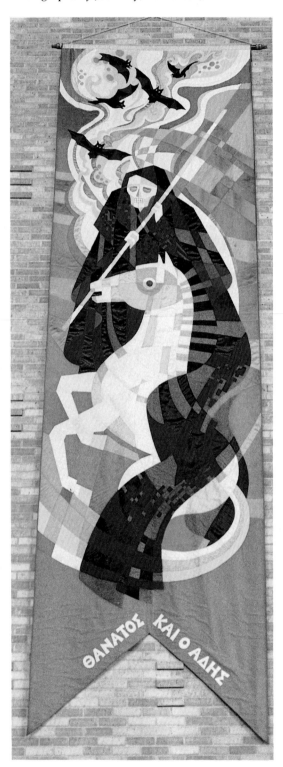

These enormous banners, part of a set of seven, were designed as a backdrop for *Apocalypsis*, a musical extravaganza composed by R. Murray Schafer. Representing part of the vision of St. John on the island of Patmos, they depict the breaking of the seven seals. The first four reveal the four horsemen; the fifth, the souls of the slaughtered; the sixth, the earthquake; and the seventh, the angels before God as described in the Revelation of St. John, chapter 6. Inscriptions in Greek at the bottom of each banner identify the seals. These outstanding hangings were designed by Marion Spanjerdt and sewn by hand and machine under her careful supervision by five different church groups in Toronto over a period of thirteen months (see author's note below).

The original production of *Apocalypsis* was to have been performed at St. Paul's Anglican Church in Toronto in October of 1977, but was cancelled because of a lack of funds. It was decided, however, to complete the banners and to permit them to be displayed in many churches over a period of years. They were actually used as intended when *Apocalypsis* was finally performed in 1980 in London, Ontario. Since 1983 they have been on permanent display in All Saints' Cathedral in Edmonton.

Another important liturgical work by Spanjerdt was featured on the poster advertising the 1989 Liturgical Arts Festival held at St. James' Cathedral, Toronto. This long, narrow banner (not illustrated) hangs at a height of forty feet in Grace Church on-the-Hill in Toronto, high above the pulpit, flanked by organ pipes. Crafted in rich, coloured silks and gold kid, heightened with exquisite machine embroidery, it is an abstract statement in a traditional setting.

The Grace Church banner speaks of the whole universe, a visual history of the world. Out of the darkness and chaos, so dramatically depicted at the bottom, emerges the order of humanity. The eyes which stare cannot be at peace in the world – this crowded world – but finally, ultimate order, peace and light are achieved. As the eye is carried from darkness up into light, one's spirit is uplifted. Captured here are the human aspiration, the river of life, and the tide of time. A sense of mystery and yearning is conveyed without the traditional symbols. The message of hope is universal.

Authors' note: The concept for the banners was initiated by artist Leo Del Pasqua. Marion Spanjerdt took that idea and translated it into designs for the seven banners, which were then crafted in workshops in Rosedale United Church, Eglinton United Church, St. Philip the Apostle Anglican Church, St. Andrew's Humber-Heights Presbyterian Church, Weston, and Hopedale Presbyterian Church, Oakville. One banner was done by Maureen Barber of Oakville Presbyterian Church.

Interior, All Saints' Cathedral,
Edmonton, Alberta, where the
Apocalyptic Banners are a permanent
installation

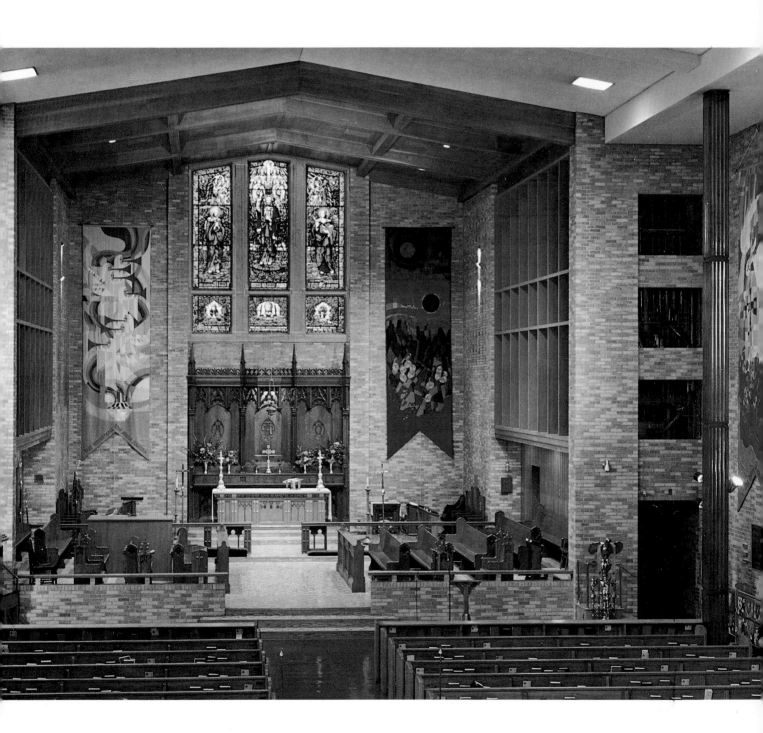

JOANNA STANISZKIS Vancouver, British Columbia

Earth and Sky (1984)
Woven tapestry, wool, cotton, silk
580.8 x 264 cm
Collection: St. Matthias (Anglican) Church,
Vancouver, British Columbia
Photograph by Maxwell C. Baker, Richmond, British Columbia

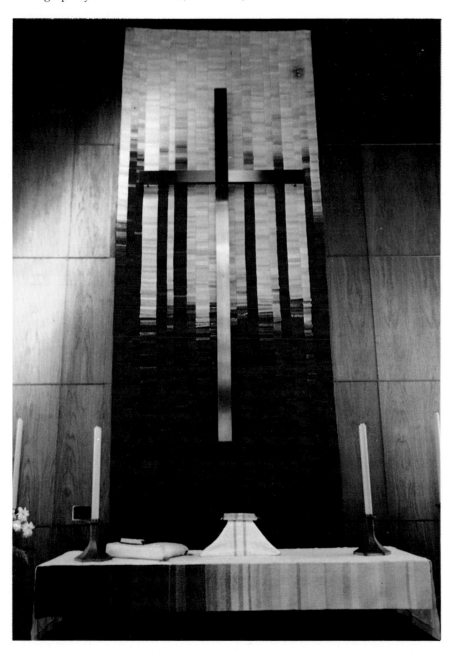

This immense woven tapestry, *Earth and Sky*, stretching twelve feet from floor to roof, forms an abstract textural background for the main altar. The suspended cross appears as part of the composition. The vertical design with deep rug-like texture and the sharp shift in colour from intense red to dazzling white creates a captivating and uplifting image.

Recognized as one of Canada's most experienced and innovative fibre artists, Staniszkis was honoured with the prestigious Saidye Bronfman Award for Excellence in Canada in 1981.

Her commissions hang in prominent locations in Vancouver and Toronto and many of her works have been exhibited throughout the Middle East, Europe and North America. Her interpretation of Vancouver's skyline was a centre-piece for the Commonwealth Conference in Vancouver in 1987, and in 1988 she was invited to create a backdrop for the Toronto Economic Summit.

LENI TAUSSIG Mayne Island, British Columbia

Tallit: My Family about Me (1981)
Handwoven, fine canvas, appliqué
Collection: Rabbi Wilfred Solomon, Congregation Beth Israel,
Vancouver, British Columbia
Photograph by the artist

The first recorded mention of embroidery is found in the Torah. The fine tradition of Judaic needlework is evident in the explicit directions given by God to Moses in Exodus, chapter 26, verse 1, detailing the construction and decoration of the tabernacle: "ten curtains of fine twined linen and blue, and purple, and scarlet." It accompanied the Jewish people as their centre of worship while they wandered in the desert and even in Canaan.

Leni Taussig has embroidered wedding canopies, ark curtains, Torah mantles, prayer shawls, wall hangings and Christian ecclesiastical pieces. The *atarah* (collar) for the *tallit* of Rabbi Solomon, which he wears daily, is personalized with symbols of the wolf, bird, lute, menorah, lion and morning star. These represent the Hebrew names of Father, Mother and four children. Rabbi Solomon can literally wrap himself in his family.

It has been suggested by sages that "blue is used in the *tallit* because the colour resembles the sea, the sea resembles the sky, and the sky is a reflection of the sapphire throne of God."*

*Miriam Chiakin, *Menorahs, Mezuzas, and Other Jewish Symbols* (New York: Clarion Books, 1990), 35.

SANDRA TOYNE Winnipeg, Manitoba

Copes and Mitres (1986)
Silk, with appliqué on velvet
Collections: (blue) Diocese of Rupert's Land, Winnipeg, Manitoba,
(ecru) Diocese of Brandon, Brandon, Manitoba,
(green) Diocese of Keewatin, Kenora, Ontario
Photograph by the artist

These three copes and mitres were created expressly for the General Synod, Anglican Church of Canada, which took place in Winnipeg in June of 1986. In fact, they were the winning design in a vestment-design contest held a year earlier in preparation for this particular synod. The entire set of vestments includes an additional five chasubles with matching stoles, two dalmatics and a further thirty-five stoles. Once these vestments were designed, the artist was assisted in the task of making them by thirteen volunteers. Ministry and Mission: Called and Sent was the theme of the synod. Reflecting the variety of settings which characterize the ecclesiastical Province of Rupert's Land, the hood on each cope is uniquely representational of a different region: the blue hood portrays a cityscape; a prairie landscape decorates the gold velvet hood on the ecru cope; while a forest landscape is defined on the green hood. The designs on the mitres, stoles and chasubles represent the three crosses of Christ: the crucifixion cross, suggested simply by a circle for Christ's head and an inverted "V" with arms hung down; the empty cross; and the ascension cross identified by a circle and a "V" with arms thrust upwards. These are rendered simply in appliqué of bright pink, yellow and green against the rich navy, gold and green velvet.

In 1991 Sandra Toyne spearheaded the project To Romania with Love, which resulted in the creation of more than 600 quilts designed to bring colour, warmth and fun to orphaned children in Romania.

ANNE POUSSART Quebec City, Quebec

Stole: Christmas along the
St. Lawrence River (1986)
Linen/silk, fine silk, doubled
Collection: The artist
Photograph by the artist

At Convergence '86: A Fibre Spectrum, there was an exhibition of liturgical weaving at St. Michael's College, Toronto. One of the weavers from Quebec was Anne Poussart, whose Pentecost chasuble, and summer and winter stoles were displayed as well as *Christmas along the St. Lawrence River.*

The contemporary liturgical stole is a natural extension of the Monk's Belt Weave. Anne Poussart has retained the apparent simplicity of the traditional two-o'clock weave, but worked out a sophisticated multi-harness variation. Because of the tendency of this weave structure to pull in at the patterned sections, she has achieved a remarkably even surface and straight edge. The natural border of the stole is executed in blue and silver, while the design is woven in green.

Due to the simplicity of the design and the even-textured quality of the fabric, it achieves beauty in its own right. The artist has woven many stoles and has taught weaving techniques for ten years.

ELIZABETH TAYLOR London, Ontario

All Season Set, Renewal (1988)
Silk with appliqué and embroidery, quilted
150 x 60 x 90 cm (worked on all sides)
Collection: St. Paul's Cathedral,
London, Ontario

Elizabeth Taylor's extensive body of work is as varied as the churches and locations in which her art is found. Her work effectively bears out her strong belief in the principle that all church commissions must "relate to and be integrated with the church itself." At the same time her pieces combine an excellent standard of workmanship and design with an understanding of the theological relevance.

The *All Season Set*, commissioned by St. Paul's Cathedral in London, Ontario, has as its theme renewal – renewal of the earth by God's work, year by year:

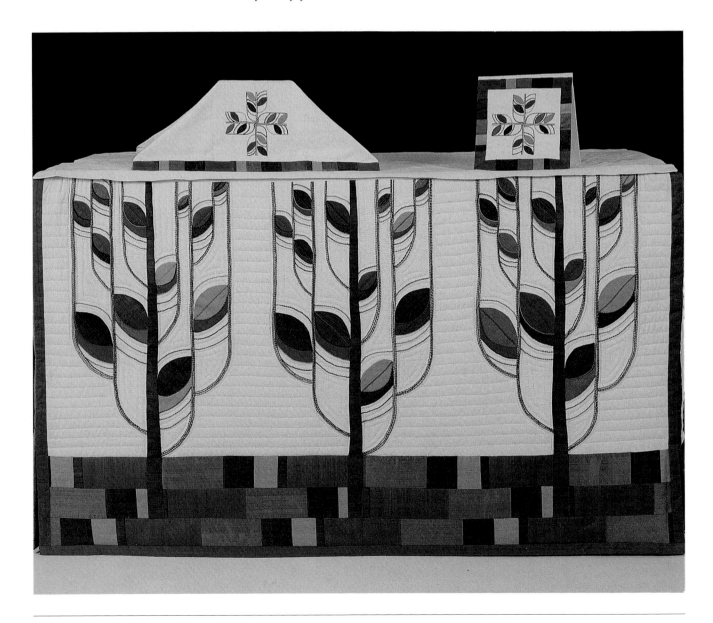

For there is hope of a tree, if it be cut down, that it will sprout again, and that the tender branch thereof will not cease. Though the root thereof wax old in the earth, and the stock thereof die in the ground; yet through the scent of water it will bud, and bring forth boughs like a plant. (Job 14:7)

Trees were chosen as the symbol, as expressed in the verse from Job. The colours are different on each of the four sides of the altar frontal and relate to the four seasons (spring, summer, fall and winter), as well as to the colours in the stained-glass windows of the cathedral. In 1989 at the Liturgical Arts Festival held at St. James' Cathedral, Toronto, this *All Season Set* was awarded Best of Show in the juried competition. Credit should be given to the women of St. Paul's Cathedral who executed the quilting of this set.

The artist best describes St. Aidan's Church in London as a small simple modern A-frame. It has one wall of windows looking out onto a marsh. The natural beauty beyond the windows is as much a part of the fabric of the church as are the artist's recreations of nature that animate the interior. Over a ten-year period, she has glorified the interior with fabric pieces always based on designs and symbols drawn from nature: the deer is representative of St. Aidan; the trillium is a sign of the Trinity and is particularly suitable for Ontario. On the pulpit fall is depicted the eagle, the bird able to fly further and higher than any other.

The artist comments, "Symbols in the church should be simple and direct, not an amusing puzzle for the cognoscenti. This is not a place for people to be puzzling over the meaning, but rather to be able to receive the

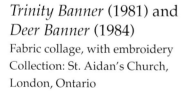

Trinity Banner (1981) and *Deer Banner* (1984)
Fabric collage, with embroidery
Collection: St. Aidan's Church, London, Ontario

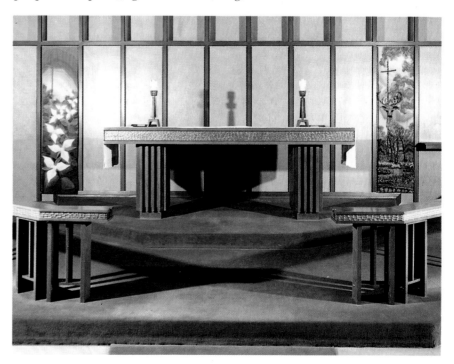

Frontal (1990)
Silk, pieced, with silver cord and embroidery
300 x 90 x 97.5 cm (worked on three sides)
Collection: St. Christopher's Church,
Burlington, Ontario

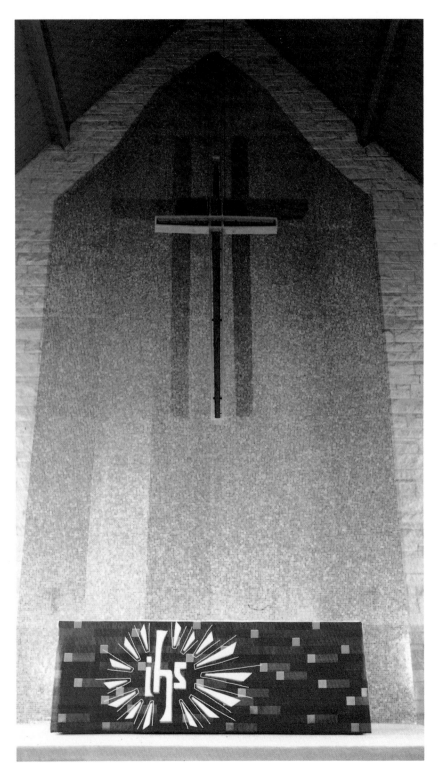

Good News visually and directly as well as verbally."

At St. Christopher's in Burlington,, Ontario, the symbol is very simple – the I H S surrounded by a sunburst. An exciting challenge was presented here, namely, how to complement an immense reredos of turquoise mosaic that is set against a lovely rough-cut stone wall. The large free-standing altar occupies the central core of worship. The silk background of the *Frontal* was selected to echo the touches of red in the stained glass, while the shape and colour of the sunburst reflect the shape and colour of the great cross suspended above it. The turquoise squares repeat the pattern of the mosaics in the reredos. The unusual off-centre placement of the sunburst is compelling.

MARGARET WALLACE Victoria, British Columbia

Baptismal Banner (1984)
Cotton broadcloth, with silk screen,
reverse appliqué
l65 x 33 cm
Collection: All Saints' Anglican Church,
Hamilton, Ontario

Cope (1973)
Wool, with handwoven panel, linen,
hand appliqué
Collection: The Rt. Rev. J.C. Fricker,
Suffragan Bishop, Diocese of Toronto

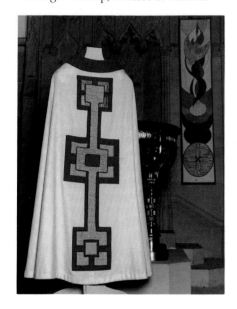

I have never repeated a design: each piece has been created for a particular place or person. For me the work has been an exploration not only of materials, techniques and architectural space, but in a very real sense of theology. (The artist)

The theme of the *Baptismal Banner* is baptism by water and by fire. "We thank you, Almighty God, for the gift of water. Over water the Holy Spirit moved in the beginning of creation." The Holy Spirit in the form of a dove comes with tongues of fire; the water falls and becomes a deep pool. The shell symbolizes John the Baptist. The mandala encircling the cross is formed of four fish and signifies the community of the church.

Completed in 1973, the lemon-yellow cope is made of handwoven wool with a deep-blue linen orphrey and hand-appliqué design. The Celtic Cross, which extends the length of the back panel, depicts the design on an early Christian stone pillar at Glen Columkille, County Donegal, Ireland. The simplicity of the design and the quality of the stitchery make an elegant and dignified statement.

The white altar frontal, *I Am the Vine*, is appliquéd in oriental silk and lightly quilted. The background is of silk and wool. The theme of the frontal comes from John, chapter 15, verse 5. Jesus is speaking with his disciples a few hours before his arrest. This quotation is also found carved on the lintel of the main porch of the cathedral.

This frontal hangs on the High Altar of Christ's Church Cathedral in Hamilton on festive occasions, such as Christmas and Easter, and for weddings and baptisms. It was commissioned to commemorate the centennial of the Diocese of Niagara, which is the chief wine-growing area of eastern Canada.

I Am the Vine
(Laudian Frontal) (1975)
Silk appliqué, quilted
Collection: Christ's Church Cathedral,
Hamilton, Ontario
Photograph by Helen Bradfield,
Toronto

DORA VELLEMAN Sambro Head, Nova Scotia

The Burning Bush (1989)
Metallics, silk, velvet, net, machine quilted
240 x 120 cm
Collection: St. John's United Church,
Halifax, Nova Scotia
Photographs by Brian Segal, Red Gull Images, Antigonish, Nova Scotia

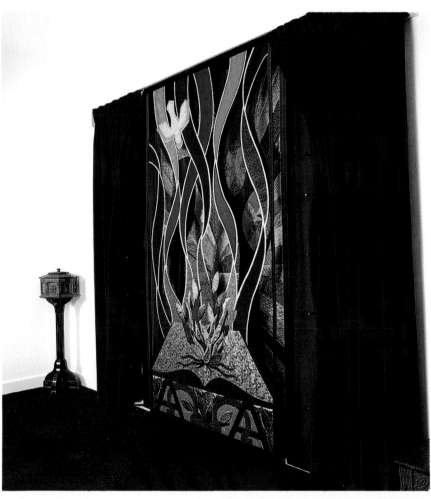

*T*he *Burning Bush* hangs in the memorial chapel of St. John's United Church in Halifax. The rear drop of the hanging is a rayed-out pattern of quilted metallic, with a very deep green velvet running between courses of machine-quilted metallic. Christian symbols of fish (with crosses) and the gold "shadow" of a dove descending (in two layers) give meaning to the work as do the burning bush, the open Bible, and the Greek letters, alpha and omega. The deep green and vibrant red of the stained-glass window of St. John's are echoed in the brilliant colours of the hanging. The interplay of the colours and the ascending forms convey a sense of motion and warmth, which give life and energy to this memorial chapel.

The award-winning *Sing* was the glorious result of several workshops on lettering with British artist Pat Russell. Constructed of five adjacent panels and suspended behind a tulle scrim, this three-dimensional hanging virtually sings with colour, with stitchery and with movement. Angels appliquéd on the tulle appear to float among the letters that repeat "Sing in Exultation," and are strongly reminiscent of medieval illuminations. On the velvet reverse side, golden chorister angels join the heavenly throng. Multi-hued light filters through the layered panels creating new images.

Sing (1987)
Lamé, velvet, metallics, damasks,
machine quilted
157.5 x 115 x 25 cm
Collection: The artist

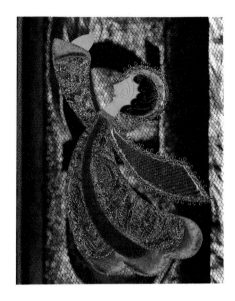

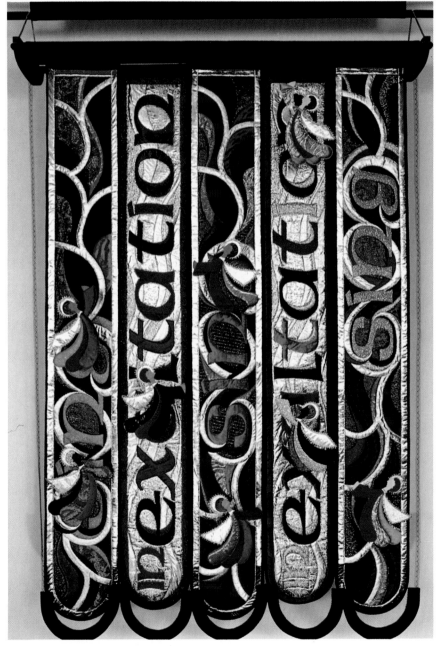

WIKWEMIKONG LITURGICAL VESTMENT CO-OP (Mnidoo Maandaa-Zhichganan), Wikwemikong, Ontario

A unique cooperative venture to create original liturgical vestments was initiated in 1990 on Manitoulin Island in Georgian Bay. Sixteen aspiring artisans in Wikwemikong combined their artistic skills in design and decoration to make chasubles and stoles for the four Roman Catholic churches on the reserve. All incorporate the traditional material of ceremonial dress with native imagination and theology. Enriched with bead work, rabbit fur, partridge feathers or porcupine quills, each piece tells a different story of spirituality and artistic expression. Father David Nazar, the Jesuit pastor on the reserve who initiated the project, says he "could not have foretold the richness of the results. They discovered that in the making of the vestment, they saw themselves."*

A chasuble of white deerskin for festive occasions has a wide border, intricately cut out and enriched with inlaid rhinestones to form a delicately patterned frame. The beaded cross is intersected by overlapping circles from which hang four feathers, beaded in the four traditional colours. The feathers and colours represent spiritual harmony and balance within the self, within all humanity and within all creation.

The natural tanned deerskin chasuble, richly beaded and laced together with cut strips of hide, has a ten-inch fringe (also of cut strips) falling from the lower borders, lending grace and movement to the vestment. The crossed peace pipes, representing prayers rising to God the Creator, are surmounted on a circle of life which contains the four sacred colours and four directions of the compass. The four colours and directions symbolize humanity and creation. The circle holds them together in spiritual harmony and unity, brought about by God's Spirit. The peace pipes are linked by the four sacred feathers. Along the lower edge, both in front and in back, are the distinctive floral patterns for which the Woodland people are renowned.

Father David Nazar and Bev Naokwegijig, Wikwemikong Liturgical Vestment Co-op Photographs by E. Jane Mundy, Waterloo, Ontario

* *Canadian Jesuit Mission* 25, no. 3 (August 1990).

BERNICE AIABENS

Chasuble (1991)

Deerskin with feathers, rhinestones and beads

Collection: Wikwemikong Liturgical Vestment Co-op

(Mnidoo Maandaa-Zhichganan),

Wikwemikong, Ontario

MICHAEL PANGOWISH

Chasuble (1991)

Deerskin with beads, feathers

Collection: Wikwemikong Liturgical Vestment Co-op

(Mnidoo Maandaa-Zhichganan),

Wikwemikong, Ontario

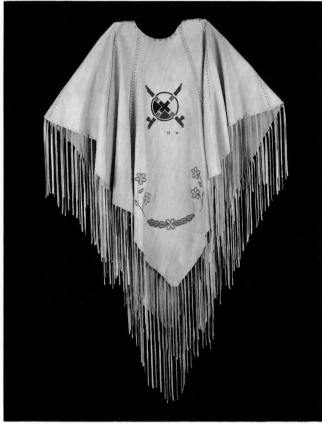

HELEN WATSON Toronto, Ontario

The Word (1974)
Heavy-ribbed cotton, with cotton and felt appliqué,
fringe of wool, felt and cork beads
237 x 79 cm
Collection: Knox College,
Toronto, Ontario

Designed by Sydney H. Watson and translated into fabric by his wife Helen Watson, this bold composition incorporates the ageless symbols of spoken oracles and written scriptures. Vibrant shades of red and blue are placed against a golden background of heavy ribbed Mexican cotton to create a banner ablaze with colour, a striking contrast to the coolness of a richly panelled university chapel.

The Word of God is portrayed as handed down and descending through the Trinity (Father, Son and Holy Spirit); the Old and New Testaments of the Bible; the Ten Commandments given to Moses; and the four Apostles (Matthew, Mark, Luke and John). All are represented by their traditional signs.

MARY VAITIEKUNAS Toronto, Ontario

The Annunciation (1976)
Appliqué with machine stitchery
145 x 72.5 cm
Collection: The artist

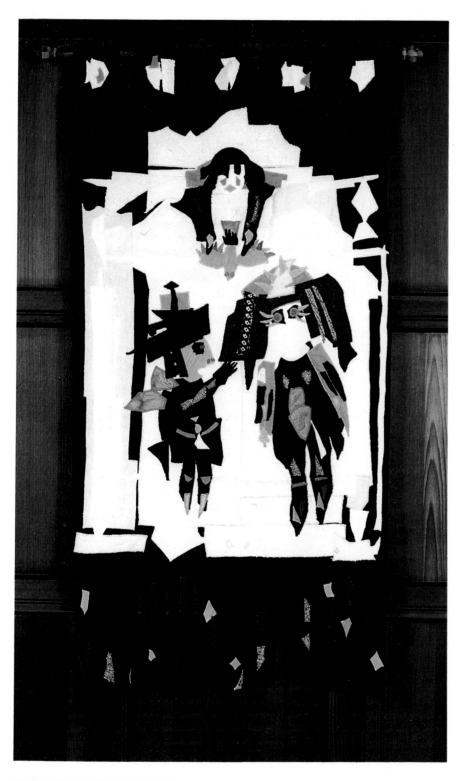

Mary Vaitiekunas's theatrical background is very evident in the many banners she has created. Using simple shapes of cloth, she creates, in her own words, "iconic figures that confront the viewer from their stage settings, like the costumed figures of some primitive ritual." Odd bits and pieces of fabric are machine appliquéd into place, creating scenes that are dramatic and often playful, wonderfully imaginative and usually very colourful.

Here the figure of God the Father, suspended in space, sends down the dove of the Holy Spirit and thus sets the stage for the central focus of a spirited angel, Gabriel, announcing the forthcoming birth of Christ to the Virgin Mary. The subject is unmistakable, and yet conveyed in a manner that is whimsical and touching. One cannot fail to be moved by the depth of feeling that is achieved by the deft manipulation of a few patches of fabric.

Vaitiekunas trained originally in theatre arts and acted both in her native England (whence she emigrated in 1951) and in Canada before turning to fabric art in which she is self-taught.

BARBARA ZIMMER Etobicoke, Ontario

Chasuble (1989)
Handwoven, cotton and linen thread,
gold rayon thread
Collection: Father N.J. Roy,
Britt, Ontario

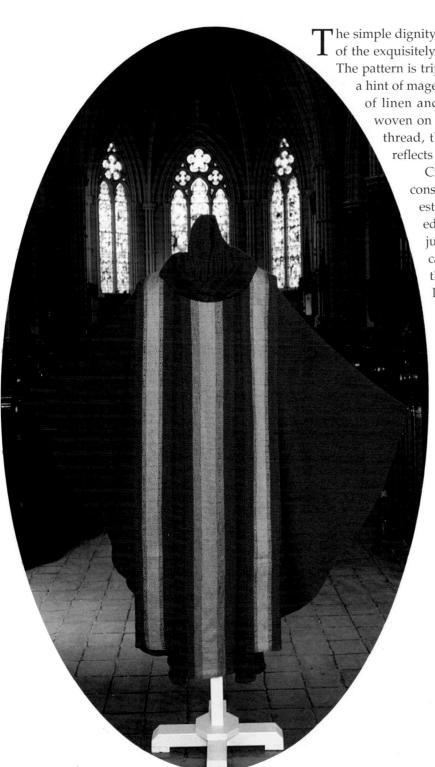

The simple dignity of this chasuble is achieved by virtue of the exquisitely woven fabric from which it is made. The pattern is triple bird's-eye, worked in purple with a hint of magenta, in threads that are a combination of linen and cotton. The stole and orphrey are woven on separate warps including gold rayon thread, thus creating a colour gradation that reflects the light.

Cited for its modest use of material and construction, and for its subtle and interesting colour, this vestment was awarded a prize at the Liturgical Arts Festival juried competition in 1989. Sophisticated but simple, it is a fine example of the ferial garment, an effective work of liturgical art for everyday.

ARTISTS' BIOGRAPHIES

Marie Aiken-Barnes, Aurora, Ontario, was born in Alix, Alberta, and studied at the Vancouver School of Art and at Penn State College and Boston University in the United States. Aiken-Barnes's specialty is lichen dyes. She has conducted workshops, led seminars and given lectures in communities all across Canada on a multitude of fibre-related subjects, including embroidery, primitive interlacement (such as knitting and crocheting), spinny and dyeing, loom and off-loom weaving, macramé, appliqué and creative stitchery. For the Ontario Department of Education she has prepared handbooks on spinny dyes and on simple looms and primitive weaves. Exhibitions in which her work has been displayed include We Among Others, and In Praise of Hands. Commissions hang in the Barrie, Ontario, Court House, as well as Trinity United Church, Gravenhurst, Ontario, where there is a dossal curtain as well as the balcony tapestry.

Marjorie Wathen Aitken, Fredericton, New Brunswick, was born and educated in Montreal. As a child she was one of those chosen from city schools to attend Arthur Lismer's classes at the Montreal Museum of Fine Arts. Since then she has studied with Fritz Brandtner, Brigid Toole Grant and Molly Lamb Bobak. Her fabric banners hang in Saint Thomas' University Chapel, Fredericton, New Brunswick; Veterans' Hospital Chapel, Fredericton, New Brunswick; St. Gertrude's Church, Woodstock, New Brunswick; and St. Andrews by-the-Sea, New Brunswick. She has also done book illustrations, and paints in pastel and watercolours.

Carolyn Beard, Wilberforce, Ontario, was born in Hamilton, Ontario, where she studied at Mohawk College of Applied Arts and Technology and at Sheridan College, School of Design. Her work has been seen in many exhibitions since 1972 when *The Denial* was displayed in Contemporary Church Stitchery and Banners, Trinity United Church, Gravenhurst, Ontario. Commissions include Imbercourt Riding School, Cambridge, Ontario, and St. James' Anglican Church, Dundas, Ontario. Her work has been featured in *Ontario Craft* magazine. Pat Beese, senior lecturer in embroidery at Loughborough College of Art Design in England, discusses Beard's work in her book entitled *Embroidery for the Church*.

Joy Bell, Burlington, Ontario, was born in Sarnia, Ontario, where at an early age her grandmother introduced her to embroidery. Later she studied design and colour at Sheridan College, and attended workshops with Jacqueline Enthoven, Jane Dams, Marie Aiken, Marion Spanjerdt, Constance Howard and Pat Russell. The Baptist Convention, 1979, commissioned a set of six banners to be based on the theme of caring. The previous year the Baptist Convention had commissioned six banners based on the Parable of the Sower. James Street Baptist Church in Hamilton has commissioned numerous hangings, including *The Reaper* which was exhibited in Create & Celebrate, 1978, at Grace Church on-the-Hill, Toronto. A Trinity frontal and antependium hang in Lonteglos, Cornwall, England, and *The Song of Solomon* is privately owned. Recently the artist has concentrated on stoles designed for women. In The Pas, Manitoba, the Cree medicine woman Irene Young (Badger Woman and the One who Walks with a Rock) requested the artist to design and work four ceremonial dresses for her and two ribbon shirts for her husband, Joseph (White Bear).

L. Claire Bird, Halifax, Nova Scotia, was born in Halifax. She is a graduate of Nova Scotia Teacher's College; Nova Scotia College of Art and Design; Commercial Art, N.S.C.A.; and Book Binding at Columbia University, New York. She has published a series of embroidery lessons for Nova Scotia continuing education. Commissions for ecclesiastical embroidery have been completed for churches in Halifax, Yarmouth, Sherbrooke, Bridgewater and Karsdale, Nova Scotia. She has lectured and given demonstrations at several churches.

Anne Boyle, Belleville, Ontario, was born in London, Ontario, and graduated from Queen's University where she studied art with André Biéler and George Swinton. Though she is mainly self-taught in fibre art, she has attended numerous workshops led by Helen Fitzgerald, Sybil Rampen, Betty MacGregor, Victor Tinkl, Marion Spanjerdt and others. She has exhibited widely across eastern and Southern Ontario since 1966, and has been awarded honourable mention upon several occasions. In the 1960s Boyle designed and created sets and costumes for the Belleville Theatre Guild, and in the 1970s for the Quinte Dance Centre. The City of Belleville commissioned the artist to create a cultural prize in 1981, and in August 1990 the city presented their twin city, Lahr, Germany, with a banner commissioned of Boyle.

Winifrede W.R. Burry, Toronto, Ontario, is recognized internationally for her quilts, which incorporate the designs of native artists Jackson Beardy, Norval Morriseau and Carl

Ray, with their permission. She has displayed her quilts recently in invitational exhibitions in San Francisco and other U.S. cities, Denmark and Austria as well as many cities in Canada. She has also given lectures and workshops in Britain, the United States and Canada. Burry's recent work incorporates the natural beauty of Canada's Northland, Christian symbolism and native mysticism. In 1992 she was awarded Judge's Commendation for *Distant Dreams* at Quilt Expo Europa III in The Hague, the Netherlands.

Lee Clifton, Oakville, Ontario, was born in Toronto where he attended Western Technical School. He has worked as an illustrator and designer for various art studios. Banners have been designed for Chartwell Baptist Church and Central Baptist Church in Oakville, as well as a mural in First Baptist Place. His commissions are many and include a set of sixty antique car paintings for Firestone of Canada. He has participated in U.S. collector plate shows.

Martha Cole, Disley, Saskatchewan, began early with drawing courses, attended high school in Regina, then completed her B.F.A. at the University of Washington, Seattle, followed by a Bachelor of Education at the University of Toronto. Drawing courses at the Ontario College of Art, Toronto, and many seminars and workshops in machine embroidery, painting and dyeing, rug hooking, and manipulation of fabric, mostly sponsored by the Regina Stitchery Guild, have been pursued, as well as calligraphy. Since 1975 Cole has been a self-employed artist, concentrating on commissioned fibre pieces and exhibitions. She is an instructor in the Extension Department, Fine Arts and Humanities, University of Regina. She has both written and been the subject of many papers and publications, has exhibited widely in western Canada and has been the recipient of fellowships and awards. Her fabric collages may be seen in many public buildings in Saskatchewan, Ontario, Quebec and in China.

Karen Colenbrander, Mississauga, Ontario, was born in Halifax, Nova Scotia. After two years of study in science at McMaster University, she attended Sheridan College School of Crafts and Design in Oakville, concentrating on design for embroidery. In 1991 she earned a diploma in lay ministry from Wycliffe College, Toronto. In the same year she participated in the production of a set of nine cushions which were presented by the Diocese of Toronto to the Diocese of Korea. Commissions include a memorial wall hanging for St. Paul's Church, Lorne Park, and four stoles for the Anglican Diocese of Toronto. She has exhibited with the Oakville Stitchery Guild; in Alleluia, at Christ's Church Cathedral, Hamilton; and in the Liturgical Arts Festival, St. James' Cathedral, Toronto, 1989.

Jane Dams, Georgetown, Ontario, was born in England and came to Canada at the age of two. In 1969 she won the Canadian National Exhibition Award for Mural Design. After working as a commercial artist in Canada, Dams left for England in 1971 to study textile design, specializing in embroidery and fabric design at Bournville School of Art and Birmingham Polytechnic. She is certified in advanced embroidery. She has exhibited widely in Canada, had a notable one-woman show at Shaw-Rimmington Gallery in Toronto, 1975, and is represented in private collections in Canada and the U.S.A. In 1980 Dams was nominated for the Bronfman award. She has lectured and led many workshops across Canada and the United States, and has been much involved in the artist-in-residence program for schools through the Ontario Arts Council. She is a member of the Ontario Crafts Council, and past member of the Board of Directors, Embroidery Association of Canada.

Sylvia Denny, Eskasoni, Cape Breton Island, Nova Scotia, was born in Eskasoni. A graduate of cooking school, she has organized bake sales to benefit her church, Holy Family Parish. In recent years she has developed her artistic skills. In addition to designing vestments for her church, she has convened a number of craft sales, making many of the leather and beaded works herself. She is truly a dedicated and committed church woman, much loved and respected in her community.

Ivy Draper, Montreal, Quebec, was born in Montreal. Her creative achievements can be traced back to a first prize won at the Canadian National Exhibition at age ten. Banners have been designed and made for the Griffith-McConnell Home for the Elderly, the Côte-des-Neiges Council of Churches and the Mount Royal United Church, where she worked with a group of stitchers to complete the *Thanksgiving Banner* and created the magnificent *Nativity*, eleven of the twelve disciple banners and *The Last Supper* wall hanging. All of Draper's pieces are made from recycled clothing acquired from rummage sales and from friends. She gives herself freely to this work with a sense of dedication and of joy.

Flo Dutka, Ardrossan, Alberta, was born in Saskatoon, Saskatchewan, and received a Diploma in Design Fibre Arts, 1983, from Grant MacEwan College in Edmonton, after having studied needle arts through many seminars, workshops and personal exploration. She has taught and has led workshops for many years and was co-founder of the Lakeshore Creative Stitchery Guild in Montreal and of the Edmonton Needlecraft Guild. Dutka is affiliated with the Embroiderers' Guild of London, England; the National Standards Council American Embroiderers; Embroiderers' Association of Canada; and the Alberta Crafts Council. She has exhibited widely in Canada, the United States and Europe, and is represented in numerous private and public collections, as well as churches that have commissioned her work.

Helen Fitzgerald, King, Ontario, was born in Edmonton, and has lived primarily in Toronto. She studied in classes at the Art Gallery of Ontario with instructors from the Group of Seven, including Arthur Lismer, and with Doris McCarthy. Upon graduation in 1940 she received the Governor General's Award. She also studied at the Ontario College of Art; Art Students' League in New York; and the Embroiderers' Guild, London, England. Fitzgerald has worked as a layout artist, calligrapher and graphic designer. She has exhibited paintings with the Royal Canadian Academy and the Ontario Society of Artists and for many years was on the staff of the Ontario College of Art. For the past twenty-five years her career has focused on textile arts. She has exhibited her work in numerous exhibitions, including Embroiderers' Guild Golden Jubilee Open Exhibition, London, England; Craftsmen of Ontario '67, Dartmouth University, Hanover, N.H. (Award); *Entr'acte*, Canadian Guild of Crafts, O'Keefe Centre, Toronto; travelling exhibitions in Toronto, London, Hamilton and St. Catharines; and a one-woman show, Ad Gloriam Dei, Brampton, Ontario. This distinguished artist resides in King City where she has her studio. She has designed and executed seventeen major ecclesiastical commissions. Her colour combinations, striking design and superb craftsmanship and textile compositions demonstrate a sensitive response to setting and a thoughtful interpretation of Christian themes.

Ottilie Fodor, Montreal, Quebec, was born in Montreal, and attended McGill University, graduating B.A., 1958. She also studied at the London School of Art and Design, costume design, 1960; at Concordia University she received her B.F.A. in 1989. Fodor has exhibited at Galerie Arts Sutton, in Sutton, Quebec, 1982; in Fibre Show at Concordia University, 1988; and at Centre International de Design, Montreal, 1989. In recent years the artist has moved away from weaving and now works mainly in printing (silkscreen) and in dyeing and batik on canvas and cotton. She teaches printing on textiles at L'Atelier d'Artisanat du Centre-Ville in Montreal.

Friedel, Peterborough, Ontario, who goes by her first name only, was born in Regensburg, West Germany, where she received her training in spinning and weaving at Textilfachschule at Moenchberg. She moved to Canada in 1954 and has lived in Peterborough since 1970. Further training in weaving was pursued at Central Technical School, Toronto; at Haliburton School of Fine Arts, Haliburton; and in Munich and Sindelfingen, West Germany. Friedel has taught in Peterborough and in Nantucket, and was artist-in-residence at Trent University, Peterborough, 1974–75. She has exhibited extensively in group and solo exhibitions, most recently in the summer of 1991 when her work was shown in Regensburg, her home town, and in Munich. Her tapestries have been commissioned in Montreal, Peterborough and Toronto, and her work is represented in private collections in Canada, U.S.A., Austria, Ireland, Holland, Sweden, West Germany and Colombia. She has been the subject of many articles and reviews, as well as radio and television interviews and a video.

Temma Gentles, Toronto, Ontario, has a Master's degree in English and Russian, and a Bachelor of Education, both from the University of Toronto. An associate of the Ontario College of Art, with concentration in design and multimedia print, she enjoys working in the large spaces of contemporary architecture, particularly where there is an interesting play of light and shadow. She is drawn to intimacy and intensity of religious motifs and to the people for whom these have meaning. Since 1967 she has received many awards, including an honour's award from the American Institute of Architects for the *Temple Emanu-El Wedding Canopy*. Her work has been shown in many exhibitions in Canada and the United States, and since 1976 she has received many commissions for Judaic ceremonial objects. She has also designed and executed secular pieces for public buildings, including window panels for McDonald's restaurant on University Avenue, Toronto. Gentles is a co-founder of the Pomegranate Guild of Judaic Needlework, Toronto;

she developed and coordinated the *sukkah* project completed by them in 1988. She is a member of the Awards Committee of the Ontario Crafts Council.

Pam Godderis, Calgary, Alberta, was born in Taylor, Texas. A graduate of the University of Calgary (B.Ed.), 1969, she is a practising fibre artist, involved in regional, national and international exhibiting, commissioned art and jurying. She is a freelance teacher and lecturer in art education and fibre art, and has worked with numerous stitchery guilds in Canada and the U.S.A. Her work has been exhibited widely, and is represented in private collections and in churches in Canada, the U.S.A. and Japan. She has written for publications on stitchery and has received the Alberta Achievement Award, Excellence Category, for Outstanding Achievement in Fibre Arts, Government of Alberta, 1988, and Director's Award, Needle Expressions, Council of American Embroiders (CAE), 1986.

Audrey Gill Grantham, Waterdown, Ontario, was born in the United Kingdom where she received her technical training in stitchery. She went on to study art history and later theology at McMaster University, Hamilton, Ontario. Her work has been commissioned by many churches in the Niagara area and abroad. She has authored several reviews and articles on liturgical art-related subjects and has exhibited widely.

Dorothy Gregson, Dundas, Ontario, was born in England where she received her early training. In Canada she studied art and design at the Dundas Valley School of Art, Sheridan College, and Mohawk College. She has taught and led workshops in design, creative embroidery and related textile arts, and contributed to *New Life: Addressing Change in the Church,* for the sesquicentennial celebration of St. James' Anglican Church, Dundas (Toronto: Anglican Book Centre, 1989). Articles on her work have appeared in several Canadian newspapers and journals, and her designs are illustrated in Pat Beese's *Embroidery for the Church* (1975). Her commissions in the Niagara region are extensive and include a set of six superfrontals for St. Matthias Church, Guelph; altar frontals for St. James' Anglican Church, Dundas; St. Alban the Martyr, Hamilton; Grace Church, St. Catharines; St. Alban, Beamsville; as well as vestments for the Bishop of Niagara, the Bishop of Toronto, the Bishop of Kootenay and the Bishop of Ottawa; banners for McMaster University; and a funeral pall and hanging for Church of the Guardian Angels, Lantana, Florida. In 1988 St. James' Anglican Church, Dundas, held a solo exhibition of her work.

Catherine Hale, Fredericton, New Brunswick, was born in Fredericton and still lives and works in that city. She studied with Fritz Brandtner and Lucy Jarvis at the University of New Brunswick. Since 1973 she has presented over twenty-one solo exhibits in the Maritimes, Ontario and Maine. Her work has also been included in an extensive list of group shows. Hale is very active in the Fredericton arts community. She has contributed time to many events and organizations, acting as juror, chairperson, organizer and member. She was a founding member of Gallery Connexion, a nonprofit artist-run centre in Fredericton.

Willem Hart, Toronto, Ontario, was born in the Netherlands, and came to Toronto with his parents in 1953. He graduated from the Ontario College of Art in advertising design in 1959; he is today a corporate communications designer and consultant. As an artist he has exhibited in group and one-man shows at local galleries and churches, including Harbourfront Gallery; Liturgical Arts Festival, St. James' Cathedral, Toronto, 1989; Art Credo, at St. Joan of Arc Church, 1990; and Grace Christian Reformed Church. His specialty, pen and ink drawings of old buildings, has won him numerous commissions for corporations, educational institutions and private individuals. Other media include tissue collage, acrylic painting in high realist style, as well as the crafts of jewellery design and silversmithing. Hart has been an ardent supporter of the arts, including the Mississauga Symphony, the Foundation for Coast to Coast Opera Publications (Opera Canada) and the Patmos Gallery. Among Hart's professional awards are Awards of Merit from the Toronto and Montreal Art Director's Clubs, the Printing Industries of America the International Typographic Association, Time-Life and *Newsweek*.

Lewis Hindle, Toronto, Ontario, studied art in San Miguel in Mexico. Although he has worked in metal sculpture, he is recognized chiefly in Southern Ontario for his contemporary banners which relate the stories of the Bible in the medium of fabric. In May 1975 the Metropolitan United Church, Toronto, held an exhibition of his recent work, and in the same year Timothy Eaton Memorial Church, Toronto, displayed his banners. During this period he led workshops in Orillia and Toronto. The Patmos Gallery was featured in

the May 1976 issue of *Presbyterian Record* with Hindle's banner *Spirit Bird* reproduced in colour on the cover. A selection of his banners was exhibited at Grace Church on-the-Hill in June 1976, and in June 1978 his splendid triptych *Hymn to the Sun* was included in Create & Celebrate '78. Commissioned works hang in the Anglican Church of Our Saviour, Don Mills, and in Parkdale United Church, Toronto.

Liz Hodgkinson, Westbank, British Columbia, was born in Winnipeg, Manitoba, and graduated in 1977 with honours from the Ontario College of Art and in 1982 from Guelph University with a B.A. in Fine Art. Her woven vestments, paraments and hangings are to be found in a number of churches in Ontario. Other commissioned tapestries hang in the Toronto-Dominion Tower and at Bell Canada. Her work has been on exhibition at the Ontario Crafts Council, Harbourfront, St. James' Cathedral, Toronto, and Christ's Church Cathedral, Hamilton.

Diane V. James, Edmonton, Alberta, has a Bachelor of Science from the State University of New York. She has studied art at New Paltz, New York, and currently is taking a Bachelor of Fine Arts program at the Kansas City Art Institute, Kansas City, Missouri. She has exhibited her work in Kansas City; St. Albert, Alberta; St. James' Cathedral, Toronto; and at the Provincial Museum of Alberta in Edmonton. Publications in which her work has been featured are *Needle Arts* (1987), *Embroidery Canada* (Nov. 1985) and *Visual Arts Newsletter, Alberta Culture* (Dec. 1984). James has also undertaken commissions for Strathcona Baptist Church, Edmonton; Edmonton General Hospital; and Steinhauer United Church, Edmonton.

Connie Jefferess, London, Ontario, was assistant head of the Art Department of H.B. Beal Secondary School in London, Ontario, for twenty-four years. In 1976 she spent the summer studying weaving techniques in England and Finland. Her textile work has appeared in group shows and solo exhibitions, including the Ontario Crafts Council Gallery in Toronto.

Susan Judah, Fredericton, New Brunswick, was born in England where she studied at the Hereford School of Art and the Royal College of Art, London, England, receiving the diploma Designer, Royal College of Art. She has been employed both as a designer and as a teacher in New York, London and Jamaica. Since 1980 she has taught in Fredericton and is studio head of textiles and weaving at the New Brunswick Craft School and Centre and also at the Textile Design Workshop, University of New Brunswick. Since 1972 Judah has been actively involved with many art-related activities with the Jamaican Government, the New Brunswick Crafts Council and Fibre Art Guilds. She has served as an advisor to the Building and Interior Committees at Sts. John and Paul Church. In 1989 she attended the International Tapestry Symposium (invitational) in Graz, Austria, and the Plein-Air-Meeting with the Central Union of Polish Artists in Lotz, Poland, in 1990. A slide presentation (invitational) for the British Tapestry Symposium took her to Morley College, London. She is a member of the British New Fibre Art Guild; a board member of the New Brunswick Crafts Council; and was elected academician for the Royal Canadian Academy of Arts. Since 1969 her work has been exhibited in Kingston, Jamaica; Fredericton, New Brunswick; Austria; and Poland. Commissions and awards have been numerous. Her work has appeared in many publications.

Sue Krivel, Downsview, Ontario, moved from Western Canada to Toronto in 1982. She attended Sheridan College and the Koffler Centre for the Arts. Her work has been displayed in numerous exhibitions in Toronto and Los Angeles, and may be found in synagogues and private collections in Canada, the U.S.A. and Israel. As well as her liturgical work, she has designed banners, doll-like figures and three-dimensional fabric constructions.

Norman Laliberté, Nahant, Massachusetts, was born in Worcester, Massachusetts, of French-Canadian parents and raised in Montreal. He studied at the Montreal Museum of Fine Arts; the Institute of Technology, Institute of Design, Chicago; and the Cranbrook Academy of Arts, Bloomfield, Illinois. His teaching career took him to Kansas City Art Institute; St. Mary's College, Notre Dame, South Bend, Indiana; Rhode Island School of Design; and Newton College, Newton, Massachusetts, and others. He has authored and assisted on numerous publications, one of the best known being *Banners and Hangings*, with Sterling McIlhany for Reinhold, New York, 1966. His work has been exhibited widely throughout the world since 1952, and is owned privately and in corporate and public collections in the United States and Canada. Though his banners, which

have been commissioned in the thousands, relate most directly to the subject of this book, it should be noted that he is equally distinguished for his paintings, drawings, wooden images, prints and murals, as well as for posters and film design.

Barbara V. LeSueur, Port Hope, Ontario, was born in New York City and earned her B.A. at Wellesley College, Wellesley, Massachusetts. She is the founding president of the Toronto Guild of Stitchery and was also president, 1982–84, of the Embroiderers' Association of Canada. *Going Forth,* made by LeSueur and Carol Neal, was a winner in the fiftieth anniversary United Church of Canada banner competition in 1975. This exhibition later travelled across Canada and the U.S.A. In 1976 Trinity College School, Port Hope, commissioned a banner for the school chapel, and in 1980 she made for the Toronto School of Theology a banner entitled *Doorways of the Schools of Theology, University of Toronto.*

Elizabeth Duggan Litch, Elora, Ontario, was born in Toronto. In 1962 she graduated from nursing at Toronto's East General Hospital. She studied design for embroidery, liturgical embroidery, gold work and banner making under Jane Dams at Sheridan College, and under Constance Howard and Marion Spanjerdt at Brescia College. She took drawing with Nan Hogg in Guelph and surface stitchery with Jo Moore of Tuscon, Arizona. Litch has exhibited in Threadworks at the Wellington County Museum, 1987; was an invited artist to Painting on the Green, Guelph, 1986; and participated in the Liturgical Arts Festival, St. James' Cathedral, Toronto, 1989. Her commissions are many: large backdrop behind choir and orchestra, Elora Festival, 1990; celebration cope for Fred Etherdin, St. James' Cathedral, Toronto; and many banners and an altar frontal for St. John the Evangelist, Elora. She has been an active member and president of the Canadian Embroiderers' Guild, Guelph, and is the midwest regional director of the Ontario Crafts Council.

Evelyn N. Longard, Halifax, Nova Scotia, was born in Halifax. She is a Master Weaver (Shuttlecraft Guild, Senior Weaver's Certificate), Guild of Canadian Weavers. She has a diploma from Nova Scotia College of Art and has attended special classes in embroidery at NSCA and Embroiderers' Guild, London, England. An M.A. in Chemistry and A.R.C.T. in organ, she is an associate, Trinity College, London. Longard's work has appeared in many exhibitions during the past forty years, most notably at Gravenhurst,

1970; Western Springs, Illinois; National Gallery of Canada, 1967 (invitational); Ars Sacra, St. Mary's Gallery, 1977; and Entr'Acte travelling exhibition. She has been a demonstrator of weaving at various seminars. She is associate editor (multiple harness weaving) for *Shuttlecraft Magazine.* Vestments and hangings have been commissioned across Canada.

Betty MacGregor, Mississauga, Ontario, has exhibited and received awards throughout Canada for her hand-painted silks since 1979. Her works are included in the Massey Foundation permanent collection, which is housed in the Museum of Civilization, Hull, Quebec; Timothy Eaton Memorial Church; Erindale United Church; and private collections. She has also taught silk painting, quilting and related techniques to guilds and at conferences in Canada since 1976. She teaches at Visual Arts, Mississauga.

Doris McCarthy, Scarborough, Ontario, was born in Calgary, Alberta, and grew up in the Beach area of east Toronto. Arthur Lismer, member of the Group of Seven, recognized her talent while she was a student in his art classes for high school students at the Ontario College of Art. In 1926 the fifteen-year-old McCarthy was awarded a full-time scholarship to the Ontario College of Art. In 1932 she joined the art department of Central Technical School in Toronto where she taught for four decades. Throughout her career she has been active in the professional societies of artists, as a member and as an officer of the Ontario Society of Artists, the Royal Canadian Academy, and the Canadian Society of Painters in Water Colour. McCarthy is primarily a landscape painter in oil and watercolour who has worked across Canada for many years on the Gaspé coast, extensively in the High Arctic, in western Canada both in the mountains and the Alberta Badlands, as well as in Ontario. In 1983 McCarthy was named Woman Artist of the Year; in 1987 she was invested as a member of the Order of Canada for her lifetime commitment to Canadian art in the community; and in 1992 she was honoured with the Order of Ontario. She has been the subject of an award-winning film, *Doris McCarthy, Heart of a Painter,* and her two-volume autobiography, *A Fool in Paradise: An Artist's Early Life,* and *The Good Wine: An Artist Comes of Age,* published by Macfarlane Walter and Ross, Toronto, in 1990 and 1991, respectively, has been widely acclaimed. In 1989 she graduated from the University of Toronto with an Hons. B.A. in Literature. A travelling retrospective exhibition of her work, Feast of Incarnation, Painting 1929–1989, and an exhibition of new

works at the Wynick/Tuck Gallery were both launched in 1991. She lives today at "Fool's Paradise" in Scarborough, Ontario, her home for over forty years.

Betty McLeod, London, Ontario, has belonged to the Canadian Embroiderers' Guild since its inception twenty years ago. She studied art at H.B. Beal Secondary School in London, Ontario, and has taken workshops over the years with the Canadian Embroiderers' Guild. McLeod has exhibited with the National Standards Council; American Embroiderers' Guild, 1974; Beal Art (a travelling exhibition); Wearable Art, London Art Gallery; and in the Canadian Embroiderers' Guild's 10th, 15th and 20th-anniversary exhibitions. She was awarded Best of Show for design at the Blyth Festival, 1991. She has designed and sewn many copes, clothes, coats, kneelers, and soft sculpture, as well as a pall for the Royal Canadian Mounted Police in Ottawa, 1990. Her work is represented in collections in Canada and the United States and at St. George's Cathedral in Jerusalem.

Lucy McNeill, Fredericton, New Brunswick, is largely self-taught with the guidance of her grandmother. In 1980 a solo exhibition, Festival of the Arts, was held at Christ Church Cathedral, Fredericton. The *Festal Stole* won first prize in Arts Atlantic, an exhibition of crafts from the four Atlantic provinces sponsored by the Canadian Crafts Council. McNeill has published *Sanctuary Linens* (1st ed., 1957; 2nd ed., 1974, Anglican Book Centre), and she has written articles for *Embroidery Canada*. There have been more than a hundred commissions for banners, stoles, frontals and matching pieces and vestments. She has taught many women techniques of stitchery and embroidery, and has acted as a consultant to clergy and lay people on materials, design and symbolism. McNeill is a highly esteemed and much-loved parishioner and resource person of Christ Church Cathedral, Fredericton.

Dini Moes, Peterborough, Ontario, was born in the Netherlands where she received her degree in textiles at the College of Industrial Textiles. In Canada, 1972–75, she completed her Comprehensive Weaving Instructors Course, North Bay, Ontario. She is a Master Weaver, Weavers' Guild of Boston, 1977; a Master Weaver, Guild of Canadian Weavers, 1977; and earned a Certificate of Excellence in Handweaving, Handweavers Guild of America, 1978. For the past eighteen years Moes has been a weaving instructor,

workshop leader, exhibition coordinator, juror and resource person in Canada and the United States. She is a board member, Handweavers Guild of America. In 1978 and 1984 the Guild of Canadian Weavers awarded her the Ethel Henderson Scholarship. Numerous honours in Canada and the U.S.A. include awards from the Ontario Crafts Council, Aetna Casualty Life Insurance Co., Nilus Leclerc Inc., and the Ontario Handweavers/Spinners. Her works are to be found in the Jack Lenor Larsen Design Studio, New York City; the Massey Foundation Collection of Contemporary Canadian Crafts in the Museum of Civilization, Hull, Canada. She contributes to many publications, including *The Weavers Journal*, a U.S. publication; *Heddle*, a Canadian publication for spinners and weavers; and *Shuttle, Spindle and Dyepot*, published by the Handweavers Guild of America Inc., for which she is a regular columnist.

Jessie Oonark (1906–1985), Baker Lake, N.W.T., is probably the best known of the Baker Lake artists. She participated in numerous exhibitions, group and solo, and illustrated several books. Included in her many commissions is a large wall hanging in the National Arts Centre, Ottawa. One of her hangings was presented to Queen Elizabeth in 1973. In 1974 she was awarded Best of Show for her hanging in the Crafts from Arctic Canada exhibition. In 1975 she became a member of the Royal Canadian Academy, and in 1977 an honorary member of the Canadian Crafts Council. She was an Officer of the Order of Canada. Of her eight children, three are professional artists in their own right: Janet Kigusiuq, William Noah and Nancy Pukingrnak.

Karen Madsen Pascal, Markham, Ontario, studied fine arts at University of Toronto's Trinity College, transferring after two years to the University of Michigan where she obtained her degree majoring in theatre and television production. Upon graduation in 1968, Pascal moved to Montreal where she established herself as an artist. As she explored the mediums of metal sculpture and fabric collage, her work gained national and international acclaim. Awarded the Brucebo Foundation Scholarship in 1972, she pursued her artistic studies and experiments in Sweden. In the years that followed, Pascal developed a strong distinctive style, pioneering in the field of fabric art and achieving full recognition in ten one-woman shows across Canada. Today, her fabric collages can be seen in public buildings and private collections throughout North America. In 1978 Pascal moved into television production, forming her own

production company, Windborne Productions, and just three years later producing dozens of successful films and television productions in both French and English. Now president of Tricord Film & Television Corporation, Pascal is headed into the 1990s "with a firm commitment to entertain audiences with delightful original stories rich in creativity and executed with an excellence and care that maximizes the production values on the screen."

Nancy-Lou Patterson, Waterloo, Ontario, was born in Worcester, Massachusetts, and grew up in southern Illinois. She majored in fine arts with a minor in paleontology at the University of Washington, Seattle. There she began her professional life as a scientific illustrator, which led to her first liturgical commission, an illuminated manuscript, followed by sculptures for churches. Soon after moving to Canada in 1962, she was commissioned to create stained-glass windows for a Mennonite chapel at the University of Waterloo. This led her directly to research in the field of Mennonite art on which she became an authority, publishing several books on the subject, most notably *Mennonite Traditional Art in the Waterloo Region* (Ottawa: National Museum of Man, 1979). Another important publication is her earlier *Canadian Native Art* (Toronto: Collier-Macmillan, 1973), a classic. Patterson has also distinguished herself as a poet, a novelist and a superb illustrator, especially of her own charming fairy tale *Apple Staff and Silver Crown* (Erin: The Porcupine's Quill, 1985). Among her greatest artistic contributions have been the numerous liturgical banners, hangings and paraments that may be found in churches and collections in Canada, the U.S.A. and England. One of the earliest exhibitions of contemporary religious art, Liturgical Artists of Ontario, was organized by Patterson at the University of Waterloo. She is unquestionably one of Canada's leading textile artists. She has contributed enormously to the field of liturgical art, both through exhibitions of her own work and through the encouragment she has offered to others. While juggling all of these artistic endeavours, she has continued throughout her career to teach fine arts at the university level. In fact, she established the Fine Arts Department at the University of Waterloo, where she continues to distinquish herself as a professor of fine arts.

Gwendolen Perkins, Waterloo, Ontario, born in London, England, has spent most of her life in Canada. Taught by her mother from an early age, she later studied with the Embroiderers' Guild in London, England, notably with

Constance Howard and Pat Russell. She was the founder of the Canadian Embroiderers' Guild, London, Ontario, and has received numerous commissions for her work in Southern Ontario, Quebec and the United States. She is a member of and holds a diploma from the National Standards Council of American Embroidery.

The Pomegranate Guild of Judaic Needlework, Toronto Chapter, was formed in 1982 "in response to a growing interest in learning about and making textile objects for use in Jewish ceremonies and life cycle events. Our membership represents men and women from the Orthodox, Conservative, and Reform movements. Our name is inspired by the biblical verses: `And they made upon the hem of the [high priest's] robe pomegranates of blue and purple, and scarlet and twined linen ... and put bells around between the pomegranates'" (Exod. 39:24–5). The guild's membership spans the whole Jewish community, but they meet and work at Holy Blossom Temple, Toronto. A full list of the guild members who created the *sukkah* installation may be found in the catalogue for the inaugural exhibition in Toronto, 1988.

Anne-Jean Poussart, Quebec City, Quebec, was born and educated in France. She has lived in Quebec City since 1952. In 1960 she became a weaver and has participated in many exhibitions since that time. She is a member of Corporation des Artisans (Quebec). Her work was exhibited in Convergence '86: A Fibre Spectrum, Toronto, 1986. She is a member of the Handweavers Guild of America and has taught weaving for ten years.

Sybil Rampen, Oakville, Ontario, grew up in Trafalgar Township, received her degree in art and archaeology at the University of Toronto, 1951, then pursued studies in Paris at La Grande Chaumière and in London at Camberwell School of Arts and Crafts. In London, Martin Bloch, German expressionist and colourist, had a great influence on Rampen's development as an artist. A year at the Ontario College of Education qualified her as an "art specialist." In 1972 Rampen studied creative embroidery with Constance Howard at Sheridan College. Since then she has participated in and led many workshops in embroidery, fibre art, wearable art, and colour and design in Canada and the U.S.A. In 1988 she turned to printmaking. Her Joshua Creek Studio in Oakville, established in 1977, has become a meeting place for stitchers and artists alike. Rampen has produced several publications and has exhibited in many shows and galleries

since 1974, her most recent being a one-woman show, Audience of One: An Exhibition of Paintings, Prints and Fibre Art, held in 1990 at Oakville Galleries.

Heather Reeves (Pocius), St. John's, Newfoundland, was born in Perth, Western Australia. She attended Western Australian College of Advanced Education (now Edith Cowan University), 1967–69, and Western Australian Institute of Technology (now Curtin University) until 1972. In 1985 she attended the University of Delaware, Newark, Delaware. Reeves has exhibited in the Maritimes and Toronto since 1986 and has completed commissions for banners and vestments in churches and schools in Newfoundland. Four provincial banners and seventy large hangings created a"liturgical space" for the Atlantic Liturgical Congress held in St. John's, 1987. Reeves teaches visual arts to secondary school students in St. John's.

Erica Laurie Richardson, Stratford, Ontario, was born in Ottawa, where she graduated from the Vocational Art Programme, High School of Commerce, in 1972. She worked as a graphic artist and illustrator at the National Museum of Man, Ottawa, before going into theatre. Upon completion of a three-year program in scenic and costume design at the National Theatre School of Canada in Montreal, 1978, she moved to Stratford where from 1979 to 1985 she worked as a dyer and costume painter for over seventy productions. Since 1985 she has operated No. 1 Brush studio in Stratford, painting theatrical fabric and costumes. Productions include *Alice,* and *Daphnis and Chloe* for National Ballet of Canada; *The Mikado,* Stratford Festival, Brian Macdonald Productions; and both Toronto and Canadian touring productions of *Cats* and *The Phantom of the Opera.* Richardson has also done work for productions for the National Arts Centre, the Grand Theatre in London and the Calgary Arts Centre. She has taught workshops in costume painting and dyeing for the National Theatre School and the Association of Canadian Film Craftsmen, as well as children's classes in drawing and painting. Her drawings have been exhibited at the Gallery Stratford and Gallery 96.

Diane Robinson, London, Ontario, is primarily self-taught. She has attended summer workshops with Constance Howard, Pat Russell, Carole Sabiston, Helen Fitzgerald and others. She works mainly in the quilting technique. She has exhibited in London, Hamilton and Toronto. Her commissions hang at Westminster College, University of Western Ontario, London; at St. James' Westminster Anglican Church, London, Ontario; as well as in many private collections as far afield as Seoul, Korea.

Mae Runions, Vancouver, British Columbia, was born in Claresholm, Alberta, and studied at the University of Alberta, Edmonton; Langara College, Vancouver; and the University of British Columbia, Vancouver. Solo exhibitions have been held at Regent College, UBC, in 1989–90; the Gateway Theatre, Richmond, British Columbia, 1990; and the Queen Elizabeth Theatre in Vancouver, 1991. Her commissions are to be seen in Regent College, UBC; Granville Chapel, Vancouver; and the Eastern College in Philadelphia, U.S.A.

Carole Sabiston, Vancouver, British Columbia, is a graduate in fine arts from the universities of Victoria and British Columbia. Over the past fifteen years, she has exhibited in solo exhibitions across Canada, from Memorial University, Newfoundland, to the Art Gallery of Greater Victoria. She has been equally well represented in group exhibitions since 1967 in Canada and in England. In 1991 she received a commission to design an international textiles wall hanging project for volunteers to work on for the 1994 Commonwealth Games in Victoria. More than twenty-four major commissions have been completed in Canada, Panama, Central America, England and Spain. She was the 1987 recipient of the Saidye Bronfman Award for Excellence in Craft ($20,000); she was elected to the Royal Canadian Academy in the same year. She has also received awards for the University of Victoria Invitational Competition, Theatre Curtain Design, in 1981, and a Canada Council Travel Grant in 1980. Sabiston has been recognized throughout Canada and abroad for her excellence as a fibre artist, and has received honours and appointments too numerous to mention here. She has contributed to her field as a teacher and designer. Her installations have been the subject of critical essays and reviews, most recently *Celebrating the Stitch* by Barbara Lee Smith (Newton, CT: Taunton Press, 1991). A network television program, "The Art of Carole Sabiston," featured her career and her art in a thirty-minute TV-Ontario video; she was also the subject of a program in a CBC-TV film series entitled "Hand and Eye: Ties That Bind." Most of the artist's work consists of large-scale wall hangings, architectural commissions, and banners for commercial and public buildings and for hospitals. She also enjoys designing theatre sets and costumes.

Susan D. Shantz, Saskatoon, Saskatchewan, was born in Waterloo County, Ontario. She received her B.A. in English from Goshen College, Goshen, Indiana, in 1980; an M.A. in religion and culture from Wilfrid Laurier University, Waterloo, Ontario, in 1985; and an M.F.A. in visual arts, York University, Toronto, in 1987. A solo exhibition entitled Iconic Structures was held at Nancy Poole Studio, Toronto, in 1986. Shantz has also exhibited at the Cathedral of St. John the Divine, New York City, and in numerous public art galleries, and artist-run centres across Canada. Her work may be seen in many public and private collections. She has authored or been featured in several key publications: *From the Great Above She Opened Her Ear to the Great Below*, with Tom Lilburn, poetry (Ilderton, Ontario: Brick Books, 1987); *Quilts of Waterloo County: A Sampling*, with Marjorie Kaethler, 1989; and *The Stations of the Cross: A Calculated Trap?* (London, Ontario: University of Western Ontario, 1991). In 1990 Shantz moved to Saskatoon to take up the position of assistant professor in the Department of Art and Art History, University of Saskatchewan.

Joe Somfay, Fergus, Ontario, architect, was born in Budapest, Hungary. He studied at the University of New South Wales, Sydney, Australia, where he completed his B.Arch., and he received his master of architecture in urban design from the University of Toronto. Somfay has practised architecture in the Kitchener-Waterloo region since 1971, and has achieved national and regional recognition for his outstanding contributions to architecture, urban design, energy conservation and building technology. In 1985 he received the Governor General's Award for *The Squire's Lodge, Rockwood, Ontario*; and in 1988 was honoured with the Canadian Architect Award of Excellence for the Elora Town Hall, Elora, Ontario. Designing the cope that appears in this publication was a unique experience for Somfay. It has been exhibited at Grace Church on-the-Hill, Toronto, 1974, and in the Liturgical Arts Festival, St. James' Cathedral, Toronto, 1989.

Fran Sowton, Toronto, Ontario, has studied design, colour and embroidery both in Canada and in England. Her teachers include Jane Dams (Sheridan College), Marion Spanjerdt, Margaret Hall and Constance Howard (Goldsmiths College), Renata Realini (colour and design), Joy Clucas and Julia Caprara. She has exhibited with the Embroiderers' Assocation of Canada (prize winner, 1982); Oakville Stitchery Guild (prize winner, 1984); Canadian Embroiderers' Guild, London, Ontario, 1986; Faith and the

Imagination, Trinity College, 1987; Threadworks, 1987; and Liturgical Arts Festival, Toronto, 1989. Commissions have included a chasuble, stole and veil for St. James, the American Church of Florence, Italy, 1975; frontal, chasuble and stole for St. James Picadilly, London, England, 1981–82; four frontals, chasubles and many stoles for Church of the Holy Trinity, Toronto; wall hangings for the Catholic Children's Aid; Koffler Gallery Invitational - *Chuppah*. She has lectured and has conducted workshops.

Marion Spanjerdt, Toronto, Ontario, was born in Eindhoven, the Netherlands, where she trained in fashion illustration and graphic design at the College of Applied Art and Technology in Rotterdam, after which she studied at the Royal College of Art and Design in s'Hertogenbosch. She emigrated to Canada in 1970. A strong interest in fabric and colour led her to develop techniques and designs for fabric collage and machine embroidery to produce banners, wall panels and embellished clothing. Since 1976 she has given workshops throughout Canada and the U.S.A. and has spent eight months teaching and travelling in New Zealand and Australia. She has participated in exhibitions in Holland, Canada and the U.S.A. Her commissioned works may be seen in public buildings in Boston, Sudbury and Toronto. Spanjerdt's current work focuses on private commissions for wall hangings and on teaching.

Goldie Leikin Spieler, St. Thomas, Barbados, was born in Ottawa and graduated in design from the Ontario College of Art, Toronto, in 1954. Her focus was on handwoven fabric and tapestries. As time passed, her creative instincts led her to deepen her watercolour painting and to work full time as a hand builder, designing and decorating clay works. Needlepoint designing was a side interest until two trips to Israel, plus a request for an "unusual" project for the women of the Agudath Sisterhood, led to the tapestries now hanging in Agudath Israel Synagogue. Spieler has been living and working in Barbados since December 1966, where she has established Earthworks Pottery.

Joanna Staniszkis, Vancouver, British Columbia, was born in Poland. She studied at the Fine Arts Academy in Warsaw, Poland; at the Universidad Catolica, Lima, Peru; and graduated Honours in Interior Design and Textile Design from the Art Institute of Chicago, 1967. Elected to the Royal Canadian Academy in 1980, she was awarded Dean's Grant UBC to conduct a research project in Bolivia. Numerous

large-scale architectural commissions are to be found in Canada. A professor at the University of British Columbia, she teaches textile design and history. In 1985 she and curator Elizabeth Johnson coordinated two continuing education series at the Museum of Anthropology entitled Traditional Textiles: Sources of Inspiration for Contemporary Textile Artists. In 1989, Translations of Tradition, showing her recent work, was a solo exhibition at the UBC Museum of Anthropology, later to travel across Canada.

Leni Taussig, Mayne Island, British Columbia, studied at the Royal School of Needlework, London, England, and at Langara College, Vancouver. She has exhibited her work at the Vancouver City Library; Shalom Gallery, Vancouver; House of Taylor, Mayne Island; and Sidney and Gertrude Zack Gallery, Vancouver. She has received many commissions for her work, mostly in British Columbia. She works full time on commissions, teaching and lecturing.

Elizabeth Taylor, London, Ontario, was born in England, and is a mathematician by training (M.A. Oxon). Her formal training in fibre art includes Ontario College of Art courses; two years in the textile department of H.B. Beal Secondary School; and several Canadian Embroiderers' Guild two-week intensive courses at Brescia College, with instructors from Canada, England and the United States. Her works are in numerous public buildings in London, Ontario, and the Olympic Visitors' Centre, Canada Olympic Park in Calgary, Alberta. Awards are many: Threadworks, 1987, first prize; Celebration '86, first prize; Centre Pieces, 1988, two prizes; Ontario Crafts Council, Toronto, 1983, two awards; 1981 and 1983, Craftsman Designs. Invitational shows include 1988 Montréal Centre des Arts Visuals; 1986 Philadelphia, the University City Science Center, Mask Transit, also travelling to Lima and Japan; and in 1980, London, Ontario, Or Shalom Synagogue, Ceremonial Objects for the Jewish Home. Over the past ten years she has exhibited in three juried exhibitions. Taylor has taught a variety of courses for the Canadian Embroiderers' Guild in London with emphasis on design and experiment; as well she has lectured and conducted workshops in Niagara, Sault Ste. Marie, Peterborough and Guelph, Ontario.

Sandra Toyne, Winnipeg, Manitoba, was born in Winnipeg, where she completed a Bachelor of Fine Arts at the University of Manitoba, followed by a Permanent Professional Certificate of Education. She taught for ten years and now works with her husband in the John Toyne Design Emporium Ltd. A member of the Winnipeg Embroiderers' Guild and the Crafts' Guild of Manitoba, since 1980 she has operated her own embroidery business called Church Embroideries and works exclusively on a commission basis, mostly for the Anglican Church.

Mary Vaitiekunas, Toronto, Ontario, was born in England and has lived in Canada since 1951. Originally trained in theatre arts, she was formerly a stage actress in England and in Canada. With her fabric art, she has participated in numerous group exhibitions since 1972, receiving several citations and awards. Solo exhibitions of her work have been held since 1974, most recently at the Shayne Gallery in Montreal, 1985, and at the Whitten Gallery, King City, Ontario, 1989. Vaitiekunas's work is represented in private and public collections across Canada, Bermuda, Brazil, Florida and England: in Lyndhurst Hospital, Toronto; Gulf Oil, Toronto; Avco, Montreal; Marcelle Cosmetics, Montreal; North York Hydro, Ontario; King Ranch Spa, King City, Ontario; at St. Andrew's College, Aurora, Ontario; and others.

Dora Moore Velleman, Sambro Head, Nova Scotia, was born in Montreal. She has studied with Pat Russell and Joy Clucas. Velleman has received awards at several exhibitions in recent years: in 1987 she was awarded Judge's Choice for her non-traditional, non-professional hanging, *Sing* at Quilts=Art=Quilts, the 7th Annual Juried Quilt Show in Auburn, New York. In Quilt '89, Recent Nova Scotia Work, she received the Golden Thimble Award, and in Quilt Canada – 1990, a juried show at the University of Waterloo, she received the Stearns Award of Excellence. As well as receiving many small commissions, Velleman was selected to design a chapel hanging for St. John's United Church, Halifax. Her work is all done on the sewing machine; she uses pattern stitches for quilting lines. Her main interests are in design, texture and colour. Although she has had no formal art training, her work is incredibly rich and her workmanship is superb.

Margaret Wallace, Victoria, British Columbia, was born in London, England. She has lived in Canada since 1957, first in Dundas, Ontario, and now in Victoria. She has studied at Sheridan School of Design, Mississauga, Ontario; Mohawk College, Hamilton, Ontario; and Dundas Valley School of Art. Exhibitions include Create & Celebrate '83, Grace

Church on-the-Hill, Toronto; Alleluia, Christ's Church Cathedral, Hamilton, 1985; Faith and the Imagination, Trinity College Chapel, Toronto, 1987; Liturgical Arts Festival, St. James' Cathedral, Toronto, 1989; and solo shows at Gallery 252, Hamilton. Wallace's work has appeared in *Embroidery for the Church,* by Pat Beese; *The Canadian Embroiderer* (November 1979); and the *McMaster Banner.* She has completed more than thirty commissions in southern Ontario, in Melbourne, Australia, and in Victoria.

Helen Watson, Toronto, Ontario, was born in Toronto and studied at the Ontario College of Art. Her work hangs in Humewood House, in Knox College Chapel, University of Toronto, and in the Benmiller Inn, Benmiller, Ontario, as well as in several private collections.

Wikwemikong Liturgical Vestment Co-op (Mnidoo Maandaa-Zhichganan), Manitoulin Island, Ontario, was begun in early 1990 when a workshop to make vestments for the church was held. Sixteen people came together to create original vestments for the four Catholic churches on the reserve: among them, Michael Pangowish, a construction worker during the house-building season, Marie Eshkawkogan, the local school-crossing guard, and Rose Toulouse, a nursing-home worker. The group also included Bev Naokwegijig and Eleanor Kanasawe, who excel in artistic design and expression; Polly Trudeau, the mother of six; Debbie and Bernice Aiabens, who are both craftspeople; Mary Lou Shawana, the prayer leader; Eva Jackson and Lucy Trudeau; Rosella Kinoshameg, the band councillor; Pat Mandamin, a craft expert who also runs a restaurant; Rosemary Manitowabi, the caretaker; and Jeanette Eshkawkogan, restauranteur. The group came together through the suggestion of Fr. David Nazar,sj, the local Jesuit priest. His idea was to encourage the expression of local native imagination in the community's daily prayer and sacred rituals.

Barbara Zimmer, Etobicoke, Ontario, was born in Kitchener, Ontario. She began weaving in 1975. At Sheridan College she completed the Ontario Handweaver's Certificate Program (First Semester) and later attended workshops and seminars. In 1983 at the Eastern Great Lakes Fibre Conference, she was awarded Best of Show. At the sesquicentennial Liturgical Arts Festival at St. James' Cathedral, Toronto, 1989, her purple chasuble and stole were prize winners. Zimmer has also created ecclesiastical stoles for the Liturgical Apostolate Centre in Weston, Ontario.

GLOSSARY

alb	a full-length white linen garment with long sleeves that is gathered at the waist by a cincture
antependium	an ornamental hanging for the front of an altar, pulpit or lectern
atorah	the collar (crown) attached to a *tallit*
burse	a square cloth case used to carry the corporal in a communion service
canticle	a liturgical song, taken from the Bible (for example, Magnificat)
chalice	the eucharistic cup
chasuble	a circular-shaped, sleeveless outer vestment worn by a priest
chuppah	wedding canopy, basically a tent-like piece of fabric fastened at the corners to four poles
ciborium	a goblet-shaped vessel for holding eucharistic bread
cope	a long cloak; an elaborate embroidered vestment worn by bishops on occasions such as confirmations and ordinations and by priests in processions on festival days
dalmatic	a wide-sleeved overgarment with slit sides worn by a deacon or prelate
dossal	an ornamental cloth hung behind and above an altar
fall	an ornamental hanging made to hang down in front of an altar, pulpit or lectern
ferial	a day on which no feast is celebrated; with regard to vestments, ordinary or everyday
frontal	a cloth hanging over the entire front of an altar
laudian	a throw-over frontal which is a reversion to the older form of pall; most suited to a free-standing altar, it is draped over the altar
mitre	the head-dress of a bishop, tongue-shaped to remind us of fire which lighted on the Apostles at Pentecost
morse	a clasp used to fasten the front of a cope, frequently of richly embroidered fabric or embellished with jewelled or metallic ornament
orphrey	an ornamental border or band especially on an ecclesiastical vestment
pall	a large cloth draped over a coffin at funerals
pallium	a white woollen band with pendants in front and back worn over the chasuble by a pope or archbishop as a symbol of full episcopal authority
parament	an ornamental ecclesiastical hanging or vestment
reredos	ornamental screen, wall painting, hanging, carving or sculpture behind an altar; frequently corresponds to the width of the space behind the altar, sometimes the entire wall
rubric	a rule for conduct of a liturgical service
stole	a long, narrow ecclesiastical vestment worn about the neck by bishops and priests, and over the left shoulder by deacons
superfrontal	sometimes called a frontlet, it extends the full length of the altar but hangs only a short distance down from the top of the altar
tallit	a long striped prayer shawl with fringes at each corner; each fringe, or *tzitzit*, consists of eight threads
triptych	a three-panel altarpiece
veil	a cloth used to cover the chalice
vestments	garments worn by the clergy

SELECTED BIBLIOGRAPHY

Books

Art Gallery of Ontario. *Art Gallery of Ontario: Selected Works.* Toronto, 1990.

Assu, Harry, with Joy Inglis, *Assu of Cape Mudge: Recollections of a Coastal Indian Chief.* Vancouver: University of British Columbia Press, 1989.

Beese, Pat. *Embroidery for the Church.* London: Studio Vista, l975.

Blodgett, Jean. *Grasp Tight the Old Ways: Selections from the Klamer Family Collection of Inuit Art.* Toronto: Art Gallery of Ontario, 1983.

Bruggmann, Maximilien, and Peter R. Gerber. *Indians of the Northwest Coast.* Translated by Barbara Fritzemeier. New York and Oxford: Facts on File, 1989.

Chaikin, Miriam. *Menorahs, Mezuzas, and Other Jewish Symbols.* New York: Clarion Books, 1990.

Chicago, Judy, with Susan Hill. *Embroidering Our Heritage: The Dinner Party Needlework.* Garden City, New York: Anchor Press/Doubleday, 1980.

Dean, Beryl. *Embroidery in Religion and Ceremonial.* London: B.T. Batsford Limited, 1981.

———. *Church Embroidery.* London and Oxford: Mowbray, 1982.

Ferguson, George. *Signs and Symbols in Christian Art.* New York: Oxford University Press, 1954.

Hawthorn, Audrey. *Kwakiutl Art.* Vancouver/Toronto: Douglas & McIntyre, 1967.

Howard, Constance. *Inspiration for Embroidery.* 2nd ed. London: B.T. Batsford Limited, 1967.

Ireland, Marion P. *Textile Art in the Church: Vestments, Paraments, and Hangings in Contemporary Worship, Art, and Architecture.* Nashville and New York: Abingdon Press, 1966.

Jensen, Doreen, and Polly Sargent. *Robes of Power: Totem Poles on Cloth.* Vancouver: University of British Columbia Press, in association with University of British Columbia Museum of Anthropology, 1986.

Kirk, Ruth. *Wisdom of the Elders: Native Traditions on the Northwest Coast.* Vancouver/Toronto: Douglas & McIntyre for British Columbia Provincial Museum, 1986.

Laliberté, Norman, and Sterling McIlhany. *Banners and Hangings: Design and Construction.* New York: Reinhold Publishing Corp., 1966.

Mather, Christine. *Native America: Arts, Traditions, and Celebrations.* New York: Crown, 1990.

Page, Daniel H., in collaboration with Victor M.P. da Rosa. *Heritage of the North American Indian People: Some Suggestions Emphasizing the Eastern Woodlands.* Ottawa: Borealis Press, 1982.

Parker, Rozsika. *The Subversive Stitch: Embroidery and the Making of the Feminine.* London: The Women's Press, 1984.

Rockland, Mae Shafter. *The Work of Our Hands: Jewish Needlecraft for Today.* New York: Schocken Books, 1973.

Russell, Pat. *Lettering for Embroidery.* London: B.T. Batsford Limited, 1971.

Smith, Barbara Lee. *Celebrating the Stitch: Contemporary Embroidery of North America.* Newtown, CT.: The Taunton Press, 1991.

Stewart, Hilary. *Artifacts of the Northwest Coast Indians.* Saanichton, B.C.: Hancock House Publishers, 1973.

Stewart, Hilary. *Cedar: Tree of Life to the Northwest Coast Indians.* Vancouver: Douglas & McIntyre, 1984.

Whyte, Kathleen. *Design for Embroidery.* London: B.T. Batsford Limited, 1969.

Periodicals

Canada Craft, formerly *Crafts Canada*, Toronto.

Embroidery Canada, Embroiderers' Association of Canada Inc., Winnipeg.

Ontario Craft (formerly *Craftsman* and *Craft Ontario*). Ontario Crafts Council, Chalmers Building, 35 McCaul Street, Toronto, Ontario, Canada M5T lV7.

INDEX *of* COLLECTIONS

INDEX *of* ARTISTS